I, TINA

LATINA

I, TINA

My Life Story
Tina Turner
with Kurt Loder

icon **!t**
itbooks
AN IMPRINT OF HARPERCOLLINSPUBLISHERS

A hardcover edition of this book was published in 1986 by William Morrow and Company, Inc.

First Avon Books paperback published 1987.

First It Books paperback published 2010.

The Library of Congress has catalogued the hardcover edition as follows:

Turner, Tina.
I, Tina.
Discography.
Included index.
ISBN 978-0-688-05949-1
1. Turner, Tina. 2. Rock Musicians—United States—Biography. Loder, Kurt. II. Title.

ML420.T 784.5'4'00924[B] 86-16455

ISBN 978-0-06-195880-9 (pbk.)

10 11 12 13 14 RRD 10 9 8 7 6 5 4 3 2 1

Acknowledgments

I would like to acknowledge:

The liturgy of Nichiren Shoshu for an introduction to spiritual knowledge;

Maria Booker Lucien and her sister Ana Maria for loving friendship, financial support, and providing a haven for me and my family;

Mike Stewart for loyal friendship and financial assistance in launching my solo career;

Leonard Freedman for finally allowing me my own credit card;

Rhonda Graam for always being there;

Dr. Chandra Sharma for bringing me back to good health and always being available for me;

Alline for sisterly support for me and my family;

Henry Ann Williams for great assistance;

Jake Bonds for photos from my high school days;

Terry Britten for my first number one;

My band—James Ralston, Jack Bruno, Bob Feit, and Kenny Moore—for hanging in from thin to thick;

All my friends . . . and all my fans who wished me well;

And finally Roger Davies, who helped make my dreams come true.

Tina Turner

I would like to thank the following people, without whose kind assistance and extensive reminiscence this reconstruction of Tina Turner's life story would not have been possible:

In Clarksdale: Mr. and Mrs. Early Wright, Wade Walton, Raymond Hill, and Tom Reardon at WROX.

In Memphis: Sam Phillips and his sons Knox and Jerry, Rufus Thomas, and Willie Mitchell.

In Brownsville: Roy Bond, Rufus Flagg, and especially Carolyn Bond Flagg.

In Nut Bush: Mr. and Mrs. Joe Melvin Currie.

In St. Louis: Gene Washington, Stacy Johnson, Ike Turner, Jr., Clayton Love, George Edick, Marian Garrett, and Robbie Montgomery.

In Chicago: Harry Taylor, and Bruce Iglauer at Alligator Records.

In Los Angeles: Zelma Bullock, Alline Bullock, Bonnie Bramlett, Little Richard, Johnny Otis, Joe Bihari, Bones Howe, Maxine Smith, Larry Levine, Ann Cain, Rhonda Graam, Jessie Smith, Craig Turner, Waddy Wachtel, Nathan Schulsinger, Pete Johnson, and Morey Alexander at Modern Records; blues archivists Bob Merlis and Tom Vickers; and Roger and Lindsay at RDM—music-loving managers *sans pareil;* and Ike Turner himself, who graciously agreed to rake over some very old coals at no possible profit to himself.

In New York City: David Bowie, Mac Rebennack, Mick Jagger, Seymour Stein, Bob Krasnow, Rhonda Markowitz, Joe McEwen, Bob Gruen, Susan Murcko, Maureen O'Connor, Marty Thau, Rob Patterson, Vic Garbarini, Doug Stumpf for editoral patience beyond all call, Deborah Feingold for snap judgment, and particularly Jann Wenner at *Rolling Stone* without whom . . .

In London: Bill Wyman and the late Ian Stewart.

Elsewhere in the world, thanks to Ronnie Turner and Venetta Fields for long-distance recollections.

Special thanks to Bill Greensmith of *Blues Unlimited* magazine, without whose exhaustive research into Ike Turner and the Kings of Rhythm—and, for that matter, the whole history of St. Louis R & B—no subsequent work such as this could hope to be complete.

Kurt Loder

Contents

Contents

I, TINA

1.

Nut Bush

It is a sun-dappled late-summer morning in Nut Bush, Tennessee, sometime in the early forties. A meandering breeze ruffles the poplars and pecan trees along State Highway 19, and the air is heavy with honeysuckle perfume. Fields of brown sorghum, soybeans, sweet corn, and blossoming cotton blanket the gently rolling countryside. Strawberries abound, and peach trees thick with fruit. There is about the scene a feeling of deep rural repose: the occasional buzz of a hornet, the halfhearted peck of an odd stray hen scratching amid the clumps of cowitch begonia, perhaps the soft flip-and-splash of a hooked perch in some nearby fern-banked pond, or a supperbound catfish in one of the creeks. And now, out of the backwoods, the unhurried clop of a family field horse bearing five small brown children down Forked Deer Road toward its oblique juncture with the two-lane highway.

As their horse draws nearer the main thoroughfare, the kids can hear the intermittent clatter of cars and farm pickups motoring up and down Number 19, headed either for the more substantial town of Ripley some six miles to the northwest—up along that part of the Arkansas border

formed by the Mississippi River, wending its way south from St. Louis down through the Delta to New Orleans—or for Brownsville, fifteen miles to the south and east; or, farther southwest, another forty-five miles or so, Memphis. Few outlanders are likely to entertain Nut Bush itself as a destination. It is a sparsely inhabited mile-long burp in the road, its populace—maybe fifty families—tucked away like weevils in the surrounding pastures, groves, and hollows. Just one in a string of such faintly evident settlements scattered along Highway 19. Passing through—en route to Ripley, say—a motorist might notice the Nut Bush cotton gin, where the annual crop is purged of its seed and prepared for baling. Or, across the highway, Gause's general store, gas pump out front, dry goods and diverse provisions within. Farther along: the Edders Grove Elementary School, a two-room wooden building attended by the children of the area's black farm workers. Next, on the right, a kind of candy shack–cum–honkytonk, owned by Miss Alglee Flowler, where by day kids buy crackers and soda and country bologna, and at night their elders crowd into the sixteen-foot-square back room to snozzle beer and perhaps stomp around to the sounds of Mr. Bootsy Whitelaw, an itinerant trombonist of local note. Finally, backed off a bit from Number 19, there is the Woodlawn Baptist Church, a tidy stack of dignified red bricks adorned by crisp white wooden pillars, where on Sundays the elders stoke their spiritual resolve for another week of strenuous endeavor.

And that, for Nut Bush, is about it. An outhouse here, a pit-dog pen there. Not much.

For the five kids on the horse, however, it is a capacious and comforting world. They are Joe Melvin Currie and his older sister, Margaret; their two first-cousins: Alline Bullock, who, like Margaret, is about age seven, and Alline's sister—younger by nearly three years and tiny by any measure—Anna Mae; and the Bullock girls' older half sister, Evelyn. Well before reaching the highway, they

rein up at the drowsy intersection of Forked Deer and Tibbs Road, just behind the gin house, and slide off their snuffling horse in front of Elvis Stillman's clapboard grocery, where a cold bottle of Coke costs a nickel, and for a bit more there's ice cream to be had as well. They're chattering absently, as small children will, but they politely defer to whatever adults are present, especially white ones. Relations among whites and blacks and the scattered intermarried Indians hereabouts are generally cordial, all things considered; but Tennessee, like the rest of the South, is officially segregated. Some black groups, such as the recently formed Congress of Racial Equality—CORE—up North in Chicago, have begun questioning this social arrangement with considerable animation (and a new political tactic: the "sit-in"). But among rural blacks, an elaborate code of deferential behavior still obtains. In any case, the five kids don't linger long at Stillman's. But as they clamber back on the horse and set a leisurely, laughing course for their homes less than a mile away, they carry with them a happy sense of event, of having done something.

Two of the smaller girls wear their hair in the tight little plaits thought proper for young black daughters, pickaninny twists that poke out like thorns on their gently bobbing heads. But the third, Anna Mae, safely away from parental purview, has undone her mother's patient braidwork and gathered her full reddish hair into a rough ponytail at the back, revealing an already exotic facial geography of elegant broad bones, richly sculpted lips, honey-toned skin, smooth as a breezeless sea, and eyes like tiny brown beacons.

The woman who would one day be Tina Turner was born Anna Mae Bullock at the tail end of another age. By 1939, tensions in the world, long building, were yielding to turmoil. In September, when the Nazis, abetted by the Soviets, sandbagged Poland, England and France finally declared war on the troublesome Huns. In Paris, a physicist named Frédéric Joliot-Curie demonstrated for the first

time the feasibility of a nuclear chain reaction. In the U.S. Albert Einstein pondered the possibility of an atomic bomb.

Such events still seemed safely remote to most Americans, however, and the U.S. remained politically neutral amid the bad news from abroad. There were, after all, more effervescent diversions. This was the year Garbo laughed in *Ninotchka*, the year of *Gone With the Wind* and *Gunga Din*, of Buck Rogers, *The Wizard of Oz*, and *The Hunchback of Notre Dame*. Pan American Airways inaugurated regular flights to London aboard its Dixie Clipper. In New York, Edwin Armstrong, a Columbia University professor, discovered frequency modulation—a marvelously static-free broadcast medium—and built the first crude FM radio station. On the AM dial, Americans contented themselves with Kate Smith's "God Bless America," and hummed just as happily through "Over the Rainbow" or "In the Mood" (it was Glenn Miller's big year) or perhaps "South of the Border," the latest hit by Gene Autry, the "Yodeling Cowboy" of the silver screen.

But 1939 was also the year of Cab Calloway's "Jumpin' Jive," Coleman Hawkins's luminous "Body and Soul," and Charlie Barnet's "Cherokee." Miles Dewey Davis, Jr., son of an East St. Louis dentist, turned thirteen in May and received a trumpet—his first—from his dad. Charlie Parker, Kansas City sax star, moved to Manhattan in 1939 (following a trial taken three years earlier by Count Basie's band, with Lester Young in tow), and was soon part of an as yet unfocused musical ferment being stirred by such musicians as Dizzy Gillespie, Thelonious Monk, and the very young Bud Powell. And that summer, a young black Oklahoman named Charlie Christian popped up in the Benny Goodman Sextet in New York brandishing an unsettling instrument—an electronically amplified guitar.

Ethel Waters, the star of Duke Ellington's steamy Cotton Club revues, appeared in concert at the New York World's Fair, and also became the first black woman to star in a Broadway drama *(Mamba's Daughters*, it was

called). It was the year that Jane Bolin became the country's first black female judge; that more than a thousand black voters defied Ku Klux Klan cross-burnings to cast ballots in Miami; that Billie Holiday, the doomed jazz singer, recorded "Strange Fruit," a blood-chilling account of a black lynching in the South. And it was the year that Marian Anderson, the noted black contralto, denied the use of the capital's Constitution Hall by its white owners, the Daughters of the American Revolution, sang instead on the steps of the Lincoln Memorial, under the aegis of the Roosevelt administration, before a shivering Easter Sunday audience of seventy-five thousand cheering people.

Anna Mae Bullock was born on the morning of November 26, 1939, at Brownsville's Haywood Memorial Hospital, a two-story municipal building whose basement was relegated to the tending of black patients. She was quickly transported back up Highway 19 to Nut Bush, home: a four-room shotgun house ensconced amid the vast and bountiful Poindexter acreage. Her father, Floyd Richard Bullock, was resident overseer on the Poindexter farm, supervising harvests and hands for the property's white owners. A deacon of the Woodlawn Baptist Church, Richard (as everyone called him) was also (as everyone knew) a man in constant conflict with his wife. Zelma Bullock, Anna Mae's mother, was a black Indian of high spirits. Anything but a homebody, she had been smoking cigarettes and shooting .45's since the age of ten, and was not—as Richard had come to be painfully aware—a woman to be trifled with. Richard and Zelma's fights, real wall-rattlers, were the dominant feature of the domestic landscape. There was one other child at home—little Alline, almost three—and she greeted her new sister as an ally.

Down the hill and across Forked Deer Road lived the Indian branch of the clan: Zelma's parents, Josephus and Georgianna Currie. Papa Joe, short and dark, a longtime Poindexter sharecropper, was a warm-hearted, child-loving, church-going Baptist (though not a militant, by any means),

and three-quarters Navajo—a distinction in Tennessee, land
of the Cherokee. Mama Georgie, a wizened squaw, had
the Cherokee blood, and was, like her husband, one-
quarter black. The Curries were happy people, optimists
always. Mama Georgie in particular, ambling about in her
oversized shoes and tatterdemalion farm duds, the very
soul of toleration and acceptance, seemed mystically con-
nected to some higher natural order. It was said that she
had been banished from her tribe for marrying below her
station, but she loved Josephus and never looked back.
Her people, the Flaggs, were distinctively Indian in
appearance—the women noted for their high cheekbones,
angled eyes, and abundant hair worn long and straight.
They still divined much from nature, the procession of the
seasons and the starlit sprawl of the heavens, although this
had begun to fade even by Zelma's day; but for the young
Bullock girls, Mama Georgie, rough and lovable and rooted
in the earth, would become a reminder of the other blood
that flowed in their veins.

Having raised seven children of her own, Mama Georgie
now sheltered three of their semiorphaned spawn. Evelyn
Currie, born in 1935, was the issue of an unconsecrated
teenage liaison between Zelma and one Jerome Beard; she
was thus a half sister to Anna Mae and Alline. The eldest
of the children, Evelyn would always seem cool, dis-
tracted, emotionally remote. But Mama Georgie's other
wards, Margaret and Joe Melvin Currie—the children of
Zelma's brother Joe Sam and his recently deceased wife,
Odessa—were to become prized pals of their cousins, the
Bullock girls.

Farther up Highway 19—hard by the church, and spiri-
tual worlds away—lived the Bible-brandishing branch of
the family: Richard's parents, Alex and Roxanna Bullock.
Mama Roxanna was a big, fine, church-centered woman
of sober demeanor and harsh, starchy virtues. Alex, an
unabashed souse, was the cross she bore through life. With
them lived Uncle Gill, the only one of Richard's many

brothers to remain at home. Visits to this senior Bullock residence, a bastion of Baptist rigor, were anticipated by the two granddaughters with something decidedly short of delight.

Such was the immediate family, comfortably sunk in the Tennessee hills, working the land and living the life allowed them.

Zelma recalled that one of her aunts—Essy Flagg, a small and sleek-figured woman with strong Indian features— had been a rousing singer, with a big, room-filling voice, good enough to go . . . well, who knew where? But she never had. Zelma thought she could detect traces of Essy's smoky vocal tone in both of her daughters, particularly Anna Mae. But Essy aside, neither branch of the family was particularly musical, apart from participation in the weekly church sings.

Nearby the Bullocks' wooden house, across a brief swatch of grassy pasture, fronting on the road, stood the larger brick home of the Poindexters: Miss Ruby and her younger second husband, Vollye. These were "good white people," in the general estimation, and they treated Anna Mae and Alline like something close to kin, counseling them by example in the ways of white folk and fashion, and having them in for snacks and, much later, when TV arrived, to watch the tube. Despite the strictures of segregation, there was a genuine and unmannered amity between the two families. Richard Bullock was a valued employee, and the Poindexters paid him well by prevailing norms. Mr. Vollye doted on Zelma's egg-custard pies, and was kept generously supplied. And Miss Ruby, who had a daughter of her own, doted nevertheless on little Alline, whose first name, Rubbie, although never used, had been bestowed in approximate honor of the white woman.

At the Poindexters', Anna Mae caught glimpses of something that was missing in her own home—easy affection, solicitous commitment. She felt it too in the tribelike embrace of the Currie household. But in her own home she

felt frozen out, barely there. It was more than just the pall that hung over Richard and Zelma's marriage. They managed to find time for Alline between wrangles, it seemed. But for Anna Mae there was little of the hearthside intimacy of a loving homelife, only a grudging toleration.

For it had been her misfortune to be the last, unwanted child of a foundering union. As Richard and Zelma turned away from each other, their puzzled daughter, stranded in the middle, began to turn away too. In those hours unoccupied by schooling, or later by work stints alongside her family in the cotton and strawberry fields, she took to roaming the pastures and the woodlands, searching for strength in solitude. This, she came to suppose, was simply the way things were.

But despair was never in her nature. If there was pain, it would pass. Another day would come, with a new sun to warm it. Her life was just beginning, and as the forties took form she managed to pry a little girl's pleasures out of her uncomplicated backcountry world. Despite the emotional dislocations, there was a redeeming sweetness to life then too, looking back.

Tina: I was raised on pork, and believe me, I'm healthy. That's what I remember clearest about those times, the food. Syrup and biscuits and salt pork for breakfast, winter dinners of beans, rice, and cornbread. And it was good. Daddy's garden must have covered an acre: Cabbages, onions, tomatoes and turnips, sweet potatoes, watermelons—we planted it all, and that garden fed us through the summer. We had fresh eggs from our chickens and fresh milk from our cows. We didn't buy anything but flour and sugar at the country store in Nut Bush, and in the winter we bought beans. There wasn't much red meat—in the winter there wasn't much fresh meat at all. There was chicken, and in the summer we'd fish the ponds for perch. And when Daddy went hunting—sometimes I'd tag along with him, 'cause I was always a tomboy—there were the

birds and rabbits he brought back. But mainly there was pork. We'd kill at least three hogs for the winter, and store the sausages and hams in our smokehouse. The taste was unbelievable. To this day I can tell you the way things should taste, because back then they still did.

Were we poor? I don't remember being poor. My father was always the top man on the farm; all the sharecroppers answered to him, and he answered to the owner. Daddy was in charge. We always had nice furniture in our house, and Alline and I always had our own separate bedroom. And we had animals—the cows and pigs and chickens and horses—and I knew people who didn't. People with the house full of children, and maybe their children's children, and the sunken mattresses and soiled covers on their beds, the mess and the smell of poverty. I knew the difference between that and what we had, and I knew we weren't poor.

There was also the segregation, of course. I don't know how it was for others, but for me, I remember the white people as being friendly then. Now, a lot of that was because the blacks "knew their place," right? As a child, you were brought up to respect white people. It was always "Yes, ma'am" and "No, ma'am" to them; "Yes, sir" and "No, sir." And you always went to the back. That was the way it was. And, yes, always a tinge of fear: It was almost by intuition that you knew the nice white people from the bad ones, and when to really stay clear. But by us all staying in our "place," as they called it in those days, we didn't experience anything too bad. Or I didn't. We knew that if the Poindexters had company, we shouldn't go over to their house—we just weren't invited. But if you passed by white folks' houses and they were sitting out, you could say hello. There was the space left to say, "Hi, Miss Mary," or, "Hello, Mr. Wesley." And that was fine, for then. There was a kind of harmony there. The whites had a fear instilled in the blacks so they could control them and keep them respectful. And they

could get uptight with the older blacks sometimes. But they were very nice to children, and I always remember being treated nicely as a little girl.

There were good times, too. A lot of picnics, especially around Labor Day: big containers of lemonade, homemade pies and fried chicken, and a whole hog spitted up on the barbecue, crackling and turning. Sometimes Mr. Bootsy Whitelaw would play, and maybe there'd be another man playing a drum with him, or someone with a trumpet. It was just country music, picnic music—not the blues or anything. Mr. Bootsy had big feet, big lips, big flaring nostrils, and big, big bubble eyes that just about popped out of his head when he played the trombone. Everybody sort of laughed about how he looked—like a frog, I guess. But he could blow. And if I was there, I would always sing along and dance around to his music: I would entertain. I was just a little girl, little Anna Mae, and I'd shout, "Come on, everybody, sing with Mr. Bootsy!" That was the first "live band" I ever saw, and I liked it.

I was just a country girl, you see. I was very curious about water and fish and climbing trees; climbing anything. I wasn't interested at all in grown-ups and whatever they were doing, and that was because, mainly, they weren't interested in me. The fact is, I had no love from my mother or my father from the beginning, from birth. But I survived. To tell the truth, I haven't received a real love almost ever in my life, believe it or not. People look at me now and think what a hot life I must've lived—ha! I never found a real, lasting love. But I have survived. *Alienation, rejection*—I didn't know those words existed when I was a child. I just knew that I couldn't communicate with my mother, and that my father didn't seem to want me around. I didn't know what was going on at the time, but now I have some idea. Apparently, my mother had taken my father away from another girl—just out of spite, you know? And that's why they never really got along, because they never really loved each other. They fought from the begin-

ning, I think, my parents. It was all right when Alline came along—even if she was the reason they had to get married—but then the marriage went bad, and when my mother all of a sudden became pregnant with me . . . well, today it would be abortion time, I think. Because my mother was in the long, slow process of leaving my father, and they were fighting constantly. Sometimes she would actually leave him—drag Alline and me off with her to Mama Georgie's house. But my father would just come and get her and take us all back home, and then they'd fight some more. My mother was the type of woman who always fought back, too, if you get the picture.

There was this strange rumor, when I was growing up, that I was not my father's child. It seems that before I was born, my father's sister, Martha Mae, and her husband were living with my parents; and Aunty Martha was fooling around with another guy, but on the sly. There was talk, but it was vague. And because my parents were not getting along, my father's people somehow got the notion that it was my mother who was fooling around, and that I was this other man's child. When I came along—this red kid: fair-skinned and fair-haired, nothing like Alline, who was very dark—my father's people said, "Oh, no, that's not Richard's child." They were church people, and they never cared for me, just never did. As for my mother, she simply didn't want a kid then—and especially not the brazen tomboy I turned out to be.

But I loved my mother, oh . . . I remember she used to sit in the window of the kitchen when she was making dinner on Sundays, and always stare out at the sky. And I used to just watch her. I thought she was so pretty, like a young black squaw: very small, with a little pointed nose, thin lips, big teeth, a bit of gold in them. I saw her in her beauty there, sitting in that window. I watched her hands, her feet, the way she smoothed her hair. I knew her toenails, and how her toes curved. And her smell: I always went to her chair when she left it so I could smell her

aroma—clean, sweet, very feminine. She was "woman" to me—what a woman was. I knew every darned thing about her. I loved her and she didn't even realize it. I'd look at her and think, "Oh, she's really pretty. I wish . . ." And I'd wish, and I'd wish. But I never got that wish. My mother wasn't mean to me, but she wasn't warm, she wasn't close, the way she was with Alline. She just didn't want me. But she was my mother, and I loved her.

I knew that my sister always loved me, that she'd always take care of me. But Alline was somehow too slow and quiet for me—I was always up to something, running, moving, doing. I felt like a complete outsider, the only one of my kind. So I just went off by myself, out in the world, to walk in the pastures and be with the animals. I was lonely, but I didn't dwell on it. I just said, "Okay," and I became accustomed to it, I guess. I had my own other thing going, my own world. And that was the beginning for me. I didn't have anybody, really, no foundation in life, so I had to make my own way. Always. From the start. I had to go out in the world and become strong, to discover my mission in life.

Childhood's End

The Japanese bombed Pearl Harbor on December 7, 1941, and within four days the world was at war. Suddenly there was movement, change, transition everywhere. Soon fresh-minted GIs were sailing off to French North Africa, and Gene Autry—an air corps cowboy now—was piloting cargo runs over Burma.

With the war in full swing and the home front rearranging itself around defense priorities, a host of new possibilities—social, economic, and cultural—began to present themselves, particularly for blacks. A certain urgency and vast new funds were assigned to the quest—ongoing in America for the previous two years—for a nuclear weapon. As Einstein put it to President Roosevelt: What if the Germans got one first? The search for fissionable materials was institutionalized in the spring of 1942 as the Manhattan Project, and among its first undertakings was the construction of a huge diffusion plant in Oak Ridge, near Knoxville in eastern Tennessee. Oak Ridge was clear across the state from Nut Bush, but news of the burgeoning demand for labor in the area spread fast. Richard and Zelma Bullock were among those attracted by the promise

of fat government paychecks and a life off the farm. Building crews were needed, hashslingers and cleanup women. Richard and Zelma felt little reluctance to leave Nut Bush, and their daughters, they decided, could be easily stashed. Alline was sent to live the Indian life with Mama Georgie; Anna Mae, less fortunate, was consigned to the dour ministrations of Mama Roxanna. And Richard and Zelma, riding the crest of a new era, set off to live in Knoxville, a short bus trip from their new jobs. He became a laborer with the top-secret Atom 12 project, she an airbase waitress and dormitory domestic. They stayed for more than two years.

Tina: I was, what—three when they left? Just a little thing. But I was miserable. I was so unhappy. I loved Mama Georgie and my cousins, and I wanted to live with them. Oh, Mama Georgie: She wore men's shoes, and a shirt over the top of her dress, and she looked totally Indian—had the layered look before anyone thought to call it fashionable. In fact, she looked a lot like Diana Vreeland when I think about it—you know, the editor of *Vogue*. She was great. She'd never beat us if we were bad; she'd just hit us on the elbow with a stick of wood, or pop us on the head with a spoon, and we'd go, "Wowww!" It didn't really hurt, but just the same, you wouldn't want to let her get near you with that spoon, or the stick. She was fun, mainly. I loved her. There was a lot of love there with the Indians, just natural affection, and that was where I wanted to be.

But where did I get thrown when Ma and Daddy left? To my father's people—it was awful. Mama Roxanna was a big woman with fair skin and long hair mingled with silver, and she was a church woman—wore the Dr. Scholl's shoes, and the hair pulled back in a ball. She was a seamstress, and in her house dresses stayed washed, starched, and ironed. And the house was spotless, of course. All I ever wanted to do was get out of there—out

in the fields, out with the animals. But she held me prisoner. She'd always make me sit in some damned chair. I hated it. I was never one for sitting still, and I was never one for a dress, either.

That's when I was introduced to church, too—Mama Roxanna dragged me to church every Sunday. Papa Alex, her husband, had nothing to do with that, of course. Papa Alex was a drunk. He'd work through the week, and on the weekends he would drink. Boy, would he drink. Mama Roxanna would be at the Baptist church praying and singing, and Papa Alex would be home drunker than a fish. He had no hair, and sometimes, when Alline and my cousins were over visiting and he'd get really drunk and pass out, we'd put makeup on him, lipstick and everything, and paint little faces on his head. When he woke up, he'd just laugh and lurch around. He didn't care. He'd found his own way to deal with Mama Roxanna.

Sometimes—the best times back then—I would get to visit Alline and my cousins at Mama Georgie's. We'd run around outside all day long, laughing and playing, and we'd go to bed worn out and half dirty and happy—so happy. We lived like Indians: At Mama Georgie's, it was time to get down in the dirt and have fun, to climb trees and chase the animals. Those visits never lasted long enough. I'd look up and there'd be my Uncle Gill coming for me, to take me back to Roxanna's, and it was like a nightmare starting all over again. I would run and scream and cry—"No! No! No!"—and they'd have to chase me down to take me back there.

Uncle Gill shot a man. Another black man, I think. Something about a woman. Uncle Gill still lived at home then. He hadn't married yet, but he was very good-looking—smooth skin, beautiful hair. He came home one day and got his shotgun, the double-barrel, and loaded it and left, and he shot this other man and killed him. And suddenly, there was the law. We opened the door and there were these two pairs of shiny black boots and these white men

looking down at us—the Hunter brothers, Jack and Tip.
One was short and blond, sort of German-looking. The
other was big and fat. We knew about the Hunters. Every-
body did. They broke up so many corn-whiskey places
around that area—I mean, these guys kicked ass. And now
here they were looking for Uncle Gill. We were so afraid.
But Uncle Gill didn't hide. He had shot this other person,
and they took him away and he went to prison. In Nut
Bush! It was quite an event, let me tell you. And there
weren't many in that place. Years later Uncle Gill got out,
married, and had three children—one boy and two girls.

In the summer of their second year in Knoxville, Rich-
ard and Zelma Bullock sent for their daughters to join
them for a few months. Anna Mae, not yet five, marveled
at the largeness of city life.

Tina: The houses were bigger. They weren't wood
houses, like ours, they were brick, and two stories, and
fancied-up, you might say. Every street was paved, and
there were lots of cars, and everything seemed shiny and
new. Sometimes my mother would take me to the shops to
buy clothes or whatever, and I would sing for the salesla-
dies. Then the people in the store would want me to sing
some more, and I would, and they'd give me money. In
those days, a little kid would be lucky to have some
pennies or a nickel, but I always got quarters from the
people, even half-dollars. And I got a big glass bank, and I
started filling it up. Someone took it from me later, I
forget who. But I can still see that bank in my mind, filled
with those shiny coins. Just for singing.

While Richard and Zelma were at work, Anna Mae and
Alline would be left in the care of a Mrs. Blake, a friend
of the black woman with whom the Bullocks boarded in

Knoxville. Mrs. Blake belonged to a local Pentecostal church, and sometimes she would take her two charges along to soak up some righteousness at its "sanctified" services. These Holy Rollers, unlike the stern Baptists back home, wholeheartedly endorsed the unity of body and soul, it seemed. They celebrated their salvation with piano and organ and hand-clapping choirs, and delirious dancing in the aisles. At peak moments, devotees might slip over the edge of enthusiasm into ecstasy—babbling in tongues, seized by the Spirit. Anna Mae was astounded.

Tina: It was fun to me—so much more exciting than the Baptist church I knew back in Nut Bush. Here I was, dancing and singing, for the first time. It was wild. The sanctified people were a little weird—they'd fall out and go into spasms and things. I didn't know what that was about. I just thought, "Well, they must be real happy."

Zelma: She could really do that holy dance. Picked it up just like that, you know? She was always quick to catch on to things.

Alline: You'd get the Holy Ghost in those services, and you'd dance around faster and faster, and the music got louder and louder. One time Ann's underpants fell down around her ankles, she was dancing so hard. But she didn't let up.

As with the more sedate form of Baptist worship back in Nut Bush, the devotional details of the Pentecostal vision left Anna Mae unmoved. The idea that there might be a white man with a beard sitting in the sky monitoring everyone's problems seemed to her improbable. But she liked the music, all right, and the leaping around: "I knew I could never be a part of that religion, really. But for a little girl, those sanctified services were something to see."

The Bullock daughters' visit to Knoxville was brief. Soon they were back in Nut Bush, apart again, nurturing first memories of a world outside. Their parents' jobs were eventually phased out and they too returned. By the time American B-29's dropped two freshly concocted atomic bombs on Japan in the summer of 1945, the reunited Bullock family had settled in Flagg Grove, an obscure clearing in the wooded bottomlands off Highway 19. Richard took up farming again, on rented land, and his fights with Zelma continued apace. Anna Mae started school—something for which she felt little affinity from the outset—and after a few years the family relocated once more, to the nearby hamlet of Spring Hill. As she grew into girlhood over those years, Anna Mae felt increasingly isolated. Her parents' relationship was clearly approaching some sort of terminal blowout. If it hadn't been for the closeness of Alline, and for her cousin Margaret, she would have felt totally out in the cold. Margaret was sweet and open and she was three years older than Anna Mae, and they could talk about life, love, even sex—things about which more fortunate children were instructed by their parents.

But Margaret and her brother, Joe Melvin, didn't live quite so close anymore. There were still family visits, of course, but mainly Anna Mae and Margaret would see each other only on weekends, usually Saturday nights. This was when both the Bullocks and the Curries, along with other rural denizens from miles around, would drive in to Ripley for a night of relaxation in the Hole, as the gaudy strip of black rib joints and boozy jukes down a cobbled back alley off Washington Street was called. The kids—Anna Mae and Alline, Margaret and Joe Melvin, and Evelyn too, before she grew irretrievably distant—would be dispatched to take in a movie at the Webb Theater: B westerns, cheap weepies, whatever was playing. When the show ended, they'd band together and steal down into the Hole, buffeted by the blare of boogie-woogie from the

jukes, the howls of fine-looking women dancing with slick-haired, sharp-dressed men. There, in this outpost of abandon, the children would make their way to Miss Laura's Restaurant, a popular fish-fry parlor, to rendezvous with their partying elders, and after a while to return home, goggle-eyed and depleted.

Tina: It always seemed to me that there was sex in the air down there in the Hole. It wasn't far from the theater we went to, and after the show was over, around ten o'clock, we'd go down there and find the folks. They'd be in the restaurant eating fried fish or something, and I'd say, "Ma, I'm out of the movie," and she'd say, "Okay, we're gonna go in a minute." And it was never just a minute, but that was fine with me, 'cause I was kind of a devilish little girl, and I liked to hang out. So I'd go stand off to the side where I could see what was going on. And boy, the things I saw, standing there in my flat shoes and my little cotton dress, nine years old, ten maybe. There'd be every kind of people down in the Hole, even some white folks standing around on the streets. You know how white people are about black people—they're intrigued by them. Black people know how to have fun, and they have a different kind of fun; so sometimes you'd see white people standing around just watching what was happening in the Hole, because there was all kinds of stuff going on down there—on the streets, in the bars, everywhere. Everybody had their best clothes on. You could tell that some of the women had just bought new shoes and worn them right out of the shop: two-tone numbers—tan and white, blue and white—with real high stiletto heels. And fine suits with the big shoulders and tight skirts. Tight skirts were in—you could see on some of the poorer women where the seams had busted and they'd just sewn them right back up by hand. Funky, right? Lord. Maybe there'd be somebody from up North there, wearing the newest styles, and they'd be the star of the scene. And the juke-

box would be playing—boogie-woogie and blues—and the women would all be flirting and gyrating and dancing and smoking and drinking beer. And I'd be looking at this one and that one, and thinking: "Wow, she's hot—she must be doing it." Because I knew something was going on. I'd passed all those cars with the fogged-up windows. I knew. But I didn't know exactly what.

There were fights down in the Hole, too, and they were scary. One night I was down in there, waiting as usual, and all of a sudden there was this screaming and shouting, and something about a switchblade, and people started running out the door. Well, when things like that happened, we would always run out and back up the hill to the street—the Indian blood I guess: Always go to the high ground. So I was running, and I turned and I saw this woman stumble out onto the pavement. She was drunk, I guess, and her chest was all red. Then she fell, and when her body hit the sidewalk the blood started gushing out all over. It was everywhere. I saw her face, and she looked dead. I turned around again and kept on running.

Real scary, as I said. But it was also kind of wonderful, all that action down there in the Hole. And those visits to Ripley were just about the only time I got to see Margaret. How can I tell you what Margaret meant to me? She was closer to me than my own mother, even my own sister. She was a strange-looking black girl, because she wasn't really black. Her mother, Odessa, had been an unusual mixture of races, too, and of course her father—my mother's brother—was mostly Indian. Margaret looked sort of Scandinavian—the nose, the cheekbones, the same kind of eyes—but with color. Her hair was a mulatto shade, worn in big braids, and she was fair-skinned, high-waisted, and tall as a cornstalk, with real long legs. Well, Margaret loved me, and I loved her, too. She was my only real friend, always there for me to talk to, to be with, to learn from. My first teacher. She was three years older than me, and she was my cousin, sister, mother—my heart. Oh, I

loved Margaret. She was godsent, truly. You see, I believe that you're always given someone—maybe not a father or a mother or a sister or brother, but someone. And I was given Margaret. For a while, anyway.

Anna Mae first formally raised her voice in song at the Spring Hill Baptist Church, chiming in with the choir on such stalwart traditional hymns as "Onward, Christian Soldiers" and "Amazing Grace."

Zelma: She had a good voice even then, oh, yes. She would go to the movie, and if it was a musical, she would come home and sing the songs and act out the parts that she remembered seein'. They weren't all musicals, of course. One day she came home and grabbed her throat and fell flat out on the floor—held her breath and started turning pale! I had to scream to get her to stop. She got up and said, "Well, that's the way the lady did it when she got killed in the movie."

She were somethin', all right. A real live wire. If I hadn't been . . . well, my husband and I had problems from the time I were pregnant with Anna Mae, and they just got worse. It was always kind of difficult for me to . . . well, things were just difficult. But she mostly liked playin' alone; sometimes with other children, but mostly alone. She could entertain herself. I remember I had a dressing table in the bedroom, one of those with two mirrors on the side that you could pull together, and a stool. She had started tryin' to climb up on that stool from the time she could walk, and finally she made it. And she would get up there and take her braids down and pull those mirrors together and then look at herself playin' piano— just pretend, of course, drummin' her fingers along the top of the table—and singin'. Yes, she had a beautiful voice, even back then.

* * *

Tina: I had gotten into the choir as soon as they found out I could sing. I wasn't much of a one for church, to tell you the truth. First you'd have to go to Sunday school, and that was all right, with all the kids there; it was kind of fun. But then, afterwards, you'd have to sit through the service, and it was hot and you'd be sweating—no air conditioning then, you know? And there'd be all these old people singing, wearing all these clothes, and the hats, and you didn't know what the preacher was talking about, and you just had to sit there. My half sister, Evelyn, used to sneak outside sometimes and get into cars with boys. That was something some of the older girls did, can you believe it? I think she almost always got caught. The choir was the only thing I enjoyed. I was the only little girl in it; the rest were teenagers. But I could sing. I wasn't aware that I was singing about God, and how good he was; I just liked the songs. And I would always take the lead on the very upbeat ones—you know, the real shouters. Even then.

I guess I already had dreams, too, as young as I was. Already had an imagination. I knew I wanted to wear my hair differently—I hated those braids. And I had a feeling about the piano, too, and it had nothing to do with church songs. I wanted . . . glamour, I guess. Not that I knew what glamour was at the time. We didn't get any beauty magazines or anything like that, although sometimes you might see one in a white person's house. I think it was mainly from the movies I saw in Ripley. Sometimes, when my mother wasn't around, I would put on one of her brassieres and her underwear and I'd lay a blanket out on the lawn and lie out there like—like Hollywood! But I didn't know it was Hollywood, exactly. I just knew that I wanted something else.

One thing I couldn't fit into any kind of dream was picking cotton. God, I hated that—hated it. I mean, that wasn't glamorous at all, right? The cotton would have to be cultivated first, with the sharpened hoe and all, and

then in July we'd have to pick it out of the husks. It was hot, and hard, and I was never very good at it; a sixty-pound bag was the most I was ever able to fill—half as much as a grown-up. We'd pick strawberries, too, a seasonal thing: When the crops came in, the people that owned the strawberry fields around there would hire the whole community to come and pick them, and we'd all make a little extra money from that. And there was corn to be cut, which the men did. But everybody worked on the cotton. I can still see those fields, the rows of cotton, the struggle of the country. Anna Mae out there, with her dreams.

I guess I probably became aware of sex back then before I ever knew anything about love. I just wasn't surrounded by lovers. My mother and father didn't love each other, and aside from them I was mostly around Baptist people, and Baptists didn't kiss or hold hands or anything. That was something white people did, it seemed—sitting real close, being in love. I never saw that among black people in those days—which isn't to say it didn't happen; I just never saw it. Among the black people I did see, you were always aware that love was sexual, and there was something sneaky about it—always sneaking off into the sheds or someplace. Oh, those sheds.

I remember there was this very pretty girl—Nancy, her name was; she was some kind of mixed-race person too—who was fooling around with a guy that worked on my father's farm. His name was Welton, and I had seen Welton go into those tool sheds with a lot of people. Alline kept track of them—I wasn't quite that nosy—and she said it was everybody. I guess the word must have been that Welton was a good lover. I didn't know about any of that. I just knew that Welton—well, this is real hard to believe, but Welton ate rats. Yes! He'd catch a rat and kill it, open it up—it was full of black yuck, gech!—and cook it up in a skillet and eat it. Unbelievable! You might say I had some preconceived notions about Welton. And

this Nancy was a tall, very pretty girl—she looked like a darker version of Jayne Kennedy—and so when I saw her sneaking off with Welton one day, I was shocked. I thought: "I don't believe she's going into the shed with him." So after they'd gotten in there and closed the door, I sneaked up on them. The door was made of wooden slats, and I had to turn my head sideways to see in between them. It was dark at first, but then my eyes adjusted.

And the things they were doing in there—I wanted to do that too! I mean, I was interested. There was a part of me that was attracted to that dirty stuff. Which is funny, because most of me was very straight. Still is. I saw beauty in love, but I couldn't see it in sneaking off to a shed with somebody. Somehow, I felt that white people's love was prettier, more romantic. Not because they were white, but because of the way they acted toward each other. They lived in a different world, of course. But I wanted that, too, the kissing and the affection.

I didn't talk about these feelings with my school friends. There were only two of them really, Wanda Jean and Glodine, both real virgin-types. We all went to Johnson Annex together—the grade school right next to Lauderdale High in Ripley, where Wanda Jean's father was the principal. She and Glodine were from a well-to-do class of black families in the town—doctors, principals, professional people—and I never heard them talk about wanting to "do it," or anything like that. But then they never saw any of the things I was seeing on the farm, the people sneaking away to those sheds and all. Even my father, who was a deacon, didn't know I was seeing that kind of stuff. But I was. My life seemed divided between the upright Baptists and the proper little girlfriends on one side, and all this earthiness on the other. The clean and the dirty—I was caught in both worlds. Maybe you have to be a bit of both to learn about life. Life is certainly about both, isn't it?

So I was ten, going on eleven. It was 1950. I knew that the problems between my mother and father had gotten

worse and worse, and now I knew that something was going to happen. I could feel it. And this time I knew Ma wouldn't just be running off to Mama Georgie's house for a few days, either. Then, suddenly, she was gone. Daddy came home and he kind of panicked. He went to Mama Georgie's, but she wasn't there. He looked everywhere, but she had disappeared. It took him about a week to find out that she was no longer down South, that she had moved to St. Louis to live with an aunt.

That's when it really hit me how much I loved my mother—and how much I hated her, too. I guess I was learning how close love and hate can be. It wasn't just that she had left—that was fine. I guess we knew that would happen eventually. But I wanted her to come back for us, for Alline and me. And I waited, and waited, and she never did. I used to go to the mailbox every day, but there were no letters. I used to cry and cry. Finally, one day I just sat up and said: "Damn you, mother." Just like that. I was so hurt. I had wanted her love for so long, and now I would never have it. How many years had I watched her acting like a real mother with Alline; watched her down in the Hole, when she was happy; watched her in the kitchen on Sundays, sitting in the window, just staring out? Then one day she wasn't in that window anymore. And she was never in it again. Gone. I cried and cried, but it didn't do any good. It never does, you know.

Richard Bullock, not nearly so deflated, perhaps, but hard-pressed for help, remarried in short order, importing into the rustic Spring Hill homestead a Ripley divorcée named Essie Mae and her daughter, Nettie Mae, who was Anna Mae's age. Essie Mae's nickname, by which she was addressed to her face, was "Frog." Similarly—and for reasons the Bullock girls found equally apparent—Nettie Mae was referred to in person as "Pig."

* * *

Tina: They were actually pretty people, with that mulatto skin—you know, very light. But Essie Mae did look like a frog, and Nettie, well . . . Frog and Pig, what can I say? They were from Ripley, so they were city people—city slick, too. Frog was one of those fine black women with big, sexy hips and the gold teeth—that was the style then—and a full head of hair that she always kept pressed and curled. They had been living well in Ripley, I think. I know Pig, the daughter, had lots of clothes, and I remember being jealous of that. And Daddy was trying very hard to be nice to the woman, to be affectionate, so that she'd stay with him, and that just made me feel worse. I was like a little dead flower there for a while, with the new stepmother I didn't want, and the Pig situation. And then Frog decided she wanted to move back to Ripley— she didn't like living in the country—so Daddy got us a house on Scott's Hill, still farm country but in the city limits, right next door to a cemetery. And that's where he and Frog started fighting.

Frog was wild, you see—she didn't take any nonsense. And when Daddy would start beating her butt—well, two times, I remember, she stabbed him. There was a lot of that sort of thing between them. The first time she stabbed him was in the groin—I think she was aiming for you-know-what—and the blood was flowing, and I got so scared. They only stayed married about a year or so—I think Daddy got scared of her, too. Anyway, one day, Frog and Pig were gone, too.

In the gloom and disarray that attended Frog's departure from the little white bungalow next to the Scott's Hill graveyard, Richard Bullock stopped going to church and generally left the tending of his daughters to a beneficent woman named Miss Jonelle and also to Ella Vera—the mother-in-law of one of Richard's brothers.

* * *

Tina: Miss Jo was like our nanny. She lived in our room, with me and Alline, and she became very close. I loved Miss Jo. She lived with her daughter, mainly, but whenever they would fight or something, Miss Jo would come stay with my father. It's funny, he always had other people living with him, it seemed—always a man that lived in some little outbuilding and helped him with the chores, or a Miss Jo to watch the girls. But then Miss Jo and Daddy would fight, and in came the other women— Mama Roxanna, Cousin Ella Vera, who lived near us on Scott's Hill with her husband, Pick. Always back and forth, back and forth. And us in this house at the top of Scott's Hill with the cemetery right next door—real spooky. I mean, you tell me you wouldn't start seeing monsters walking in through the windows. Sometimes, if I was there all alone, I'd have to run off to a neighbor's house, I got so scared.

By the time I was thirteen, I still didn't have my period. I didn't think of it as being "late," or anything. It just hadn't come yet, and that was fine—because I didn't want to know about it, anyway, me still being such a tomboy. But Cousin Ella Vera found out—to this day I don't know how—and I guess she figured, "Well, there's no woman in that house, and Richard is there with those two girls . . ." So she told Daddy that I didn't have my period, and what he should do about it. And Daddy took me to a doctor—to be examined! Oh, God, I felt so ashamed and humiliated, with the poking around down there and all. So embarrassed. I can still remember how much I hated that.

And then, you know what? Daddy left. Moved to Detroit and left Alline and me with Cousin Ella Vera. Just like that. I couldn't believe it. Here I was, thirteen years old, with no mother, and now my father was gone, too. And then, just a little while after he left—here comes my period. What a nightmare! I refused to accept it at first. I remember washing myself all the time and kind of whimpering about "I'm not gonna have this every month, I

want you to know," and washing and washing. I was so mad at my father—I felt like if it hadn't been for him, I would never have gotten this thing. And now here it was, and where was he? I mean, "Thanks a lot, Daddy," you know? "You got me started and then you left."

I didn't dislike Cousin Ella Vera, but I didn't like her a lot, if you know what I mean. So I became a real loner then. If anybody took care of me, it was my sister. Her and Florence Wright. Now, Florence was a beautician that Daddy had found to do our hair, and after he left, she became like a mother figure for me. The Wrights were well-to-do black people in Ripley, had their own home and everything; and Florence was a big, fine yellow woman, with red hair, and real feisty, you know? She had a husband, but he didn't matter—it was just her, she was wonderful. But she was wild, too. Once when she was drunk, I saw her stand in front of the house and go to the bathroom, without even taking her undies off. Oh, it was shocking! But I don't want you to get the wrong idea. Everybody knew that Florence worked hard and lived nicely. She was really very nice, and she sort of took care of us a little after Daddy left—I mean, I wouldn't have to pay to get my hair done, that sort of thing. There was a whole family of Wrights—red people, looked like a tribe of Indians—and some of the women were beauticians. These people were very interesting to me, being a country girl. They didn't work in the fields or any of that. They worked in beauty shops, that was their business, and they did well, had their own homes. And that was when I really started to realize that there was another way of living. Not in those little houses we had in the country, with the linoleum floors and the dirt yards, but in a neighborhood, with paving on the streets and grass lawns out front, white houses with green shutters. And with nice furniture inside, and hardwood floors and carpets. That was the first time I really saw that, what life could be like. I was fourteen.

But we weren't living with Florence Wright, we were

living with Cousin Ella Vera, and that became hard. You see, after my parents left, there was never any contact with either of them. When my mother left us, she didn't send back money for food or clothes or anything, not a card or a letter. And when Daddy left, it was pretty much the same. He had sent a bedroom suite along with us, and he sent money to Cousin Ella Vera for a while, but it wasn't a lot. So we were forced to become independent. That's when I started working for the Hendersons, a white family in Ripley. And the Hendersons changed my life. Saved me, you might say.

The Hendersons were typical young white people. They'd gotten married and bought their first house—had it built for them, a nice brick place—and had a baby. Miss Connie Henderson had been a teacher in the elementary school before she got married. Her husband was Guy Tucker Henderson, who owned the local Chevrolet franchise in Ripley, and their baby's name was David. I started working for them after school, taking care of the baby and helping Miss Connie around the house. I learned how to wash David's diapers and fold them and all that, and how to clean, how to organize things. Before long, I was basically living with the Hendersons. I'd stay with them on weekends, and on Saturday nights Mr. Guy would drive me in to the movie, and when it was over, one of them would pick me up. The theater, remember, was right near the Hole. But I wasn't even interested in that place anymore. Because I was learning about this other world—the white world, I guess—with magazines and books and culture. I worked for the Hendersons, and I cleaned for them, but I wasn't just a maid. I was a part of their life; I lived there. And it was from being around them that I started thinking about marriage, and what it might be like. I had never thought about marriage before—not when I was living with my parents, with all their bickering and fighting. But the Hendersons' marriage was different. Mr. Guy was the faithful type—I can't imagine that he ever even

thought about cheating. He loved Miss Connie, and they had their baby and they had their house. And I realized that that was what I wanted, too—I wanted that kind of affection and caring and commitment. A real romance, you know? The Hendersons, just being the way they were, opened my eyes. They taught me so much, those people. They were really like parents to me, and they corrected old patterns of mine.

Still, nothing can really take the place of a girl's mother. So it was a good thing I still had Margaret. There had been some changes in the family by 1954. Papa Alex had died—Mama Roxanna's husband—and she was living with Uncle Gill now, the one who'd shot that man in Nut Bush. Uncle Gill had been released from jail and even gotten married, finally. And Evelyn, my half sister, had gotten pregnant by this rich high school boy, Alonzo Curry. He wanted to marry her, but she said no, because she was really in love with somebody else. So she had had the baby, a girl, Dianne Curry—she wouldn't even let Alonzo see her—and she just took the child home with her to Mama Georgie's.

Well, Evelyn and Margaret were inseparable—mainly because Mama Georgie made them go everywhere together so they wouldn't get in trouble. And every Saturday, they still came to Ripley. It wasn't too hard for them to get a ride, because Nut Bush people all went somewhere on the weekends, either to Brownsville or to Ripley. Ripley was hipper—Brownsville was just a cut above Nut Bush—so that's where Margaret and Evelyn went. Now, Evelyn didn't really like to hang around with any of us, because she was older, getting to be an adult. She was a cold girl—I guess she loved us in some way, but she wasn't verbal or physical about it—and she could be a mean little son of a gun, too. Evelyn was short and she had big hips and a wide, flat fanny and big brown eyes. She was pretty in some ways—but evil! So I never really cared that Evelyn was coming to town, but I waited all week for

Margaret. I would be staying with the Hendersons, and when Margaret and Evelyn came, I would go into town to see them. Those were the happiest hours of my life back then. That's how much Margaret meant to me.

She really was like my mother. She told me what sex was—I didn't understand exactly how you got pregnant, but I got the idea. Margaret told me the things a mother would tell a daughter. My mother had left me, and so Margaret had to tell me everything. She even taught me how to kiss. I remember one time she told me about this new kiss—tongue-kissing, it was called. She said, "This is how they're doing it," and then she showed me. Now, this wasn't sexual—it was kissing your first cousin. The tongue-kiss was something new, something happening, and she was teaching me how to do it. Alline was the same age as Margaret, so those two would get together and whisper and giggle about things a lot—high school girls, you know? But then later Margaret would always come and tell me what they'd been whispering about—like if Alline had had sex or whatever. Ha-ha! Margaret was wonderful. She was intelligent and clean and organized— had every Christmas or birthday present that had ever been given to her, all neatly collected. I think I took a lot from Margaret. She was truly my first teacher. God, I miss her still.

Margaret became pregnant that year, and the last time I ever saw her was the day she came to tell me about it. Margaret had actually had very few boyfriends, but she had fallen in love with this one boy, Ham Stocking, and they were already planning to marry when she became pregnant. But now Margaret wasn't so sure. She said, "I don't know if I should have a baby—I want to go to college." Well, no one in my family had ever gone to college. It was a special word, you know? *Col-lidge*. And I just know that Margaret would have become a teacher, too, if she had gone. But she was wondering what to do, and she was drinking warm water and black pepper—this

awful mixture—thinking it might help her to lose the baby. She came and told me all this—I was the only one she told—and it was the last time I saw her alive.

After all these years, it still hurts to think back to what happened. I guess it was the following weekend. Margaret and Evelyn and another distant cousin, Vela Evans, had gotten a ride with this guy to a basketball game. The guy was drinking, and on the way back he went to pass a car on a hill and ran head on into a diesel truck. I got the call at Miss Connie's house. It was the first time in my life that I ever fainted. I mean, I had always laughed about that— black people don't usually faint, you know? White people were the ones that had nervous breakdowns and fainted and cried a lot. Black people just cried and dealt with it, whatever it was. We dealt with slavery, right? But when I got the call that Margaret and Evelyn were dead—not "in the hospital," but dead—my legs went right out from under me. Not Margaret! Oh, God. I just sank to the floor.

An accident that awful was big news in a small town. I can close my eyes and still see the pictures in the Ripley newspaper. They were so horrible. Both of their bodies were gashed and scarred, really cut up. Margaret had been sitting in the front seat; Evelyn and Vela—the only one who survived, with a broken leg—were in the back. When the car hit the truck, Margaret was thrown out and killed immediately; Evelyn was crushed to death when the backseat was pushed into the trunk. Vela told us how they had begged the guy driving to slow down, but I guess he was too drunk to care. And she told us about Margaret being pulled from the wreckage and lying there.

I was fourteen, what did I know about dying? I just thought it was cold and hard and final, and that people cried. But I had never cried. I had been to Papa Alex's funeral, but I just thought he looked great in the casket, better than in life—all done up in a suit and tie, and not acting crazy like he always did. But with Margaret and Evelyn, it was the first time I realized how cold death

really was. The funeral home had them both there together, and Evelyn didn't even look like herself. Her skull, her whole face, was crushed in, just about smashed flat; but her hair was the same—it was so strange. There was a gash running down the side of her face, God—couldn't they have hidden it somehow? And they had folded her hands together, and there was a big scar on one of them, too. And Margaret, my friend—there she was, that pretty, pretty girl: not just dead, but mutilated, destroyed. I touched her hand with mine. I'd never felt anything so cold. She had been pregnant, and nobody knew it but me. Then I heard myself crying and yelling: "Margaret!" "Evelyn!" Wanting them back, and knowing they were gone forever.

When the mortuary sent back the clothing they'd been killed in, Mama Georgie didn't burn it or throw it away. She put the clothes on hangers and she hung them up in a back room. Each time I went in that room I would see them there, all ripped and bloody, and I'd think about Margaret, how she had looked, and how much I missed her, and soon I'd be crying all over again. That was the first time I realized what hurt was, I think. Real hurt.

First Love

There was a new kind of music playing by 1954: rhythm and blues. The intermingling of black and white music in America had begun in slavery days, when African rhythmic sensibilities were plopped down amid traditions of song and harmony that had originated in Europe. The subsequent welter of black field hollers and spirituals and backcountry dance music (often performed on improvised instruments) had evolved by the turn of the century into intriguing new hybrids. The blues—a raw secular outgrowth of the call-and-response style of black gospel singing—spread throughout the cotton fields and turpentine camps of the South by itinerant singer-guitarists. At the same time, the cakewalk, a dance initially done to the strut-inducing rhythms of black marching bands, became a vaudeville craze and paved the way for the rise of ragtime, an intricately syncopated piano style forged in the all-night milieu of black saloons and bordellos. In New Orleans, Dixieland bands combined the harmonies of the blues with the rhythms of ragtime, then added a spirit of improvisation and began (along with musicians in many other cities) to create jazz, the soundtrack of the Roaring Twenties. By

the thirties, jazz music—now played by both black and white ensembles—had become one of America's most popular exports. With the breakthrough of Benny Goodman in 1935, the swing years began.

As swing music exploded, jazz bands grew bigger, and arrangers were called upon to organize the interplay of the ever-increasing number of instruments—a development which tended to limit freewheeling improvisation. Gifted bandleaders such as Duke Ellington and Count Basie maintained an improvisational spark, but in the hands of more pop-inclined white orchestras jazz was processed into simple dance music.

With America's entry into World War II, many swing stars began departing the scene for military service, and the swing era began to ebb. Black jazz musicians began reclaiming the field with hot black R & B groups that applied the horn playing of the big bands to stripped-down combos led by frantic saxophonists and blues-shouting vocalists. The result, on a good night, was pandemonium. And hit records—at least in the circumscribed "race" market to which such music was consigned.

Live radio shows were piped out over the "Delta Network" across Arkansas and Mississippi. And black fans weren't the only people listening.

Tina: We had radios then, but we didn't have record players. The radio was enough. Daddy had had one of those wooden ones, and we used to tune in for *Inner Sanctum, The Fat Man*—sit there and be scared to death, Alline and me. We would put potatoes on the stove and pop popcorn—it was wonderful back in those days, you know? The stoves were wood-burners, and we'd slice sweet potatoes and put them on top, then turn them, and that was what we would eat, straight and plain. Then we'd take the lid off the stove and put the skillet there and pop the popcorn. Oh, it was great. No soft drinks, just water.

And no cookies or anything either; just pieces of bread, if we had to munch on something.

The music I heard on the radio when I was a kid was mostly country and western. I knew an awful lot of those country songs, although I've forgotten them now. Mama Georgie always listened to country and western, hardly ever blues; but Papa Joe always listened to WDIA, the black station out of Memphis, and I remember hearing B.B. King on there—he was very popular—and in the early fifties a few women, like Faye Adams with "Shake a Hand," and LaVern Baker with "Tweedle Dee." Women with a certain style: the hair pulled back, the mole on the cheek, just so. I didn't care that much for the blues, but I did learn to sing "Tweedle Dee," because it was fast. I always liked the fast ones, liked that energy, even then. But I didn't know where radio came from, and I didn't think of these things as being on records, or connect them with people traveling around performing. To me they were just songs. Just music in the air.

I was fourteen going on fifteen when I entered Lauderdale High School, and I began to blossom a bit although I still felt a little out of place. I was short and skinny, and I didn't have the clothes the other girls did—all the girls from the well-to-do black families. Alline and I had friends in school—we always tried to be friendly and outgoing— but I had lost Margaret, and that was like losing a part of my heart. There was an empty space there. But as I say, you're always given someone, and about a year after Margaret died, I met the first real love of my life.

Now, back then, Ripley had the hottest basketball team around. Couldn't be beat. And I was a cheerleader, so I went to all the games. Well, one day the Carver High School team from Brownsville came up to play Ripley, and of course I was there. And that's where I saw him— Number Nine. I tell you, my heart started beating so fast I almost fainted. It was first-sight love—and from across the court! I had to meet this guy, it was a force that drove me.

So I went up to Mr. Reed, one of the Carver High School coaches, and just asked him: "Who is Number Nine? Can I meet him?" Do you believe it? And Mr. Reed went over to this guy. He was the captain of the Carver High team, Harry Taylor, my first love.

Harry was two years older than me, eleventh grade, and he was just a beautiful black boy. His hair was natural, not processed, and combed straight to the front, which was the style then. His skin was smooth and dark, the color of my sister's, and he had beautiful white teeth—not too big and not too little: just right. The right size lips, the right size nose—everything was just right. And he had a great little body! Beautiful body, God. And there he was, across the court. And he looked over at me, and I looked at him, and—*whooh!* To tell the truth, I wanted to go to bed with him right then and there.

Harry Taylor: I remember. It was an invitational tournament. There was quite a rivalry between Brownsville and Ripley at the time, so it was a big game. She was a cheerleader—very, very enthusiastic, very lively. Beautiful girl, she was. But by the time I got up and over to the other side of the court, she had disappeared. I didn't see her for a while after that, not until Brownsville played Ripley again.

Tina: Harry and I didn't get together right away. There was a problem. Her name was Rosalyn—the little bitch! Rosalyn was at Johnson Grade School Annex with me; she was a cheerleader too, and she was real smart. Now, Alline and I were friendly and well liked, and I think Rosalyn was the only person there that really didn't like me. She used to make me feel like such an ass, always laughing at me and smirking whenever I couldn't answer a question in class. Of course she always had the answer, right? And I was such a terrible student—good at sports, and English and history, I guess, but awful at things like

math. So Rosalyn was always laughing at me. Her parents were well-to-do, with the big house and all—damn, I could still kill her if I saw her today! Anyway, the next time I saw Harry was after one of the Brownsville-Ripley games, when all the cheerleaders got together and he came over and started talking to us. Well, Rosalyn just moved right in on him—I couldn't believe it. I guess they must have exchanged numbers or something—I didn't even have a telephone—and soon she was telling me, "Oh, I got a letter from Harry!" And she'd be sure to show it to me, too, you know? I thought I had missed out. But Rosalyn wasn't in the picture for long, because the next thing I knew—*da-da-dahhh!*—I was moving to Brownsville!

What happened was, my father stopped sending money to Cousin Ella Vera for keeping Alline and me, and so we had to move back down Highway 19 toward Nut Bush to live with Mama Roxanna, the church woman, and Uncle Gill. This took us out of Lauderdale County and back into Haywood County, which meant we'd be going to Carver High in Brownsville. And that's where Harry was. ☺

Carver turned out to be a pretty good move in my life. The principal there, Mr. Roy Bond, took a liking to me. Maybe he noticed some bits of refinement I'd picked up from living with the Hendersons, because they had raised me, basically. One day, when I'd been sent to his office for some kind of misbehavior, he told me he expected better of me. "You're not like the other kids," he said. And you know, I had never thought about it exactly like that, in those words, but it was true. I had always felt different. Mr. Bond seemed to understand that. Some of the teachers were very supportive too. They saw that I wasn't with my parents, and I guess they thought there was good in me, so they gave me guidance, tips on things. The school librarian told me once, "Don't ever let me see you walking around with your stomach hanging out"—and I've been holding it in ever since!

Carver had a hot girls' basketball team, and I got on it,

playing forward. I was a cheerleader, too—always on the move, right? When there were big games—there might be two or three a week sometimes—I'd stay in town after school rather than take the bus back to Roxanna's, and I'd sleep overnight at Carolyn Bond's house. She was a cheerleader whose parents had a house on Jefferson Street. Carolyn—we called her "C'al Jean," with a real Southern twang—was no relation to Mr. Bond, I don't think. There were as many Bonds around there as there were Flaggs. And now there were two new Bullocks.

Roy Bond: She was involved in everything. Basketball, cheerleading—she'd be on the court playing, and then she'd go put on a cheerleader's uniform and come back out and lead the cheers for us. If there was a track meet, she'd run track. She would have played football, too, if it had been allowed. She was a leader, an organizer—parties, sock hops, class trips. She might not have been an A student, but she made up for it with her energy.

Brownsville was different back then. It was run by four or five wealthy people, bankers and landowners, all Democrats, and they'd blow a whistle at ten o'clock and the town would close down for the night. Segregated, too, of course—about sixty percent black, forty percent white—but we got along pretty well. All whites in the South are not bad. But Carver was all black; the white kids went across town to Haywood High. And we had a split season because of the cotton. We picked it with our hands, didn't have the machines yet, and the children had to help. So we opened the schools early, in July, and closed down from the middle of September until after Thanksgiving. It was not an ideal setup. No, the white schools didn't have to do it.

Carolyn Bond: We were the type of kids that never worried about mixing with whites or any of that. We got involved in our own things. Our girls' basketball team

was very good—we often played for the championship—
and Anna Mae was a very important part of it. That's why
when there was a game and the weather turned bad, she
would always stay over so she'd be sure to make it,
because they needed her on the team. And at half time
she'd come out with the cheerleaders and do stunts and
dance to music. She was always very energetic, always
doing something—school plays, talent shows. She had a
beautiful voice, and when she sang something—some little
talent-show song—she'd always put her whole body into
it. We were in the choir together, and I can still hear her
singing "Onward, Christian Soldiers." We always kept
busy, even though there wasn't a lot for black children to
do in Brownsville then—no soda shops or anything like
that. Sometimes the teachers would organize a little Satur-
day afternoon dance party for us in the gym; or my parents
would let us have a house party, and all our friends would
come over. Anna Mae always seemed to think she was too
skinny, unattractive. Skinny wasn't the style then. I re-
member sometimes she wouldn't have changing clothes
when she stayed over with me, and I'd share my clothes
with her. One time she tried on a pair of my blue jeans and
said she loved them because they made her hips look
bigger. "Someday," she said, "if it's the last thing I do,
I'm gonna have long hair and some big hips and big legs."
She was hysterical.

She lived out in the rural area, but she didn't associate
with the rural people; all her friends were here in the city
limits. Didn't have a lot of boyfriends. In fact, she was
only involved with one boy the whole time she attended
Carver, and that was Harry Taylor.

Tina: Well, what had happened was, as soon as
we got to Brownsville, Alline and I had gone out and
walked around the streets to see what was going on. This
was the weekend before school started, and I just knew I
was going to see Harry that night; I knew it. Unfortunately,

I wore my worst dress, some strange-colored thing—one of those dresses you hate from the day you get it, but it lasts forever so you have to keep wearing it. It was missing something, too—the belt or the sash, I forget what. I just looked sort of incomplete in it. Out we went, though, anyway, me and Alline, looking for wherever it was the hip guys hung out. This turned out to be a Hole—there's always a Hole—just like the one in Ripley, a little off the main street and down a hill. And there they were, the hip guys. And there he was.

These Brownsville guys dressed very white. Sneaker guys, you know, with tight-leg jeans and white shirts. And the girls they hung out with dressed like white girls: skirts and sweaters, that kind of thing. There was a whole clique of these kids. You could tell by looking at them that they were from nice homes, with families—and there they were, hanging out on their cars down in the Hole. And there was Harry. He still looked like a god to me. Really. My heart started beating real fast again. I didn't go up to him, though. I just hung around on the edge of things, hoping he would notice me. Finally he did. He already knew that I liked him, of course. He came up and said hello, and I said, "Hi," as if I hadn't seen him. He said, "What're you doing here?" I told him I'd moved, that I was going to Carver now. He goes, "Oh, really?"

And that had been the contact. School started three days later, and soon he was coming to my class to borrow pencils—everybody knew what was going on—and before long I was wearing his jacket. The whole school was buzzing, because Harry was the most popular guy in Brownsville. He already had a girlfriend at Carver when I arrived—Antonia Stubbs was her name. I met Antonia later, and she turned out to be a real pretty girl. Really sweet, too. But what can I say? I was in love. And little Anna Mae took Harry away.

He'd started coming out to the house on Wednesday nights with his friend John Thankster, to take me and

Alline to the movies. Of course, that wasn't always where we actually went.

John had the car. He was an older guy. He had been in the service for a while and come back. He and this girl Flossat had two babies already—and they were still in high school! I guess there was nothing else to do in Brownsville. Anyway, the idea was that I would be with Harry and Alline should go with John. I don't want to say that Alline was one to go to bed real fast, but she had a lot of dates, you know? John wasn't her type, though, so he never got her. But Mama Roxanna made Alline go along with us anyway, to make sure nothing happened between Harry and me. Ha!

Harry Taylor: I had to keep that thing going between Alline and John, because if he didn't go along, I couldn't get there. I lived in Brownsville, and Anna Mae lived on this farm out around Nut Bush, down a gravel road, with no telephone. John had a 1937 Plymouth—it was in great shape—and so after school we would get in his car and drive out to see them, following their school bus home.

John was into drinking. He had gone in the service when he was a freshman, lied about his age. His parents got him out, but not before he saw a couple of bad scenes in Korea. So he liked to drink, and sometimes he and Anna Mae's Uncle Gill would go out to some all-night joint out there, and Ann and I would stay at the house and sit on the porch and swing. Or we'd just sit in the living room, you know. Nothing like what happens today, I guess.

We'd all go out on dates, too. Saturday nights were big things, especially downtown. And we'd pick them up to go to the movies, either in Ripley or the Rice Theater in Brownsville. Actually, I guess we didn't go to the movies a whole hell of a lot. John and Alline liked to go to the beer joints out past the city limits—you know, one-room

shacks with a jukebox and beer. There was one near Bells, north of Brownsville, that we went to, and one up on the way to Humboldt. But I was an athlete, and I wasn't into smoking or drinking; and neither was Anna Mae—she was on the girls' basketball team, a very aggressive player. So John and Alline would go in these places, and Anna Mae and I would stay in the car. The beer joint near Bells was where this thing happened. She still remembers that, does she?

Tina: Naturally I lost my virginity in the backseat of a car: This was the fifties, right? I think he had planned it, the little devil—told me there was nothing playing at the movies that night. I guess he knew by then that he could get into my pants, because there'd already been a lot of kissing and touching inside the blouse, and then under the skirt and so forth. The next step was obvious. And me, as brazen as I was, when it came down to finally doing the real thing, it was like: "Uh-oh, it's time." I mean, I was scared. And then it happened.

Well, it hurt so bad—I think my earlobes were hurting. I was just dying, God. And he wanted to do it two or three times! It was like poking an open wound. I could hardly walk afterwards.

But I did it for love. The pain was excruciating; but I loved him and he loved me, and that made the pain less. I was really stimulated by Harry, and he was a good lover, too. Everything was right. So it was beautiful.

My dress was all soiled from this experience, of course. When I got home that night I folded it up and stuck it in this trunk under my bed. And wouldn't you know it—the very next day my grandmother started spring cleaning and found the damn dress! I came home from school that day and there she was: "You can get pregnant if you want to! Your mother and father's gone!" All this stuff. I thought: "Oh, God!" I tried to tell her nothing had happened: "I had my period." But Mama Roxanna was no dummy. She

knew what it was. And Harry did not get a Wednesday night date after that for a long time.

Harry was the beginning of my Scorpio phase, which lasted the whole first half of my life. Scorpio guys, as I later came to learn, are a pain in the ass. Harry was kind of a playboy, because he was so popular in school, and after he got what he wanted from me, I think he lost interest a little. Another girl moved in and started breaking us up. It was C'al Jane, actually. This went back and forth for a while—he'd break up with her to come back to me, then go back to her again. Then he graduated and went in the air force. His grandmother, Miss Sally Ann Pruitt, told me he was back, and one day he came to see me, and we kind of got back together again. He started writing to me, and we even talked about marriage.

Then one day I got on the school bus and one of my girlfriends said, "Guess what—Harry and Theresa got married." Theresa was this other girl at school. I had thought Harry was back with me, but I guess he was still fooling around, and Theresa had gotten pregnant, so they got married. My girlfriend heard the news before I did because I was still going to Ripley on weekends to work for the Hendersons; I didn't know what was going on in Brownsville. When she told me, I had to be as strong as I could not to cry. And I had to go the entire day without crying, and the whole school was talking about it. I was so heartbroken. Harry had been the only thing I still had that I loved. I'd scratched my mother and father. I'd lost Margaret. I didn't really like the grandmother I was living with. Alline was graduating and moving to Detroit to live with some relatives and be near our father. And now Harry was gone, too.

So I just moved. Finally moved in with Mama Georgie, back on the Poindexter farm, where I'd always wanted to be. But things had changed by then. I guess because of the way Margaret and Evelyn had died, Mama Georgie was afraid to bring a teenager into the house again. Also, she

was already raising the baby daughter that Evelyn had left behind. So when I arrived, and she came home and saw I was there, she didn't turn me down, exactly; but it was like—"Okay." Nothing more.

Things started getting crazy by the spring of 1956. I had continued working for the Hendersons in Ripley, and Miss Connie would come pick me up every weekend. But the Poindexters didn't like that, me living on their farm but not working there, and they started giving me a little flak about it. When the summer came, the Hendersons took me with them on a little vacation trip to Dallas, Texas. While I was gone, Mama Georgie got sick and passed away. Oh, God.

Well, of course my mother came down for the funeral. By this time—with Daddy completely out of the picture— she had started sending clothes here and there, and a little money occasionally. And I'd sort of started feeling a little bit better about our relationship. So she came down from the North, from St. Louis, and she was beautiful. She wore a white suit with big shoulder pads and real high brown and white shoes—beautiful. And I thought . . . well, I could've moved to Ripley, just gotten me a little room there and continued working for the Hendersons. But Ma wanted me to go back and live with her in St. Louis. Alline was already there—she hadn't stayed in Detroit too long. And so I decided to go. I felt I had outlived Tennessee. There was nothing there for me anymore—nothing but Mama Roxanna and Uncle Gill. So I left.

St. Louis in the mid-fifties was a fairly sedate place— especially in comparison to East St. Louis, its sister city across the Mississippi River. East St. Louis had *action*, and it never seemed to stop. There were cathouses and gambling dens and an infinity of clubs that ranged from lavish nightclubs to nondescript roadhouses at the end of anonymous dirt roads. The whole area was awhirl with

night life, from places like the Blue Note and the Bird Cage, the Sportsman and the Lakeside, and all kinds of jazz clubs to Perry's Lounge in Eagle Park, Kingsbury's and Garrett's Lounge in Madison—the list seemed endless. "Some of those places didn't even have keys to the front door," says Gene Washington, a local drummer at the time. "They just stayed open twenty-four hours a day, three hundred sixty-five days a year." Adds Clayton Love, the Clarksdale singer who got his first sight of the St. Louis area around this same time: "It was better than Vegas. There was every kind of entertainment you could want. And on the East Side, it was just ridiculously happy."

Anna Mae Bullock, sixteen years old and fresh from the backwoods of Tennessee, knew nothing of such high life upon arriving in St. Louis to live with her mother. She would soon learn, however—entrée was provided by her sister Alline, already employed as a barmaid at a local club. Like an extraordinarily large number of other local young women, Alline would rave about what she considered the hottest band in town: the Kings of Rhythm, led by a wiry little guitarist named Ike Turner.

Tina: Sumner High was all black, but very high class—these were the children of doctors, professional people. And here I was, fresh from the country. My mother was basically a maid, and the man she was living with, Alex Jupiter, he was a truck driver, driving the big diesel trucks to Kansas City and Chicago. So in this new school, I was still feeling sort of lower class.

I started going to the clubs because Alline was already doing that sort of thing. She worked for Leroy Tyus, an upper-class black man. He had some dealings with the government, I think, and he drove a Cadillac and had a white wife, and he had this bar, the Tail of the Cock. It was a very high-class place; the biggest people in town went there, and they tipped big, too. Alline made good

money there. And when she went out on dates, there was always a Cadillac or a big Lincoln picking her up.

I idolized Alline, and I tried to copy her. She was about my size now—34-26-38—but with big breasts and great hair—really very pretty. She had this wonderful coat— wool with velvet stripes—that she would never actually wear: She'd put it around her shoulders and turn up the collar, then pull out one of these great cigarette holders she used. And she always wore high-heeled pumps—leather in the winter, patent in the summer—and black hose, with the seam, and garter belts. And she would tear the lining out of her slips so that if she undressed there was just this lace shift that you could see through—ha-ha! I guess she was doing things, right? But she was really a beautiful girl, and I tried to be like her, to act like her. But I was all wrong. She wore her hair very loose, and mine was tight and curly. She had a smaller nose, smaller lips, smaller face—with me, everything was too pronounced. I really wasn't quite up to it.

Well, on weeknights after work Alline had the dates. But on weekends, she and her girlfriends would get together and they would go to see Ike Turner, first at the Club D'Lisa, and then, after hours, from about two A.M. on, at the Club Manhattan, across the river in East St. Louis. None of the doctors and things that Alline was dating would go to places like that—they'd go to the high-class restaurants and cocktail bars, you know? So Alline would go with the girlfriends. Because Ike Turner and the Kings of Rhythm were what was happening—in St. Louis, they were as big as the Beatles would be later on. But they had a pretty rough reputation, too, and the idea of a teenager like me going to one of those clubs to see them was definitely a *don't*.

One Saturday night, though, I got permission from Ma to go out with Alline. And I got dressed up in some of her clothes, with lipstick and all of that, and Alline said, "We're goin' to East St. Louis to see Ike Turner and his

band." I tried to act older—like just another one of the girlfriends, you know?—but I was nervous, didn't know if I was going to be able to get in. And I didn't like East St. Louis—it seemed like the South to me. But off we went.

Well, we arrived at the Club Manhattan and boy, was it a jumping joint. It was like one of the Holes back in Ripley or Brownsville, but all in one club—about a two-hundred-fifty-seater, with the stage in the center of the room and tables all around it, and a great big painting of the Kings of Rhythm up on one wall. The band was already playing when we arrived—they always warmed up the house before Ike came on—and the place was filled with women. Tons of girls, black and white—and that wasn't really allowed then, you know, the white ones being there. But they came anyway. As I later found out, Ike's band mostly drew women, hardly any men—when men came, they were usually looking for their women, you know? So there were some white girls, young and old, and lots of fine black women: The ones with the big butts and big legs—well proportioned, but big. And all these women were sitting there in their bare-backed shoes, seamed stockings, and backless dresses—I mean, looking good—and smoking and drinking and making eyes at the band, right? Trying to figure out who would be going home with who when the night was over.

I was sitting there, a little bit bored, because this wasn't really my cup of tea, you know? Or at least I didn't think it was. Then Ike walked in the room, and you could feel it, somehow. He had the body then that David Bowie has now—great! His suit looked like it was hanging on a hanger. He walked through the room, and everybody was going, "Hey, Ike, hey, man," and I thought: "What an immaculate-looking black man." He wasn't my type, though—not at all. His teeth seemed wrong, and his hair-style, too—a process thing with waves that lay right down on his forehead. It looked like a wig that had been glued on. When he got closer, I thought, "God, he's ugly." But

there was something about him. Then he got up onstage
and picked up his guitar. He hit one note, and I thought:
"Jesus, listen to this guy play." And that joint started
rocking. The floor was packed with people dancing and
sweating to this great music, and I was just sitting there,
amazed, staring at Ike Turner. I thought, "God, I wonder
why so many women like him? He sure is ugly." But I
kept listening and looking. I almost went into a trance just
watching him.

Clarksdale

Izear Luster Turner was born November 15, 1931, in Clarksdale, Mississippi, the most renowned of the Delta blues towns. The son of a Baptist minister, he was raised mainly by his mother, Beatrice, a seamstress, who taught him to hem slipcovers at an early age and generally doted on her diminutive son. Ike was the baby of the family—his only sibling, a sister named Lee Ethel, was ten years his senior—and his mother called him Sonny to the end of her days. The Reverend Turner—a man of the cloth, but a man nonetheless—met an untimely end at the hands of a local white thug called Bird-Doggin', to whose girlfriend he had been extending extraclerical ministrations. One of Ike's earliest memories is of the day that Bird-Doggin' and some vengeful white friends turned up at the Turner house on Washington Street looking for his futher.

"I remember it like it was yesterday," Ike says. "That door bustin' open, and Mama tryin' to hold on to Daddy and to me, too, and them pushin' her to the floor. For a kid in his mother's arms, it was a long way to fall, you know? They took Daddy out, and he stayed away a long time. When they came back, they threw him in the yard,

and he had holes in his stomach—they had took him out and kicked holes in his stomach.

"The white hospital wouldn't take Daddy, so the health department put up a little tent right outside our house. I used to go out there and draw these strings to pull the windows up and let the air go through. Daddy laid there three years and he died there."

Clarksdale was a railroad hub, and thus host to a significant, shifting population of gandy dancers and other transients—people essentially en route to someplace else. However, it was also a town of deep traditions. At Hill Bennett's furniture store ("We'll Feather Your Nest for a Little Down"), credit was advanced solely on the basis of vows sworn on the company Bible. Temperance was nominally honored, but corn whiskey was available for seventy-five cents a jar (not bad if the batch hadn't been distilled in an automobile radiator, in which case death to the drinker would sometimes ensue). Of course, Clarksdale was strictly segregated, with blacks confined to the east side of the tracks that divided the town. It was here that the very young Ike Turner first started hustling money by selling rugs he'd pieced together from swatches of material discarded by his mother. He also picked up change by leading a blind man, Mr. Brown, around town—and in his spare hours he learned guitar from Brown's wife. Like most other blacks in that place and time, Ike's musical diet was mainly white hillbilly music—particularly the Grand Ole Opry broadcasts out of Nashville. But even as a child, Ike already felt himself drawn to the blues scene that flourished along Fourth Street and Issequena, the heart of the black district, where the mother of one of Ike's pals, Raymond Hill, ran a café. There she occasionally employed such entertainers as guitarist Robert Nighthawk and Sonny Boy Williamson, the Glendora-born mouth-harp player who'd once worked with the legendary Robert Johnson. Although Ike's mother had agreed to finance after-school piano lessons with his second-grade teacher, Ike

had little patience for formal instruction, and soon was cutting school altogether to shoot pool. By night he would sneak away to peek in on jam sessions conducted by Joe Willie "Pinetop" Perkins, the boogie-woogie pianist. Whenever Ike's mother inquired about the progress of his piano lessons, he would whip off a few of Pinetop's boogie riffs to allay her suspicions.

By the age of eight, Ike was hanging around WROX, the Clarksdale radio station, and before long he was being allowed to spin records whenever the disc jockeys took a coffee break. Eventually, he would land his own show on the station.

Moving into his teens, Ike began playing piano in local honkytonks, and then joined the Tophatters, a big swing band put together by a saxophone-playing dentist, Dr. E. G. Mason. The Tophatters would play anywhere, sometimes for as little as thirteen cents apiece—in schools, at clubs, even on the back of flatbed trucks, in such nearby towns as Chambers and Greenville. When the group broke up around 1948, its more sophisticated members—those who could read music—realigned themselves as the Dukes of Swing; Ike and his less tutored but more aggressive young friends became the Kings of Rhythm. They gigged under primitive conditions. Since there was no music store in Clarksdale, Ike would repair broken guitar strings simply by tying them back together. If a piano string went, he would melt down car tires to get at the steel wire in the treads for a replacement. "I'd cut up chamois cloth to make new pads for the saxophone keys," he says. "Air would always leak around them, so just before a job we'd take the horns to a pump and pump water through them, to swell the chamois. Musicians today have it so easy, man."

The Kings of Rhythm prospered by Clarksdale standards, but Ike realized that the big time lay elsewhere. Finally, in early 1951, Ike fortuitously encountered Riley B. King at a blues club in Chambers, Mississippi. King, a guitarist and gospel singer from a plantation near Indianola,

was six years Ike's senior. In the late forties, King had made his way seventy-five miles up the river to Memphis, where he had formed his own band and was already recording. One night, returning from a gig in Greenville, Ike and his band stopped off at the Harlem Inn in Chambers and saw B.B. and his group up onstage.

"Well, when B.B. and his band come off at intermission, they let my band play. We were doin' jukebox: Amos Milburn, Jimmy Liggins, Roy Milton—all these cats were big then. After we played, B.B. says, 'Boy, y'all need to record.'"

So, in March 1951, Ike Turner and the Kings of Rhythm—sax players Raymond Hill, Jackie Brenston, and Eugene Fox, guitarist Willie Kizart, drummer Willie Sims, and Ike's nephew Jessie Knight on bass—piled into Hill's Buick in Clarksdale, along with all of their equipment, and set off on a rainy Wednesday for Memphis to meet B.B. King's record producer, Mr. Sam Phillips, and maybe even make a record.

"It was rainin' like heck," says Ike. "A tire blew out, and the bass amp fell off the top of the car—we had all kinds of troubles. We got to Memphis and set up and started playing, and that's where we wrote 'Rocket 88.' The song was Jackie Brenston's idea—he was always talkin' stupid stuff like that."

"Ike had a pretty good, together band," Sam Phillips remembers. "But I listened to Ike sing in the studio, and I told him in no uncertain terms that I just didn't hear him as a singer. The inflections weren't there, the phrasing, none of it. But he was a whale of a damn musician—one of the best piano players that I had heard up to that time. So he told me that Jackie could sing, and that's when we cut 'Rocket 88.' It wasn't a complete song, believe me. We improved the lyric a lot—not that there was that much to it. But the Rocket 88 Oldsmobile had just come out, and everybody wanted one. I thought, 'Man, what a topical subject.'

"Then I said, 'Ike, now I want some damn piano.' And he got up there: *dooda-dooda-doo-doot*—this was before Jerry Lee Lewis, man. And I heard them damn saxophones, and I said, 'Damn, that's good.' It may not win any high-fidelity awards, but I'll tell you, 'Rocket 88' is a hell of a record."

Released on the Chess label, "Rocket 88"—a crudely pulsating tune on the model of "Cadillac Boogie," a recent Jimmy Liggins hit—rose to number one on the R & B charts in June 1951. Unfortunately, to Ike's dismay, the record was credited not to the Kings of Rhythm, but to the nonexistent entity of "Jackie Brenston with the Delta Cats." Worse yet, while Phillips estimated that the single ultimately sold half a million copies (at a time when anything over 50,000 constituted a hit for Chess), Ike and most of his band cleared a grand total of $20 apiece from the record's success. The exception was Jackie Brenston, the song's nominal composer, who sold his rights to Sam Phillips for $910. "Rocket 88" was later claimed by Phillips to be the first rock 'n' roll record.

Of equal significance was the single's impact on a young Georgia singer called Little Richard, who would emulate its sound several years later. "I took that introduction, and that same style of piano," says Richard, "and I put it on 'Good Golly, Miss Molly.' "

Jackie Brenston, convinced by Leonard Chess that he was now a star, left Ike to go solo, and the Kings of Rhythm fell apart, some of them reuniting to back Brenston on the road.

Ike returned to Clarksdale, occasionally commuting the seventy-five miles back to Memphis on his bicycle in search of fresh opportunities. During one of these visits, he happened upon a B.B. King recording session. The session wasn't going well. During a break, Ike slipped behind the piano and started playing. Suddenly, he heard a white man shouting, "That's what I want! That's what I want!" It was Joe Bihari, one of the brothers who ran the

record label Modern/RPM. Bihari hired Ike on the spot to complete the session, and afterward paid him thirty dollars—more than he'd made off of "Rocket 88." Bihari said, "Man, is there any more talent around here like you?"

"Lots of it," Ike replied, "all over Mississippi."

"Let's meet tomorrow," Bihari said. "You take me and we'll get some."

Thus Ike took Joe Bihari throughout the South to record such blues giants as Howlin' Wolf, Elmore James, Bobby "Blue" Bland, and of course more B.B. King sides. Impressed by Ike's ear for talent, Bihari bought him his first car—a Buick Roadmaster—and with a portable Magnacord tape machine loaded into the trunk they continued to record at empty clubs, in YMCAs, and in musicians' living rooms.

When Bihari returned to L.A. with the tapes they'd recorded, Ike continued to scout out artists. Twice a week he would receive checks from Modern/RPM—sometimes one hundred dollars, sometimes two hundred dollars. It was more money than he'd ever seen in his life.

Throughout this period, Ike continued trying to keep the Kings of Rhythm together. By July 1953, Ike returned to Memphis to record with his latest band, which by now included singer Johnny O'Neal and pianist Bonnie Turner—an erstwhile girlfriend of Raymond Hill's whom Ike had recently married. (Unable to find a steady guitarist, Ike had switched to guitar himself for stage appearances.)

Ike's marriage to Bonnie was fated to be brief. One time, when he was cleaning his right ear with one of her bobby pins, she accidentally jogged his arm, pushing the pin all the way in and partially deafening him. They broke up in Sarasota, Florida. Ike returned to his hometown and began recording in a makeshift studio of his own.

By mid-1954, Ike had a new piano-playing wife—teenaged Annie Mae Wilson, from Greenville—and an irresistible urge to be gone from Mississippi. His sister and her husband had recently moved from Clarksdale to St.

Louis, and Ike decided to follow her suggestion to pay a visit and check out the music scene.

"We went up there to play one night at Ned Love's place in East St. Louis," Ike recalls, "and boy, he kept us for the next night, the next night, the next night. So we came back to Mississippi, got our clothes, and we moved up there."

East St. Louis and its environs proved to be a wonderland of work opportunities for Ike and his Kings of Rhythm—which eventually came to include many old pals, including two of the original Kings: saxmen Raymond Hill and the now-fallen and humbled star, the composer of "Rocket 88," Jackie Brenston (Annie Mae moved over to the business side of Ike's operation). Club dates abounded: at the D'Lisa, the Bird Cage, the Club Harlem; at Kingsbury's in Madison, Illinois; and, most important of all for the Kings, at Booker Merritt's Club Manhattan, a wild and popular place that became the band's home base.

"They had gangs there," says Ike. "I'm talkin' real gangs. One time they took one of my buddies and they cut him up and left him to bleed to death in a park. We all had guns—we needed 'em. One time a guy sent a note into the Manhattan, said, 'Tell Eddie Jones to come out with his gun in his hand.' Eddie gave Fred Sample his two horns, and he went out the front door, and him and this guy stood right there and emptied their guns at each other. East St. Louis was rough, man."

Ike continued recording after his move to East St. Louis, usually at small local studios such as Technisonic, in nearby Brentwood, Missouri. In 1956, he took the band to Cincinnati to cut tracks on various band members for the Federal label. One of these numbers, "I'm Tore Up," featuring Billy Gayles's vocal, became a regional R & B hit; but then Gayles—like Brenston before him—left the Kings to go solo. Back in East St. Louis, Ike resumed his endless round of club gigs, amassing enough money to buy a three-story brick house on Virginia Place, where he

moved the band. This communal house was dubbed by Ike "The House of Many Thrills"—largely because of the extraordinary number of other men's wives who were frequently to be found there.

By this point, the Kings of Rhythm were the talk of the town. Word about the band began to reach across the river, spread by fearless white fans who would brave the rowdy East St. Louis clubs to catch the hottest black acts. George Edick, owner of the white, teen-oriented Club Imperial on West Florisson Street in St. Louis, decided to start booking the Kings for his popular Tuesday jitterbug nights.

George Edick: By that time the big bands had all become small bands, and they went to jazz. Jazz wasn't good for me; I had to have good swinging music for the dancers. Black groups were the best, so I started booking them. Well, the Imperial held about a thousand people, and we packed 'em in. People would come from all over on Tuesday nights. Then one of our jitterbug champions told me about Ike Turner and his Kings of Rhythm. He'd seen them at this colored place in East St. Louis. He said, "You oughta hear this band they got over there." So I brought them in one night, and the kids just loved them. I said to Ike, "You want to work here every Tuesday night?"

I think I paid the group seventy-five or a hundred dollars a night. This was in the fifties, when most bands made thirty-five, forty dollars. Ike stayed with me I don't know how many years. For a while I played him on Thursday and Friday nights, too. It was funny: All the rich people from south St. Louis would come in to see him. And I remember white chicks used to always come up to Ike, and . . . Well, I told him: "Look, we can't have any trouble." I said, "I don't care what you do, but get twenty miles away from this place before you do it, understand?" And Ike was very good about that.

On the bandstand, he was the strictest man I knew. Ike's

band had to be dressed—they wore suits and ties. And he wouldn't let them have drinks up on the bandstand. There was no drinking at all. He used to rehearse at my place sometimes, and if one of his men was late or something, he would raise holy hell with him. That's why he changed musicians so much—he would just get rid of guys if he had trouble with them. Ike was a strict businessman. He played three or four gigs a night, and he was strictly straight. He was just a workaholic.

Ike: After a little while, I was playin' fourteen jobs a week around St. Louis. The Imperial was all white kids at first, and George didn't want blacks in there. It was the same deal with the black club owners, like Booker Merritt and this guy Kingsbury, up in Illinois. Kingsbury didn't want whites at his club, especially kids, because he had gambling in there, and he was scared he was gonna get his license took. But I wouldn't play at no black club that wouldn't let in whites, and I wouldn't play at no white club that didn't let in blacks. Then the white kids started followin' us from places like the Club Imperial over the river to our gigs in East St. Louis. We would line up, man, like thirty-some cars of us, and we'd go straight across that bridge, man, at sixty, seventy miles an hour, and nobody paid a toll. We were hot.

Clayton Love: We'd play pop at the Club Imperial, anything they wanted. Then we'd go to outlyin' areas, like Boonville, Missouri, and we knew what they wanted out there—they wanted the blues, and we'd give it to them. And some clubs, they'd just be fascinated by the moves we made. Ike and Junior would turn a flip with their guitars onstage and never miss a beat—never. Boy, it was something.

*　　*　　*

It was around this time when Alline Bullock, who had begun dating Kings drummer Gene Washington, showed up at the Club Manhattan with some friends and her sister—Ann Bullock, a sixteen-year-old junior at Sumner High, across the river. Ann was skinny and underfed by Ike's country standards and he paid her scant notice. But as she kept coming back over the ensuing weeks, other band members began to take an interest.

Gene Washington: I had been dating Alline for some time, and I was tight with their mother, too. So I told Zelma I'd take care of Ann if she'd let her go with us to the Club Manhattan, which was the Kings' home base. Now, I'd gotten tired of sitting flat onstage behind the drums, where I couldn't see; so I got the owner, Booker Merritt, to let me build a platform of my own, a riser, over in the corner. So when Ann would come, I always told her to sit at a table right down there near me, where I could keep an eye on her. Well, she would always be humming and singing along—I could hear her, but nobody else could. So I started telling Eddie Jones to slip a microphone across the stage and let it hang off near where Ann was sitting, and it picked her up. She didn't realize it herself, but we would be playing and everybody would be looking around wondering who in the world that was singing.

Ann, now seventeen, continued showing up for the Kings' sets occasionally, at the D'Lisa and the Club Manhattan. She struck up a friendship with Jessie Knight, the bassist, who was close to her own age ("I think he kind of had eyes for me"), and got to know the rest of the band, each member of which had a nickname. Raymond Hill, the tenor saxophonist, whose maternal grandfather was Chinese, was called "Chink." Gene Washington, the drummer, was "Stompy." Ike was "Weasel." Their wild music and clamorous popularity spelled glamour to Ann, and

soon she became hooked. Might the mysterious Ike, she wondered, ever allow her the chance to get up onstage and show what she knew—just knew—she could do?

Tina: I wanted to get up there so bad. There was tons of talent on that stage. But there were also lots of people in the crowd always trying to get up and sing with the band. And I was real thin then, and the fashion among black women, as I say, was to be real big in the hips and legs. So I was just this frail little thing, and nobody paid much attention to me. But I was determined. What really sparked it for me was this girl named Pat. She went to the same school I did, and she would always come to see the Kings, too. Well, one night at the Club D'Lisa, Ike was after her. She was his type—had an ass like a pillow, that girl did. Totally out of fashion at school, but you should have seen her at the Club D'Lisa! I was the one that was out of place there. Anyway, Ike was flirting with her, like all those guys in the band did with the women—they'd pull them right off the dance floor, go "Hey, girl," and feel their fannies, you know? And this Pat told him that she could sing. Well, she was younger than me, but Ike let her get up there—and she could not sing. So I told Alline to tell Gene, her boyfriend, to ask Ike if I could try a song. Ike said something like, "Yeah, sure, I'll call her up," but he never did. I would sit there every night trying to get his attention, but he avoided me. Probably thought, "Oh, God, there's that girl again." I was so disappointed. But I just was not his type of woman. I never was.

Finally, one night, I made my move. It was intermission and things were quiet. Most of the band had gone outside for some air, and Ike was up onstage by himself, just playing the organ. He stayed up there sometimes between sets to avoid troubles with all his women. I mean, this band had tons and tons of women: Each of the guys must have had ten girlfriends apiece, and Ike had twenty. And sometimes maybe six of them would show up at the Club

Manhattan all at once. So he would stay onstage to avoid getting into fights. Well, he was up there at the organ, and suddenly I realized that I knew the song he was playing. It was "You Know I Love You," the B.B. King tune. Right about then, Gene came in from outside. He had been tipping around a little that night, and Alline wasn't too happy with him. He came over to our table and started teasing her, because he knew she was mad. He got a mike down from the stage and started trying to get her to sing into it. Well, Alline would die before she would ever sing in public. And she's going, "Get that damn mike out of my face," you know? Still mad at him. So I took the mike, and I started singing:

Darling, you know I love you, I love you for myself . . .

And boy, Ike—that blew him away. He went, "*Giii-rrrlll!*" And he stopped playing the organ and he ran down off that stage and he picked me right up! He said, "I didn't know you could really sing. What else do you know?" I was real embarrassed, but I said, "Everything they play on the radio." I told him I knew some Little Willie John songs, and some of the blues stuff, and a lot of the things that he and the band were playing. So Ike started playing the things that I knew, and I started singing, and the band began drifting back in with their women— who are all wondering, "What's this," you know? "Who's that girl up there?" But once they got a good look at me, they fell in love with little Ann—because I was no threat to any of them. I didn't have a big ass, so they didn't think the guys would be interested in me, right? So, soon they're going, "Girl, you can *siiing!*" It was the first time I ever felt like a star. And I was in: I started singing with the Kings of Rhythm. Ike let me do "You Know I Love You," and "Since I Fell for You," and I duetted with Jimmy Thomas on "Love Is Strange," things like that.

But then it was like, "Uh-oh, if Ma finds out, she's gonna have a fit."

And of course she found out.

Zelma: One day, Ann and a friend of hers said they were going swimming. I was at home when this lady drives up in this long Cadillac. Her name was Annie Mae Wilson, and she wanted to know where Ann were. So I asked what did she want with her. She said Ann was late for rehearsal. I said rehearsal for what?

Well, when Ann came back from swimming, I said, "Annie Mae Wilson's been here lookin' for you." Her eyes got real big, and she said, "Oh?" I said, "So you're singin'?" She says yes. I didn't like it at all. She were too young to be goin' in bars and clubs, you know? I said, "I thought you were goin' to be a nurse." That's what I really wanted her to be, because she loved working with kids. But she said, "I'd rather sing." Which I thought she would say.

Tina: Ma hit the roof. She could be a mean old son of a gun. I'll tell you. We really almost had a fight. She hit me a backhand lick to the side of my face, and when I saw it had given me a nosebleed, I nearly hit her back. She said, "So you been singin' with Ike Turner" —and the way she said it sounded like a banner headline: PISTOL-WHIPPING IKE TURNER. Because that was the reputation he had—if there was a fight, Ike would pistol-whip you, right? Here some guy would come, looking for his wife, maybe, and ready for a decent fight, and Ike would go *whunk-whunk-whunk*—get him with the butt of his gun. The whole band had guns. So nobody wanted their daughters involved with these guys, you know?

But I hadn't done anything wrong. I felt that I was a good girl. I went to school. I did all the housework at home. I didn't think I deserved to be hit. That was when I realized how much I resented my mother. Here she had

left me when I was ten years old, and now she was gonna start playing mother on me? But she said, "No more singin'—don't even ask." And that was that, for a while.

We moved from that house down to the Hoderman Tracks, where all the streetcars were—things weren't looking too good for the family at that point—and after that I didn't go to hear Ike Turner anymore. But then one day—it was still summer—I got a call from him. He needed a singer. Well, Ike was always getting along bad with his musicians. So he came over to the house to talk to Ma. He was wearing a red Ban-Lon shirt and gabardine pants—Ike always dressed nicely—and he looked very boyish, not at all like the bad man Ma and everybody else had heard so much about. He was only a little bit taller than me. He sat down and said, "How're ya doin'?" And Ma was immediately won over. Ike wanted me to come with him for a very important college engagement in Columbus, Missouri—the out-of-town jobs paid more money than the local ones. He promised Ma that nothing would happen, that he would take care of me. And she said okay: I could go, and I could sing with him every weekend, too.

Boy, was I happy! From then on, Ike and I were like brother and sister. He went out and bought me my first stage clothes: sequined dresses, honey, in pink and silver and blue, with long gloves up to here and rings to wear over them. Bare-backed shoes, the stockings with seams, even a fur stole. Boy, I was sharp! Got me a gold tooth, too. See, Ike was very into taking care of people. The first thing he would do when he met you was buy you clothes; and if you needed your teeth done or anything—I think I had a cavity at the time—he would take care of that, too. He had to make you become his. He had to own you.

Well, we played this fraternity party in Columbus, and God, those were wild white kids—all screwing and getting drunk. The band was rocking. And we came back to St. Louis, and I was riding around in Ike's pink Fleetwood, with the fish fins and all, sitting right next to him and

whichever girlfriend he had along, wearing my first form-fitting dresses, and a padded bra, and long earrings—I tell you, I felt like I was rich! And it felt good! We would pull up at the club, and I would get out and walk in and sit there real grand, like I was the star. And after a while, Ike would call me onstage. He'd say, "Now we're gonna bring Little Ann up." And I'd walk up there and sing my three songs, and everybody would clap. It was wonderful. They were clapping for me. Little Ann.

Slowly, Ike began to look upon Little Ann as his possible ticket out of St. Louis. He lusted for the big time, the national-tour circuit—the Apollo in New York, the Howard Theatre in Washington, the Regal in Chicago. But the Kings of Rhythm—as sharp and exciting as they were—were still an R & B party band: capable of covering any hit, but short of distinctive original material.

"Ike could cover," says Clayton Love. "He had a keen ear, and he could play a song just like the record."

A copy, however, no matter how expert, is still a copy. Ann Bullock had introduced an element of the extraordinary into the Kings' sound. Her voice combined the emotional force of the great blues singers with a sheer, wallpaper-peeling power that seemed made-to-order for the age of amplification.

"Her voice was different for the type of music we were doing," says Gene Washington. "A woman doing that type of thing then was kind of a no-no. She was like Bessie Smith and some of those other great singers; but they sang the down-home blues. What we were playing was more of a swinging-type thing. So Ann was something completely different for us—but she fit right in. And things just exploded right from there."

Ike's patronage of Little Ann was to remain platonic for some time. Turner, for his part, had taken up with Lorraine Taylor, the daughter of a local sausage manufacturer.

Ann had begun dating Raymond Hill, Ike's old friend from Clarksdale and now the sax player in the band. In November 1957, just turning eighteen and midway through her senior year at Sumner High, she became pregnant.

Tina: The kids at school had started calling me "Sexy Ann" from the time I first started sneaking off to sing with Ike Turner's band on weekends. That was when I'd be with Raymond. Raymond wasn't an educated man, but he could play. He was one of those musicians that put all of his heart into his music; nothing else was important. And he was different from the other guys in the band—he was quiet, and he didn't have a lot of women. I mean, he had two or three, where everybody else had six or eight or ten. I liked him, too, because he was yellow—I've just always liked the light ones.

After work each night, Ike and the whole band and whatever women they had with them would go back to his house to jam and to write songs and rehearse; and I would go with them, to sing. It was a party for the guys, I guess; but I was busy singing, and the other girls would have to cook: steaks, chops, spaghetti, vegetables—Ike didn't like a lot of soul food. And I guess the girls went to bed with the guys, I don't know—I've always been pretty naïve about things like that. The guys would sleep all day, and if I was there I'd get out and rake the lawn or something. Then the girls would get up and start cooking again.

The musicians lived on the second and third floors of Ike's house, and down in the basement, and when I became pregnant, I moved in with Raymond for a while. We talked about marriage or whatever, but it didn't happen. Soon he was gone.

Raymond Hill: Me and Carlson Oliver were wrasslin' in the bathroom of the club one night. And Carlson, now he weighed about two hundred sixty pounds, and all of it went down on my ankle—*crack!* We thought

it was just sprained, so we wrapped it up and I sat on a chair and played through that night and the next two nights too. Then I ended up in the hospital, and then I had to go back home, to Clarksdale. Ike cried like a baby when I left.

Ike: Now, since Raymond was gone, Lorraine got real suspicious when she found out Ann was pregnant. Wanted to know whose baby it really was. She used to call Ann "your million dollars," you know? One night she got a gun and was gonna kill her. I had been up gamblin', and when I came home and went to sleep, Lorraine got my gun—it was a thirty-eight—and a poking iron from the stove and she went down the hall to Ann's room, where her and Raymond used to stay, which was two doors away.

Tina: I woke up and there was Lorraine, with the gun and the poking iron. I guess she was going to beat me until I told her the truth and then shoot me. But I really hadn't done anything wrong at that time. So I said, "What's wrong, Lo?" She said, "I want you to tell me now if there's something going on between you and Sonny." I said, "No, Lorraine." She said, "If you don't tell me the truth, I'm gonna kill you." I said, "I am tellin' the truth." Then she said something like, "Bitch, you're not worth it, anyway." Then she headed for the bathroom. I got up and went to Ike's room.

Ike: I remember gettin' a shake and wakin' up, and Tina sayin', "Ike, Lorraine's got that gun." By the time I sat up on the side of the bed, I heard the bathroom door slam, and then *click-click*—Lorraine had locked herself in the bathroom. I went over and knocked on the door and said, "Lorraine, gimme that gun!" She didn't say nothin'. I said, "Lorraine!" Then she unlocked the door, and I heard a *click-pow!* She had shot herself in the chest.

The bullet went through both lungs and her heart sac and came out low down on her back. So I went in there—nude, right? I picked the damn gun up first—now it's got my fingerprints on it—and I brought it back into the room and laid it down to pick up the phone. But I was too nervous to dial. So I put the phone back down and went back in the bathroom and picked Lorraine up and brought her out and put her on the bed. Then I dialed the operator to get an ambulance. And do you know what Lorraine was sayin' when they got her to the hospital, lyin' on a table with her guts hangin' out of her? She was sayin', "Sonny, don't kill me."

"Sonny"—that's me! Shit.

Fortunately, Lorraine lived, and her hospital ravings were apparently passed off as delirium. It became clear that Raymond Hill was the father of Ann's expected baby, and Ann moved back to live with her mother. Ann was graduated from high school, and on August 20, 1958, she gave birth to a son, Raymond Craig. Zelma was not happy with this development, so Ann moved with Craig, as she called her new baby, from her mother's house to a small, cheap apartment of her own near the Hoderman Tracks—an area rife with rib joints, hookers, and other urban staples. Ike—who also became a parent, on October 3, when Lorraine bore him a son, Ike junior—had already begun expanding Ann's role with the Kings, using her every night now and paying her fifteen dollars a week. To make ends meet, Ann also took a day job as a practical nurse's assistant in the maternity ward of Barnes Hospital.

Tina: I had to have the two jobs to take care of Craig. I was really a good mother, I think—got him all the vitamins, and the best clothes; made sure the baby-sitter was one that would really care for him. And I was becoming my own little young woman, too.

Barnes was the biggest Jewish hospital in St. Louis, and all the rich ladies came there to have their babies. This was where I began to realize what rich was—women coming in with satin robes with fur on the collar, you know? It was also where I first learned about makeup. I walked into this lady's room one day and she was using Maybelline mascara and an eyebrow pencil. I said, "What're you doing?" She was so pretty, this woman—there's not many in the maternity ward that're looking pretty, you know? But she looked great. And she was still happy about having her baby, and having the husband come to visit—all those things you might see rich people doing in the movies. The pretty wife. And she showed me what she was doing with the mascara and the pencil, and while she was there, I sort of started to pattern myself after her a bit. I went out that weekend and bought the Maybelline pencil and the mascara, and that was the beginning of makeup for me.

I liked working at Barnes. I didn't really want to be a nurse, but I kind of liked washing the babies, and even cleaning them. But it got to be too much, working there days and singing with the band at night. And then, because Ike was always bickering with his musicians—always fighting with them about something, usually money—I suddenly became like the main singer. So I moved out of the Hoderman Tracks apartment, and Craig and I moved into Ike's house in East St. Louis. And that was the beginning, although I didn't know it at the time, of Ike Turner moving in on my life. The first thing he did was raise me up to twenty-five dollars a week.

5.

"A Fool in Love"

The late fifties were years of barely submerged social ferment. In 1958, the beatnik movement, first harbinger of a generalized dissatisfaction with mainstream culture, began to spread across the country from California. To the beats, blacks were the spiritual elite of American society. This concept held considerable appeal for aspiring teenage bohemians already hooked on black-bred rock 'n' roll music.

Youth culture, in all its tatty, unselfconscious glory, was ever-more-noisily being born. (Although there were already signs of a rock backlash: New York singer Harry Belafonte had successfully introduced an ersatz calypso sound into pop two years earlier, and by the fall of 1958, the Kingston Trio, three clean-cut, collegiate-looking Californians, were topping the pop charts with their pointedly nonelectric hit "Tom Dooley." The rock-loathing mainstream fought back in hapless fashion: The army drafted Elvis Presley, and at KWK-Radio in St. Louis, DJs devoted an entire week to smashing rock 'n' roll records on the air. But the times were not on their side.)

Little Ann made her first appearance on record in 1958, chiming in with Ike and the boys on a novelty song called

71

"Box Top," released to little effect on a local St. Louis label.

Bonnie Bramlett, then an R & B-loving teenager haunting the St. Louis scene, remembers hearing Tina sing.

Bonnie Bramlett: That was around the time I first saw them, and it was devastating. I thought she was the greatest thing I'd ever seen in my life. She made me cry—yeah: I stood there and cried like an idiot. I knew right away that that was what I wanted to do, too. And I wanted to do it just like her.

I was Bonnie Lynn O'Farrell then, about fourteen years old, growing up in a lily-white neighborhood in Granite City. And I would sneak down to East St. Louis to see the Kings of Rhythm at the Harlem Club, which had this big boxing ring for dancing. The Harlem was down by the stockyards—it was definitely the wrong neighborhood for white girls. But me and my friends were havin' a ball—sneakin' and smokin' and drinkin' and doin' damn near everything. I thought I'd never get right.

Ike Turner used to be madness then, swinging his guitar, kicking his leg up. Everything you saw Jimi Hendrix do later—well, Jimi learned all that from Ike. Oh, yes. The Kings would come out and play this instrumental, "Prancin'," that used to just set me on fire. Then came the Revue—all the singers, and everybody doin' steps—and they created a whole lot of excitement. I think they were already doing "A Fool in Love" then. I know they did that song for quite a while before they actually recorded it. It was great, too. The whole place would just pulsate. I mean, the Kings of Rhythm were a big, humpin' band, you know?

Tina: In the very beginning, Ike and I really were just like brother and sister. I wasn't his type of woman, and he wasn't my type of man, either. But we communicated through music. I loved what he played. I didn't like

the songs he had me sing, necessarily, but I liked singing. And I could sing his ideas. For him, I guess, it was like, "Finally, thank God," you know? Because I could sing his songs the way he heard them in his head. So we became very close. He would tell me about the Bihari brothers and Howlin' Wolf and Big Mama Thornton and all these blues people he knew. I didn't know about any of those people. And we would go out a lot—not to movies or anything, because Ike never did "young" things, or fun-fun things. But we'd run by clubs and meet different people, talk a little business, catch different bands. It was always a business sort of thing with Ike.

All of this was new for me. I guess Ike was really teaching me, in a way, because I didn't know anything about bands and singers or any of that. I was right out of high school, you know? So Ike and I got really tight. Sometimes, at the house on Virginia Place, I might even go into his room and sleep in the bed with him and Lorraine. It was nothing bad. We were friends, that's all, close friends. Ike made me feel important. And I don't think there was anything I might have wanted at that time that Ike wouldn't have given me. And that kind of confidence was a foundation for me, for the first time in my life—a kind of family love. We were like brother and sister from another lifetime.

But then Ike sort of broke up with Lorraine for a while. And one night, when we were driving to a show somewhere, that was the first time he tried to touch me. I felt awful. I thought he was my friend. I never thought he'd try to do something like that. Then one night back at the house, I went in to sleep with Ike because one of the musicians had threatened to come to my room that night, and you couldn't lock the doors in that place, right? So I went to sleep with Ike. And the next morning he started fooling around in bed. I had never thought of having sex with him. I thought, "God, this is horrible. I can't do

this." But I went ahead and I did it. And from there it just sort of went on and on and on . . .

Ike: The first time I went with her, I felt like I'd screwed my sister or somethin'. I mean, I hope to die—we really had been like brother and sister. It wasn't just her voice. I had another girl in St. Louis that sang better than she did, girl named Pat—I don't know her last name, but I got a baby by her, too. Anyway, Ann and me was tight.

Tina: Yes, I fell in love. Became addicted to it, you might say. Well, everybody liked Ike then, pretty much, and some loved him a lot. He was a different person at that time—kind of shy, in a way; didn't drink or take drugs or anything. I would have been lost in my life at that point without him. I mean, I could do two things: work in a hospital or sing with Ike's band. I didn't know anything else. Or anybody else. And I wanted to sing.

Ann remained loyal to her mentor, but was often appalled by his violent life-style. A popular tale told around St. Louis, to which Ike's name is generally attached (and in connection with which he later appeared in court), concerns the unauthorized acquisition of twenty thousand dollars from a local bank, allegedly to obtain new uniforms for the Kings of Rhythm. Ike doesn't deny the story, exactly, but he's vague about details.

But during the end of January 1960, Ann became pregnant again, this time by Ike. At the same time, Ike decided to get back together with Lorraine Taylor, by whom he'd since fathered a second son, Michael, born February 23, 1959. He maintained Ann, however, as his number-one girl-on-the-side. Depressed, and uncomfortable with Lorraine back on the scene, Ann moved out of the house on Virginia Place and back over to St. Louis, where she rented a small house of her own and found a woman

nearby who would keep Craig while she was at work. Maybe, she kept telling herself, she wasn't really pregnant.

Amid the usual blur of unending club and college gigs, Ike began preparing to cut "A Fool in Love" as his next single. The session would be conducted at Technisonic, with the lead vocal assigned to Art Lassiter, late of the Trojans, now with Ike and, on his own, doing Ray Charles covers around the area backed by a female vocal quartet called the Artettes. Ike liked the all-girl backup idea, and asked Lassiter to bring along three of the Artettes—Frances Hodges, Sandra Harding, and Robbie Montgomery (the last pregnant by Lassiter at the time)—to the "Fool in Love" session. The resulting record would be farmed out to whatever label would have it. All went well right up to the day of the session, in the early spring of 1960, when Lassiter, unhappy with his financial arrangement, failed to show.

Ike: Man, I sat there and wrote that song for Art Lassiter, and then he was gonna beat me outta some money. So I had Ann do it. This was out at Technisonic, and the guy that owned the place, all he ever cut out there was TV commercials. When she started singin', "Hey-hey-heyyy-hey-heyyyy"—boy, he turned red. "Goddam it," he said, "don't you scream on my mike!"

Robbie Montgomery: Some girl wrote that song. I don't remember her name—Carol or something. Ann and I were both pregnant when we cut it. You should have seen us.

Tina: I don't know what Art Lassiter's argument with Ike was. They fought a lot. Ike was always losing singers—he was very hard to work for. Well, I had been there at the house when they were rehearsing the song, so I knew it. And Ike had already booked the studio time, so he said, "Little Ann, I want you to come and do this demo

for Art.'' I didn't really want to sing it—I didn't care for all that "hey-hey-hey" stuff. But I did it. It was a demo. I think Ike planned to record it again with Art Lassiter's voice if he could get him back. But it didn't work out that way.

Ike sent tapes of "A Fool in Love" to a St. Louis disc jockey, who in turn sent them out to several record companies, including Sue in New York City. Sue was that rarest of record-biz phenomena, a label owned and operated by a black man. Its proprietor, Henry "Juggy" Murray, had grown up on the streets of Hell's Kitchen dancing for nickels on street corners. He acquired his unusual nickname from a liquor-loving but near-blind grandfather who, in reaching for his favorite jug, more often than not wound up latching on to little Henry. Murray claimed to be a "self-made" success in the real estate business. Entering the record business at the suggestion of a New York DJ, he had started Sue (named after his mother) in 1958, and scored a hit that year with "Itchy Twitchy Feeling," by Bobby Hendricks. Like Berry Gordy, Jr. (just getting started with Tamla and Motown in Detroit), Juggy Murray was something of an eccentric. He had ears, though.

Juggy: Ike sent "A Fool in Love" to every record company in the country, and every one of them turned it down. I didn't know him from a hole in the wall when the tape arrived in my office. But I knew it was a hit, and I got in touch with him. He wanted to know how come I thought it was a hit and nobody else did. I said, " 'Cause they don't know." Ike was a musical genius, but he wouldn't know a hit record if it fell off the Empire State Building and hit him on the head.

So I flew down to St. Louis. Never been there before. He sent his driver to pick me up at the airport in this long black Cadillac and take me to his house. East St. Louis

was a hell of a town—had gambling twenty-four hours a day, and they bet down there like they bet in Las Vegas, I'm serious. Ike'd bet a thousand dollars in a minute. He was the hottest thing in that area. He didn't have a hit record, but he wasn't poor. He was sharp, he was clean, had Cadillacs, and pretty blond white girls worshiping his ass, all that he wanted. That's where I met this Anna Mae Bullock. She was around—actually, she was wherever Ike wanted her to be. Along with his other forty women.

Ike thought he was the hotshot, but I blew his mind— went down there with a contract and said I wanted to sign him up. He looked me over and thought, "Who is this little nigger?"

Juggy Murray signed up Ike and his song for a twenty-five-thousand-dollar advance. He told Ike to forget about recutting the tune with a male vocal—it was Ann's voice that made the track. Maybe, Juggy suggested, Ike should concentrate on making her the star of his stage show—not just have her up there singing background with the other singers, but save her for the "star time" segment that wound up each set. Ike, after a frustrated decade of striving, could almost feel his grasp closing around the brass ring of the big time. One day he announced to Ann that "A Fool in Love," her lead-vocal debut, would be released under a new name. Not the Kings of Rhythm this time; "A Fool in Love" would be credited to Ike and Tina Turner.

Tina?

Turner?

Ike explained: As a kid back in Clarksdale, he'd become fixated on the white jungle goddesses who romped through Saturday-matinee movie serials—revealingly rag-clad women with long flowing hair and names like Sheena, Queen of the Jungle, and Nyoka—particularly Nyoka. He still remembered *The Perils of Nyoka*, a fifteen-part Republic

Pictures serial from 1941, starring Kay Aldridge in the title
role and featuring a villainess named Vultura, an ape
named Satan, and Clayton Moore (later to be TV's Lone
Ranger) as the love interest. Nyoka, Sheena—Tina! Tina
Turner—Ike's own personal Wild Woman. He loved it.

Ann, however, had reservations—about this name change,
about her whole relationship with Ike. At first they had
been just friends—fine. But now here she was pregnant by
the guy, and getting in deeper every day. She wanted to
sing, and—yes—she wanted to be a star. But what about
love, and marriage? She wanted them too. But Ike—with
his compulsive womanizing and violent temper—seemed
an unlikely candidate for either. When she had become
pregnant, he had left her and gone back to Lorraine. Could
he ever change? She doubted it. She did love him, it was
true—he was her guide, her show-biz teacher. Whatever
she—a twenty-year-old country nobody from Nut Bush,
Tennessee—had achieved so far in her young life was due
to him. She knew how long he'd lusted after a hit record,
and she vowed that if he finally got that hit with her, she
wouldn't desert him. But . . . maybe she and Ike could go
back to being just friends, fellow professionals.

Tina: I loved Ike—as much as I knew about love
then—but I didn't want our relationship to go any farther.
He had already told me that if the record was a hit, he
wanted to leave St. Louis and go to California, and he
wanted me to come with him. I'd said I didn't know about
that—I didn't even know what California looked like. He
described a place where there were lots of pink houses and
palm trees, and I closed my eyes and tried to visualize
that. After a while, it started to seem like a little paradise.

But we were two totally different people. I knew it
could never work out between us. So when he got the
record deal, I went to talk to him. First, he told me how it
was going to be from then on: He would pay my rent, but
basically keep all the money for himself. I told him I

didn't want to get involved any further with him. And that was the first time he beat me up. With a shoe stretcher—one of those men's shoe trees with the metal rods in the middle? Just grabbed one of those and started beating me with it. And after that he made me go to bed, and he had sex with me. My eye was all swollen—God, it was awful. And that was the beginning, the beginning of Ike instilling fear in me. He kept control of me with *fear*.

Why didn't I leave him? It's easy now to say I should've. But look at my situation then: I already had one child, and I was pregnant with another by him. Singing with Ike was how I made my living. And I was living better than I ever had in my life. What was I going to do—run back to Barnes Hospital and try to get my job back as a nurse's aide? No. I was hurt and I was scared, but I couldn't think about going back. I had to keep going forward. So I decided to stay with Ike. Because I really did care about him. And I knew the story of how he had tried to get his career going for so long, and how every time he'd get a foothold, people would walk out on him. And I swore I would not do that to him. So I said to myself: "I'll stay right here, and I'll just try to make things better." I wasn't as smart then as I am now. But who ever is?

"A Fool in Love," the debut single by Ike and Tina Turner, was released late in the summer of 1960. It was an extraordinarily raw and primitive record—as crudely galvanizing, in its way, as some of the early Howlin' Wolf sides Ike had once worked on. With Jessie Knight's over-amped bass rumbling through the mix, Gene Washington tapping out crisp paradiddles on the rim of his snare, and the three Artettes providing tight unison backup to Tina's unearthly wail—"Yay-ay-hey-hey-heyyyy!"—"A Fool in Love" was the blackest record to creep into the white pop charts since Ray Charles's gospel-styled "What'd I Say" the previous summer.

And creep into the pop charts it quickly did. Because by

1960, black music—not just rock 'n' roll, but really deep black music—was becoming ever more audible on the airwaves for those interested enough to seek it out. A prime vehicle for the music's new outreach was radio station WLAC, the fifty-thousand-watt powerhouse located in Nashville.

White kids from as far away as Texas and Florida and on up the East Coast into New Jersey and New York were beginning to discover that on a clear night they too could tune in to WLAC's freewheeling R & B marathons. To hear "A Fool in Love" at that time—lying in bed, perhaps, late on a school night, with the transistor radio pressed right up against one's ear to avoid tipping off the folks—was to be sucked out of the cozy middle-class world of boy-girl pop and into some strange new place, peopled, apparently, by awesome women along the lines of this Tina Turner. The song itself was nothing special—no particular melody, no ear-catching riffs—but the singer! Unlike the reigning pop mistresses of the period—nice white girls like Brenda Lee and Connie Francis—when Tina sang, in that unforgettable a cappella intro, "Whooo-aaah, there's something on my mind" . . . well, one was immediately convinced that the something she meant was more than just a new Toni home perm.

In the style of the time, most "girl" songs tended to fetishize The Boy—the irreplaceable hunk without whose incandescent presence life would lose all meaning: Brenda Lee cooing "I Want to Be Wanted," Connie Francis gaily chirruping "Everybody's Somebody's Fool." But Tina was talking about "Got my nose open and that's no lie/ And I'm gonna keep him satisfied." This was a real woman singing. And the male under consideration in "A Fool in Love" was a man, not a boy—and, judging by the Artettes' backup commentary (talking about "why he treats you like he do"), something of a bastard too. The ironic tension in the song derives from the fact that, while the woman depicted by the lyrics was helplessly in thrall to

her no-good man, the actual woman singing those lyrics seemed incredibly strong.

"A Fool in Love" started making noise the minute it was released. At last, Ike was going to have a hit with his name on it—a hit that he controlled. If, that was, he could get the newly christened Tina Turner out of the hospital. Because his lead singer, inarguably pregnant at this point, had come down with hepatitis after cutting the record—an advanced case by the time she tore herself away from Ike's endless gigging to see a doctor, who speculated that she'd probably been bitten by infectious mosquitoes at an outdoor show that summer. Ike's patience dwindled in direct proportion to the length of her confinement, which, as "Fool" hit the airwaves, had lasted six weeks. And still the doctors wouldn't let her go. Ike became frantic. Because with the release of "A Fool in Love," Tina, unlike Ike's interchangeable array of other vocalists, could not be replaced.

Tina: I had taken Craig to the doctor with a cold or something, and the doctor looked at me and said, "Mother, you have jaundice, we can't release you." And zip—right into the hospital. I couldn't believe it. But it was really serious. I was turning yellow—my eyes were totally yellow, and real glassy. I couldn't eat anything, but I had to go to the bathroom all the time. I had fever, and I was real tired. I mean, my bloodstream was infested. It was killing me, and I hadn't realized it.

Well, I was pregnant, too, of course. Not showing yet, though—I walked into that hospital in a tight dress and high heels, honey. But after two weeks in there, my stomach went boof! So there I was, lying in bed with the big stomach, and yellow jaundice. Not feeling too glamorous, you know? And then Lorraine was wanting to know who this baby was by, right? Oh, God. So after about six weeks I'm lying there, and what starts coming on the radio?

"You're just a fool, you know you're in love . . ."

The record is getting played! And this is St. Louis, so it's getting played a lot. And boy, I got to hate that goddamn song. I'd have to lie there, all sick and swollen up, and listen to "A Fool in Love" every day, and I'd be thinking—it sounds funny now, but it's the truth—I'd be thinking: "What's love got to do with it?" You know? Because here I was, pregnant by Ike Turner, who's gone back to his wife, and now she's getting suspicious. . . . I mean, this was not my idea of love at all.

Then the record started getting really hot. Ike was ready to travel. One day he came to see me and he said, "You gotta get out of this damn hospital." He said, "These doctors are crazy if they think they're gonna keep you in here forever." Well, I was getting better by then, but the doctors still didn't want me out on the street yet, because I might've still been contagious. Ike said, "The record is hitting, I've got some dates booked, and you've gotta sneak outta here." I said, "All right."

So Ike found out the best way to get out, and he had somebody bring me some clothes to wear, and one night after dinner—"TV out, radio off, goodnight, Mother"—I got up and snuck out of the hospital in an orange maternity suit. Bright orange, Lord. Ike sent somebody to pick me up—he always had somebody else do his dirty work—and I walked out the exit he'd told me about and got right into the car and went back to the little house I was renting. The next night, Ike came over and told me what was happening. The record had hit, and we were going on tour. We had an engagement the following day at a theater in Cincinnati, Ohio, with Jackie Wilson. Well, I could not imagine myself being onstage pregnant. But Ike . . . Ike was from the underworld, you know? Totally. And you'd do what he said. So I had to get myself ready. For a costume, I designed a kind of sack dress and put chiffon over the top—people didn't realize I was pregnant for a long time. And the next day we left, the musicians first, packed into a

station wagon with all their gear, and then Ike in his Cadillac an hour or two behind them. Fortunately, I always rode with Ike, because on the way to Cincinnati there was an accident; the station wagon turned over. None of the guys got really hurt, but they were all skinned and bruised. We finally got to Cincinnati, though, and that's where we played the first Ike and Tina Turner show. Some of the band guys weren't too clear about this new billing—they thought I'd changed my name to "Ockateena" or something. They played the date in their wrinkled clothes, all torn and beaten—and the people loved us. Our record was way up in the charts by then. We were riding high.

The Ike and Tina Turner Revue was thus launched on its first tour. An immediate requirement was female backup singers to replicate the new "Fool in Love" sound. (Ike previously had employed only male vocalists in the group.) With Robbie Montgomery and her fellow Artettes unavailable to tour, vocal backup, as Robbie remembers it, was handled for the first three months by three other local singers. Robbie returned after having her baby and was joined before long by a St. Louis singer named Jessie Smith (recruited from a group called Vinny Sharp and the Zorros of Rhythm), and the following year by an East Coast gospel singer named Venetta Fields. Other singers came and went, but these three women would form the backbone of the Revue's female vocal contingent for the next five years.

But what to call this new trio? Clearly they required a distinctive designation within Ike's carefully structured Revue. Many people are willing to take credit for supplying the famous name. George Edick insists he suggested it to Ike one afternoon at the Club Imperial. Robbie Montgomery says it was actually Art Lassiter, her boyfriend, who hit upon it. Ike himself dismisses all such claims, contending he came up with the name—and quickly had it copy-

righted—all by himself. In any case, with Ray Charles and his Raelettes all the rage in R & B circles at the time, Ike's choice of a handle for his female backup group was hardly original: He decided to call them the Ikettes.

In August 1960, "A Fool in Love" climbed to number two on the R & B charts. Propelled by its success, the Revue had begun playing bigger clubs, and finally made it to the theaters too: At the Apollo in New York City, on a typically star-studded bill with Hank Ballard and the Midnighters, Ernie K-Doe, Joe Jones, Lee Dorsey, and comic Flip Wilson, Tina—eight months pregnant—wowed the crowd by jumping off the stage and down into the audience. In Philadelphia on October 3—the week "A Fool in Love" peaked on the pop charts at number twenty-seven—Ike and Tina appeared on Dick Clark's *American Bandstand,* the eight-year-old local dance show that had gone national three years earlier. This was it: the big time. And then, more wondrous yet, the Revue was off to fabled Las Vegas.

Tina: I thought, "Oh, Las Vegas! Will we have one of those rooms with the star on the door?" But the place we played was across the tracks, in another Hole. It was a big club, but predominantly black—not like those places on the Strip where Diahann Carroll and those kinds of people played. We were always kind of second fiddle, you know? Anyway, I had been wearing a maternity girdle to hold me in place, and Ike wasn't looking at me that much—I mean, Ike didn't like kids, he never wanted kids, and he never paid any attention to a woman *with* kids. But we got to this hotel in Las Vegas, and I started undressing to take a shower, and that's when Ike got a good look at my stomach. I was really blown up by then. And he said, "Girl, when're you supposed to have that baby?" I said, "Well, sometime this month." I'd only had one child before, and my mother wasn't around this time, so what did I know? But Ike got all scared. He canceled the date

we were supposed to play and he told Jimmy Thomas, "Get the car, we're goin' to Los Angeles." You see, he wanted me to have the baby there because he could work in L.A. So we took off, and Jimmy would hit a bump in the road every now and then, and Ike would curse him out, scared to death I was going to go into labor out there in the desert between Las Vegas and Los Angeles.

We arrived in L.A. around seven in the evening, checked into a hotel, ordered dinner—and I started feeling pressures. At one in the morning, I woke up and I was in labor. Of course, Ike was no help, so I got up and went into the living room. After a while, I was tossing and turning so much that Ike got up and called Annie Mae Wilson. By about seven o'clock in the morning, Ike had found out about this shot I could get to freeze my muscles and hold off the labor until I could make it to the hospital, which was pretty far away. Well, this involved going to a doctor nearby. So Annie Mae arrived and took me in the car and we headed off onto the freeway; I got the shot, we got back on the freeway, and then the labor started again anyway—I began dilating right there in the middle of the midmorning traffic. We finally arrived at the hospital, and I made it up all these steps and got inside, and Annie Mae said, "She's fixin' to have this baby," and they took me right away. Ike was nowhere around, of course.

In the early morning hours of October 27, Tina gave birth to her second son, Ronald Renelle. The baby, as Lorraine, among others, was not slow to notice, had a very familiar look about him.

Tina: That was a shameful period for me. Up till then, Lorraine never really knew what was going on, because Ike and I had kept our relationship sort of low-key—everyone thought we were still just friends. But out on the road, the fans all thought Ike was my husband—because I

was pregnant, and I was out there with him, right? And that was a dilemma for Lorraine. But she hardly ever traveled with us, so she thought the fans just misunderstood the situation. Sometimes she would come out, and then I felt really bad, because everybody knew by then and they would all be mumbling about it. And then in the car, I would have to ride in the front seat because Lorraine would be in the back with Ike, and the fans would see us and go, "Oh, we thought you two were husband and wife." And I'd have to say, "No, no . . ." I became very unhappy with that setup. I mean, here I was having a baby for this man, and here was the common-law wife that I was replacing. And when she left to go back home again, I really was like Ike's wife—which was where the fans had got the idea in the first place. Or maybe he'd be carrying on with one of the Ikettes—although in the beginning he kept that sort of thing kind of hidden from me. Anyway, it was awful. Then the baby was born, and he came out looking just like Ike. That's when Lorraine finally got fed up and decided to leave him. So eventually we got all the kids, and we just started living together. But the whole thing was a public scandal, really embarrassing.

I had other things to worry about, though, when I got out of the hospital three days later. Because Ike had this important date up in Oakland, I think it was. It was just two days away, and he said I had to make it. Well, I was real weak, but I rested those two days and then I went to do the show. Now, Ike didn't miss a trick: While I had been in the hospital, he had found this other girl that looked like me and he used her on some dates, telling the people she was Tina. Actually, she was a prostitute, and she had been turning tricks, too—and of course the men she pulled had thought they were making love to me. Can you believe it? And so these guys started calling my room, saying like, "You were with me last night and you promised me a date"—and I was going, "What are you talking about?" Ike wasn't around, so I called this girl up to my

room and told her, you know, "You can't do this." She
started cursing—and I don't know where I got the strength
from, but I picked her up and threw her in the bathtub! I
wanted to kill her. I thought I'd never be able to clear my
name after that.

So then I got dressed and went onstage and did the
show. It wasn't too bad. I only did two songs, and I sat
down to sing them. Bled a lot when I hit the high notes,
though. After that, I got two weeks to completely recover.

A crucial stylistic event occurred around this time in Wash-
ington, D.C., where the Revue was scheduled to play the
Howard Theatre. Ike had flown back to St. Louis to stand
trial for the bank job he'd allegedly been involved in, and
Tina, given some room to move, decided to have her hair
bleached.

Tina: That was a trendy thing at the time, but they
overbleached my hair, and they left the heat cap on too
long—and all my hair fell off. There was just like a
stubble left. I thought I would die. My hair! Well, it would
grow back, but slowly, right? And so that's when I started
wearing the wigs.

Ike: I get back to Washington, and Tina's hair is
that long! And we gotta do a show. Tina was cryin', boy.
Well, I could've bought a wig right there in Washington,
but instead I flew all the way back to St. Louis, bought a
wig there, and then flew back again. I don't know where
my head was at.

Tina: I got to like wearing wigs. Because I loved
movement, especially onstage, and I had this image of
myself and the Ikettes singing and dancing, and all of our
hair constantly moving, swaying to the music. It seemed
exciting, but at the same time very classy, you know? So

pretty soon we had the Ikettes in wigs, too, and that was the beginning of "the look." I loved it.

Tina's voice, and now her long, flowing wigs, provided a further distinctive kick. This was no longer simply the Kings of Rhythm, an ever-shifting assemblage of R & B musicians; now it was a crack band in the service of a blossoming star.

6.

Los Angeles

In 1961, a new dance craze began sweeping the nation.
Dance-floor fads were nothing unique, of course—over the
years there had been the lindy, the jitterbug, the bunny
hop, the cha-cha. But the twist was different. Not because
it was a black musical phenomenon that went on to make
truckloads of money for watchful white entrepreneurs—
that was an old story in the music business. The twist was
unique in that it marked that curious cultural moment when
teenage kicks—a symbol of all things hip and happening
and, above all, youthful—became the obsession of the
social mainstream. Essentially, it was the beginning of
"The Sixties."

The twist soon spawned a plethora of free-form dances
distinguished by an absence of any bodily contact between
the dancers. First came the pony (Checker's "Pony Time"
topped the pop charts in March 1961), then the fly, the
slop, the Bristol stomp, the mashed potatoes, the hully
gully. The nation, now led by John F. Kennedy, the
youngest president in its history, was going dance mad.
And the original twist refused to fade. In New York,
mainstream celebrities of every stripe—from Norman Mailer

and Jackie Kennedy to, it was said, Greta Garbo—began flocking to a tacky dance club on West Forty-fifth Street called the Peppermint Lounge, where Joey Dee and the Starliters pumped out nonstop twist music. By January 1962, Chubby Checker's version of the twist was topping the pop charts once again, with "Peppermint Twist," by Joey Dee and the Starliters, lodged firmly in the number-two slot.

This dance mania provided the perfect context for the Ike and Tina Turner Revue, which traded in spectacle as much as it did sounds. As each new twist-based dance appeared, Tina and the Ikettes, rehearsing endless hours backstage and after shows, would get it down and add it to their act. Ike was ambivalent about this development. "Tina and I never agreed on a show," he says. "She would think about goin' fast onstage and all that. But I'm thinkin', like, you got some people out there that's not into the dancin' thing; they're into the groove of the music."

But it was Tina who lent star heat to the stage show—and it was on the stage show that Ike could always bank to see him through slim times on the charts. These, however, were not slim times. In the wake of a second big hit, "It's Gonna Work Out Fine," Ike—a do-it-yourselfer from the outset, and still free of such costly business trappings as managers and producers—was flush with cash. In 1962, he decided the time was ripe to move, at last, to California. The St. Louis scene had been good to him, but by now, with two Top 30 pop hits under his belt, he had outgrown it.

In L.A., Ike could hustle with the big boys. True, he still lacked charisma as a performer, and that would proba-bly never come—Ike remained happiest onstage with his back to the audience, calling the songs and delineating the groove with the drummer. But Tina, with her resounding voice, her heartbreaker face, her knockout legs—Tina had star power to spare. And Ike, in an increasingly complete way, had Tina.

* * *

Tina: I think Ike had decided to make me one of his "ladies" as soon as our first record hit. But during the year that followed "A Fool in Love," I began to realize how unhappy I was with my life. I guess I had achieved success of some kind, but the truth was, it was constant hard work. If we weren't onstage, we were on the road to the next show; if we weren't on the road, we were in the studio—in every city, no matter where we were, he'd find a studio to work at. If we weren't recording, we were rehearsing—running down songs, working out steps. It was nothing to drive seven hundred miles from one show to the next, Ike sitting in the backseat with his guitar, me and maybe an Ikette or two there with him, singing and practicing new tunes all the way. It never stopped. And the music—I know some people say those old records are classics now, but I hated them. And onstage, the music was so loud, so noisy, and the keys were all too high. Ike always had me screaming and screeching.

But it was my relationship with Ike that made me most unhappy. At first, I had really been in love with him. Look what he'd done for me. But he was totally unpredictable. You'd hear this sound and you'd look up and he'd be sitting there, drumming his nails on the table, staring at you, kind of muttering: "You're screwin' around with me." Like that. For no reason. And then you knew you were gonna get it. You just never knew when. Out of nowhere, he would leap up from a couch and walk right up to you and—*pow!* And you'd go, "What did I do? What's wrong?" *Pow!* again. It was insane. It got to be that I always had a black eye and a busted lip—that was the basic beat-up. He would beat me with shoes, shoe trees, anything that was handy. And then he would have sex with me. It was torture, plain and simple. I always had a cut on my head somewhere, always had bruises. And on top of that, there was the mental torture. We'd be in the back of the car and he'd suddenly look at me and say, "What's

the matter with you?" And I'd freeze—"Oh . . . nothing, Ike. Nothing." But I'd have to try to be sweet then; and I'd be sitting there wondering if he was going to hit me, and when. Waiting for it. And he'd be saying, "What's on your fuckin' mind?" "Nothing, Ike." "Yes it is. You're just tryin' to fuck with me." And finally—*bam! Bam!* And then *whomp! Pow!* And then the shoe would come off . . . and there I was. And then he would be fine, as if nothing had ever happened. And later I'd be onstage *thryin' to thing* through these cut and swollen lips.

He could be so mean. One time he made me eat a whole pound cake. We'd stopped outside a store somewhere and sent somebody inside to get some food. They came back with this pound cake and said I'd ordered it. I said no I didn't. Ike said, "Well, you gonna eat it." And I had to sit there and eat the whole thing, while he watched.

So in that first year of touring, fear moved into our relationship, and it never left. I was a loner again, all on my own.

The fighting got worse when we moved to Los Angeles. Ike was so desperate for another hit, he just got crazier and crazier. And that's when I started thinking about the life I was living, and how unhappy I was. One time, early on, I was dumb enough to tell Ike how I felt. Still thought he was my friend, right? Wrong—*pow!* After that, I kept my feelings to myself. I didn't complain. The kids—his two, Ike junior and Michael, my son, Craig, and our son, Ronnie—were still back in St. Louis. So we rented a place, and we just continued working. That was our life. I didn't say anything, not out loud. But deep down inside, I started telling myself: "I am not going to be with Ike for very long. I am not, I am not. . . ."

Ike had lost most of his original band—because of money disputes—by the time he moved to L.A., and had had to hire new musicians. These too would come and go

over the years. The Ikettes, at least, had been semistabilized with the addition, a few months earlier, of Venetta Fields, a twenty-one-year-old gospel singer from Buffalo, New York. The Revue had come to Buffalo to play a gig at a skating rink one night in the late fall of 1961. Fields, a mighty-voiced member of the Pentecostal Church of God in Christ, had up until that time only performed spiritual music with a local group called the Corinthian Gospel Singers. But she had heard Tina Turner on the radio, and was impressed. And curious.

Venetta: I used to listen to her scream that opening part on "A Fool in Love" and I just couldn't imagine what kind of woman that was. So I went to this dance at the skating rink, and there was a DJ there that I knew, a guy named Eddie O'Jay. He told me that the Ikettes needed a new girl, and did I know where this other girl in my gospel group was. I told him she was in New York, singin' rock 'n' roll. But I said, "Oh, Eddie, I'll audition!" And he said, "Now, Venetta, you know you ain't goin' nowhere." And I said, "Yeah?"

I had never thought about singing this kind of music before. I mean, I came from a very religious family, and the Ikettes were wearing makeup and these short strapless dresses—I had never worn anything like that. And there were boys on the tour, too! But Eddie came out during intermission and got me, and I went back in the dressing room, and there was Ike. He said, "You a singer?" I said yeah. He said, "Well, get to singin'." So Barbara George had this song out then that I'd heard on the radio, called "I Know," and I started singing that. But halfway through it, I realized I didn't know all the words, so I had to stop. I said, "Oh, well, I'm really a gospel singer." So Ike said, "Well, sing a gospel song." And I did—it was Aretha Franklin's "Never Grow Old." Then Tina sang some harmony runs for me to follow on "Down in the Valley"; that was one of her songs then. And I followed her, and I

guess Ike liked what he heard, because he gave me cab fare and told me to go home and get my clothes. I didn't tell my family; I just stole away into the night. It was like a Cinderella story. I woke up in Boston the next day with a wig on and one of those little dresses.

It was around this time that Ike hired his first—and last—white Ikette: little Bonnie Lynn O'Farrell, his fan from the St. Louis club scene. She would become noted later in the sixties as one half of the rock team Delaney & Bonnie.

Bonnie Bramlett: I was working by then—I'd started singing in clubs when I was fourteen, 'cause I was big for my age. By that time I was working around St. Louis with people like Albert King and Little Milton, and whenever Ike and the Revue came back through town, I'd go to see them in East St. Louis after my gig. Well, Ike fired his bass player then, Sam Rhodes, and when Sam left he took his girlfriend, Jessie Smith—the Ikette—with him. So Ike needed somebody—he had a gig the next night. I knew the parts, so he said, "You wanna go?" I said, "You've gotta ask my mom." And he did. He pulled up to our house in a big silver Cadillac, him and his nephew Jessie, who was the driver. It was really very daring, because in Granite City, blacks weren't allowed on the streets after dark, you know? But Ike didn't care about rules. He came in and asked my mom if I could go on the road, and she made him promise that he would take care of me—which he did. My mom's a very prejudiced lady— she'd tell you that herself—but Ike gave her his word, and she accepted it. She knew anyway that if she said no, I would've run away from home. That's how bad I wanted to sing with them. I never wanted to be Tina—I knew that in my wildest dreams I could never be that good. But I wanted to be an Ikette in the worst way.

Well, we left that night. Tina had so many clothes, I couldn't believe it. Little did I know that I was gonna have to wear them, because Jessie's were too small. Tina's clothes were way too big in the butt for me—not because her butt was wide or fat or anything; it was just nicer than mine. I didn't have an ass at all; she did. I wore her shoes, too; stuffed them with toilet paper.

We were going down into Kentucky, so they had to make me look like I was black. This was hard, because I was very blond. We used Man-Tan—and it turned me bright, streaky orange. I was a mess! But I put on one of those wigs and I got out there onstage.

Everybody knew I wasn't black, of course, and somewhere in Kentucky we got in trouble. We were driving along some turnpike and suddenly this old beat-up Plymouth full of white kids came up and started trying to run us off the road. They were calling me a nigger-lover, a lot of filthy names. Well, Ike said to Jimmy Thomas, who was driving, he says, "Why don't you just pull right off on this exit here." The exit was only wide enough for one car, and these white kids, like idiots, followed us. Then Ike said, "Stop the car, Jimmy." And he got his gun out of the glove compartment and he got out of the car. These kids in back of us were tryin' to turn their car around, but they couldn't get out. So they were rollin' up their windows and lockin' their doors—they were terrified. And Ike put that gun to the car-door window and he said, "I ain't gonna be another nigger for you boys this afternoon, so take your ass away from here or I'll blow your goddamn brains out." They were cryin', "Oh, please, dear God, oh God, oh God . . ." And then they were gone.

I had to leave, of course, had to go back to St. Louis. It broke my heart.

Meanwhile, Ike and Tina began to fade from the charts. "Poor Fool," released at the end of 1961, was a blatant

rewrite of "A Fool in Love." It lingered on the pop charts for eleven weeks, peaking at number thirty-eight. "Tra La La La La" was even less successful. A new rendition of "Prancing," Ike's old theme song, went nowhere; ditto for one of the duo's least characteristic singles, a pairing of "You Shoulda Treated Me Right"—a horn-driven jump tune that echoed Ike's roots in Ray Charles–like R & B swing—and a lacerating slow blues called "Sleepless."

One exception was the totally bizarre and wonderful "I'm Blue (The Gong-Gong Song)," which Ike had recorded earlier with erstwhile Ikette Dolores Johnson, with Tina adding her unmistakable wail to the other Ikettes' backup vocals. By crediting "I'm Blue" as the debut single by the Ikettes, Ike was able to slip the song past Juggy Murray and lease it to another record company, thus maximizing profits. One of the great dumb rock 'n' roll nuggets, it streaked to number nineteen on the pop charts in the first week of February 1962.

The early songs, at their best, were vibrant and startlingly earthy, a powerful commercial transfiguration of the roadhouse blues of Ike's Delta youth. But they also began to reveal the limits of Ike's compositional abilities— limits that Tina was already beginning to find stifling. Minus her voice, most of this music would be of considerably less interest. Tina's continued presence, on record and in the Revue, was obviously imperative. Ike decided to marry her—a strategy that had always proved effective in the past whenever he required the prolonged services of a useful woman.

Ike: It wasn't really no marriage. See, what happened, we had some time off, so we went down to Mexico, down to Tijuana—me and Tina, Bobby John, Duke Thornton, our bus driver, a bunch of us. We went down there to see the stuff they got down there, you know—sex shows and whores. So we were at a booth in this bar on the main street, all of us sittin' there, me in a big ol'

'spañol hat, and this guy came up to us. He had a camera, and he said, "You wanna get married?" We said sure, so he "married" us, if you call that gettin' married. Hell, I was still married to some other woman; didn't get divorced from her till 1974.

Tina: Let me tell you about my marriage. One night, Ike said, "Do you want to marry me?" This was during one of those intimate, mushy-mushy moments, and I said, "Yeah." By then, it was always, "yeah," because if you said no to Ike, you were going to get beat up a few days later. I knew that I didn't want to marry him, I didn't want to be a part of his life, didn't want to be another one of the five hundred women he had around him by then. But I was . . . well, I was scared. And by now, this *was* my life—where else could I go? So, two days later, he says, "Get dressed, we're goin' to Tijuana." I had never been to Mexico before. I didn't know what to expect. We drove into Tijuana looking for a justice of the peace in order to marry us—it wasn't as if Ike had made any plans. We were driving around for quite a while—and we ended up going down this narrow, dingy road till we saw a sign that said MARRIAGE, or whatever. Inside, it was dusty and dirty, and all I remember is this guy pushing this paper over to me across a table, and me signing it. And I thought, "This is my wedding."

The next day the sun was shining, and I called my mother in St. Louis: "Oh, Ike and I got married." Trying to put it in the best light, you know? And she was going, "Oh, I'm so happy!" I wanted to say, "Ma, forget it, this is not a marriage." But it was too late for that. I was now Mrs. Ike Turner. Or whatever.

Touring

In 1964—the year the Beatles led the British Invasion, which quickly began transforming the American music scene—Ike and Tina made the pop charts only once, in the fall, with "I Can't Believe What You Say," a punchy, chant-based rocker.

Ike's recording contract with Sue Records had expired, but Juggy Murray soon approached him about re-signing.

Joe Bihari: Ike and I had always remained friends. When Juggy Murray wanted to re-sign him, he called and asked my advice. We met on the corner of La Cienega and Sunset, and went into a coffee shop. He had the new contract with him, and I read it. Juggy was going to give him all this money to re-sign—but it didn't say when. So I put in one word: *forthwith*. And a few other words, like *cashier's check only*. And I said, "You go sign this contract as soon as he types those words in."

Juggy Murray: It was forty thousand dollars, and Ike beat me out of it. I gave him forty big ones and the son of a bitch would never do anything that I'd tell him to

do anymore. He'd just cut the records on his own and send me the masters. And they weren't shit. That's how he wanted to get out of the contract, you see? He took that forty thousand dollars and bought that house out there and then stuck his finger up his nose.

Juggy's advance did enable Ike to buy his dream house, a one-story three-bedroom ranch house just off La Brea up in View Park Hills, on the southern rim of L.A. This new neighborhood abutted the black enclaves of Inglewood and Baldwin Hills; but although Ray Charles and singer Nancy Wilson had homes there, View Park was still mainly white at the time. Ike Turner, the country kid from Clarksdale, Mississippi, had now truly made it.

Tina: Ike went and bought the house and everything, then he took me to see it. I was supposed to be happy, I guess. It was like, "Oh, how nice." What else could I say? Then we brought the kids in from St. Louis—a woman there had been taking care of my two, and his two had been living with Lorraine. We put them all together and brought a housekeeper in from St. Louis to take care of them while we were on the road, and then we went back to work.

The touring, vital to Ike at a time of diminishing hits, virtually never stopped. The Revue's annual routine was unvarying. First there would be ninety days of dates in and around L.A.—at local white clubs like the Cinnamon Cinder and black establishments like the 5-4 Ballroom, interspersed with out-and-back excursions to San Diego and El Monte, and north to Bakersfield and San Francisco. Then came ninety days of hard-core one-nighters all around the country—kicking off someplace in Arizona, usually, then striking out through New Mexico, Texas, and on into the

Deep South, following the seaboard up through the Carolinas, and curving around from New York and Pennsylvania into Ohio, Michigan, and Illinois, then dropping down into Tennessee, Missouri, Kansas, and Oklahoma, and finally lurching to the North to cover Denver before heading home—and right into another ninety days of local dates. At the end of each year, there would be maybe a week off in Los Angeles—a week in which Revue members were of course expected to be on call for rehearsals and recording.

For Tina, these nationwide treks offered little in the way of glamour. Each outing was a nightmare of hot, smoky clubs that made her eyes water and her throat go raw, of "dressing rooms"—usually a storage locker of some sort—in which dusty beer crates doubled for bureaus and illumination was provided by a portable construction lamp hooked up on a wall.

There were no roadies, so band members had to hump their own equipment onstage and then hump it back out to the bus again after each show. Since there was no technical crew either, Duke, the bus driver, was expected—after driving perhaps seven hundred miles to get to a gig—to stay awake and man the spotlights, then get back behind the wheel and drive another several hundred miles to the next club. Sometimes, when the bus entered a straightaway, Duke would lash a rope to the wheel, knot it around the window post, and get up to pace the aisle for a while, just to keep himself awake. Occasionally, there were accidents.

This incessant touring required massive organization—intricately booked dates, precisely arranged hotel reservations (often a problem for a black band touring the South), and eagle-eyed attention to the various financial scams attempted by club owners. Normally, a national touring act would have to commission outside logistical assistance—contracting and scheduling engagements, for example, through such companies as the Queens booking agency in

Chicago or the Buffalo agency out of Houston. But Ike, intent as ever upon eliminating all possible middlemen, was determined to internalize such functions within his own organization. He had done it in St. Louis, with the help of the business-minded Annie Mae Wilson, and he would do it again, on an even larger scale, in L.A. Wherever he played, he kept an eye peeled for useful people, preferably women.

The women started early—or continued, since Ike had already been a relatively open and enthusiastic philanderer back in St. Louis. Among the first of his West Coast liaisons was Gloria Garcia, a Hispanic woman who began turning up at Revue gigs in California very early on. Garcia was more than just a passing dalliance: Ike was seriously smitten. ("I almost married that girl," he says.) Before long, he had also set his eye on Ann Thomas, the heart-stoppingly beautiful teenage daughter of a Bakersfield, California, schoolteacher. Ike was attracted to Thomas the first time he spotted her in the audience at Bakersfield's Cotton Club, and she would ultimately outlast Garcia—and even Tina—in his obsessions. There were many others, of course; Ike would later estimate that he disported himself with at least a hundred girlfriends over the course of his relationship with Tina.

Tina: Sometimes I'd see him fooling around with one of the Ikettes, or picking up women from the audience at a show—and sending me home early. He started renting party rooms at the hotels we stayed at, just for him and the band and the women they'd bring back from the show. I was never allowed in there. Later on, the party rooms became party suites. I was jealous and hurt. But I couldn't say anything—no one could say anything to Ike. Because you never knew what he'd do.

He might go out shopping and come back with tons of boxes: diamonds, fur coats, all kinds of presents—it was

like Christmas. But then a little while later, I'd see an Ikette or one of his other women walking by wearing the same thing he'd just bought me. And I knew. I'd known what he was like when I met him—all the women—and now I was beginning to realize that he'd never change. That I would never be enough for him. That no woman could.

One of the most useful women ever discovered by Ike was Ann Cain (not to be confused with Ann Thomas).

Cain was young, born the same year as Tina, and like her had cotton-country roots (in Louisiana) and a mixed racial makeup (black, French, Irish, and Cherokee). She was also quite beautiful, which was probably the first thing Ike noticed upon meeting her at a record store off L.A.'s La Brea Avenue sometime in 1963.

Cain had been brought to Pasadena by her parents during the war, shortly after her mother had witnessed a black man being castrated in the street back in Shreveport, Louisiana. She was smart, ambitious, and mad about music. Her high school vocal quartet, the Shells, cut a minor single called "Dirty Dishes" in the late fifties, and wound up touring the West Coast with James Brown and Little Willie John. Since then, Ann had been hanging out with musicians at such post-gig eateries as the Red Hut, a rib joint, and the original Fatburger, both on Western Avenue, and of course haunting such local R & B meccas as the Oasis, the California Club, and, in particular, the 5-4 Ballroom at Fifty-fourth and Broadway on the east side of L.A.

So when Ike Turner turned up in her record shop, Ann Cain knew who he was. And Ike knew a good prospect for cheap recruitment when he saw one.

The Turners had just lost their housekeeper, so Ann—who was neat, clean, industrious, well spoken, and had been educated at a mostly white Catholic girls' school—

was brought in to look after their four children, by now ranging in age from about three to five. They proved a substantial challenge.

Ann Cain: Ike and Tina were always gone and the housekeeper they'd been paying hadn't trained these kids. One was spoiled as hell, one thought he was rich—always ripping his clothes so he could wear new ones to school the next day—and one wet his bed because he had emotional problems. They didn't know their address, their phone number, how to wash, how to eat. I taught them manners, etiquette; taught them how to tell time; helped them with their homework. I moved right in with them, and I kept them in line—because, honey, I'd get them at the sidewalk and I'd beat their behinds all the way into the house if I had to. Those kids did not like me, but they respected me.

Tina: That was when the kids finally started getting proper training in manners and things, when we got Ann Cain. Before that there had been other housekeepers, who were okay, but not as strict as Ann was. And I could always depend on my sister, Alline, who lived nearby— she was like a combination aunt and mother to the boys when I was away. And I was away a lot, because Ike always kept us on the road. There was nothing I could do about that. But when I was home, I always made sure they were healthy, and I talked to them to find out if they had any problems. Craig turned out to be college-minded, but the others were like Ike and me—they mainly just wanted to get through school and be done with it. I guess it was an unusual kind of life for the kids, with Mother and Daddy being gone so much. But I think they were happy as kids. They were all together, for one thing—I think that family feeling helped. And they were boys. If they had been girls, I would've worried a lot more about them. If they were a

little wild, well, when Ann Cain arrived, she took them right in hand.

Ike was quick to realize that Ann Cain, with her sharp mind and polished manner (she sounded white on the telephone), would be an even greater asset as the manager of Spudnik, the booking agency he was operating out of the Olympiad Drive house. In addition to booking Revue dates, Spudnik also arranged local gigs for out-of-town musicians visiting L.A. to appear on TV shows and anxious for quick under-the-table cash to subsidize their stays. The agency was thus another profit center for Ike, but running it personally gave him the professional aura of a small-timer. Ann Cain would be his intermediary. He set up living quarters for her at the house, in a room adjacent to the garage, and began showing her the ropes.

Ann Cain: Ike knew every end of the music business: writing, recording, pressing, merchandising, promotion, booking—he knew everything. And I think he was the only black person in the business in those days that the Mafia never got to. So I was tutored by one of the masters.

She proved so sharp that Ike was soon taking her on the road too, having her "clock" attendance at the doors to make sure club owners didn't undercount the house, and delegating her to collect the band's cash between the two-hour sets they'd play each night. In this capacity, she was frequently witness to the true nature of Ike and Tina's relationship.

Ann Cain: Nobody should treat another human being the way Ike treated her. He was so horrible. One time, in Dallas, I saw him stick a lit cigarette up her nose.

And he would beat her with clothes hangers, too—for no reason. Ike would just get mad at anything. Another time, in Valdosta, Georgia, I think some girl he had been fooling around with made him mad. So when he came offstage, he went to take it out on Tina. I could hear him beating her up in their dressing room, and I went in their room just as the fight ended. Tina was covered in blood and Ike had fractured her ribs.

But Tina stayed—she stayed because of the children. When they did photo sessions, Tina would have to use makeup to cover up the bruises from his beatings, it was that bad.

Nevertheless, Ann Cain, too, soon came under Ike's erotic sway—a development of which Tina became aware during Cain's first road trip with the Revue.

Robbie Montgomery: We were in Phoenix, and Ann had gotten a little too bold with Ike. It was to the point where she was riding with him in the car and Tina had to ride in the bus with the band. Then . . . you know those "His" and "Hers" T-shirts? Well, Ann showed up wearing a "His" this one day, and Tina said, "I'm gonna get her." And the next time Ann walked in the room, Tina beat her up.

Tina: Ann Cain was really after Ike, which was what I didn't like about her. Over the years, Ike was involved with other women that worked for us, but none of them openly tried to take him. Ann was different—she was *after* Ike. She almost took over the house, cooking for him and all. It really started getting on my nerves. But there was nothing I could do, really, because if I said anything, Ike would say I was messing with him, and I'd just get beat up. But Ann made me angry, and I *stayed* angry—and waited for a chance to get back at her.

* * *

Ann Cain: I had picked up the money from the date and come back to the dressing room, and there was Tina. And she picked up this table—like King Kong—and threw it at me. I must have had eight-hundred-some dollars in my hands, and it went flying all over the room. And then she was hitting me, fighting with me, and I was trying to say, "I'm not like that . . . I want to be your friend." But she hated me so much. Because here I was, this other woman involved in their life.

By 1964, with Ann Cain firmly ensconced as business manager and concubine, Ike was once again in the market for a housekeeper for the kids. The likeliest candidate, he decided, was Rhonda Graam. Born in Texas in 1944, Graam had moved to California at the age of seven and was living with her parents out in Reseda, in the bland suburbs of the San Fernando Valley. Rhonda was white, but wild about R & B music, and it had been at the Reseda branch of the chain of teen nightclubs called Cinnamon Cinders that she had first seen Ike and Tina Turner. That was in 1962. Since then she had been following the Revue around to the black clubs it played, getting to know Ike and sticking around to have breakfast with the group in the early morning hours after shows. Occasionally, Ike would even invite Rhonda—by then working days at the Prudential Life Insurance Company in L.A.—to sleep over at the Olympiad house rather than drive all the way back out to the Valley. Finally, she began devoting so much of her life to the Revue that she lost her Prudential job. At this point, in late 1964, Ike hired her to replace the recently promoted Ann Cain as keeper of the kids.

Cain was immediately annoyed by the addition of this latest bauble to Ike's collection of women.

* * *

Ann Cain: I really hated Rhonda then; hated her coming around. Because I realized, "This is the new one," you know? It was a natural jealousy. But Ike had told me—'cause we used to sit in the office at night and talk for hours—about his obsession to have this white woman, to take her everywhere and show the white man something. And when he first laid her, he said he pinched himself to see if it was really true—this black guy from Mississippi with this young white girl. I'm sure that every one of his relationships had something to do with proving something—that he wasn't growing old, that he was smart enough to get these women to run his business. Because he always surrounded himself with women. They were always the go-betweens, so that nobody could get to him business-wise. Ike always spoke through someone else. The man was a genius, but he felt that people laughed at him because he wasn't educated and didn't know how to structure words and sentences. So he had us.

Before long, Rhonda too was touring with the Revue, alternating with Ann Cain as road manager. For a white suburban kid, those excursions—particularly into the Deep South—were astonishing experiences.

Rhonda Graam: You had to get the money from the owners before the band went back on after intermission, or you might not get it at all. And then you had to watch where you put it, or they'd take it back from you. In the South, we'd only play black places—a black group couldn't play white clubs down there in that period—and there was always a lot of drinking and fighting. I remember one guy getting his ear cut off while I was standing there at the door, trying to clock the house. There was a club in Waco, Texas, that had this great big cop at the door, and a woman cop with him: He'd frisk the guys and

she would frisk the girls. And the stuff they found! Girls would have knives stuck down in their bras, or in their purses; it was hysterical. I'd be sitting on a stool, clocking the door, and underneath the stool there'd be this dishpan, and these two cops would be throwing knives and razor blades and all this stuff into it. There was always an amazing collection of weapons by the end of the night. Then we'd be traveling through Alabama or someplace, and getting run off the road by pickups full of honkies with rifles. I mean, I saw everything down there.

Rhonda's more intimate involvement with Ike—that inevitable feature of most of his relationships with female employees—was "a big mistake," she says.

Rhonda Graam: The work and the traveling, that was a great experience; I wouldn't trade it for anything. But this other part, with Ike, was just the worst thing that ever happened to me. A lot of it was by force, too: You either did it or you got hit. I remember one time I was talking on the phone, and he came in and started cursing, and he took the receiver and cracked me in the head with it. I've still got a scar there.

You lived in such fear, you know? You wanted to get out, but you were afraid to. Just like Tina. And if somebody did leave, Ike would always track them down. Then it was, "Oh, well, I'm sorry," and everything was supposed to be okay, erased, and you shouldn't want to leave anymore. It was rejection, I think—Ike just couldn't handle rejection.

I guess you have to remember, too, that he was born and raised in the South, and things are totally different down there. I remember, in the poor black communities that I saw, there seemed to be a lot of wife-beating in those days. We were in Mississippi once, and I saw this guy beat this girl to smithereens with a lead pipe. I mean,

she was a bloody mess. We tried to bring her inside, but she said, "No, no, leave me alone—he'll get mad, he'll get mad." The next night we were playing the same club, and there they were, back again, arm in arm.

It was around this time, apparently, that Ike—still a cigarettes-and-coffee loyalist—began to take an interest in drugs. The Ikettes were known to sneak an occasional marijuana joint, but when Ike found out, he didn't fire them.

Venetta: He said, "What is this y'all do when you get high?" He wanted to know, right? So we said he should get the pot and wreck us, and we'd show him. Well, when he came out on the road—this was in Tennessee somewhere—he had heaps of it! And we got so crazy the first show that night—Jessie got up onstage and went to sing the first verse of her solo and just stood there at the mike and grinned through the whole number. Oh, we were actin' so silly. Then, later that night, we all went to Ike's room and turned on Sam Cooke's *Live at the Copa* album, which had just come out, and smoked some more pot. He said, "Is this all you do?" We said, "This is it." He made Tina smoke a joint, too, and pretty soon we was all actin' crazy. Then we got hungry.

Tina: I started laughing hysterically about everything that everybody said. I mean loud and hard—"Hahaaa!" And then I got *real hungry*. Ike went to this party somewhere, so I put on my fur coat, and me and the Ikettes all walked out to this restaurant across the street. The first thing we saw outside was a police car. I almost fainted; thought I was gonna go to jail. But we got inside, and I ate—I mean really ate—and when I was finished I took my plate back and asked for seconds. Seconds! Handed back the already used dish and said, "Can I have another

order?'' Then I flashed on what I was doing, so we got out of there, went back to the hotel, and they took me to my room. I was sitting there in a chair, and it seemed to be floating off the floor. I thought, "God, this is really weird, I'm floating." Then I ran to the bathroom to brush my teeth, and it felt like I was brushing them for hours. Finally, I went and laid on my bed and floated some more. I didn't know what that stuff was they had me smoke, but I said, "I don't want that anymore. I'm not in control with it." And that was the first and last time I ever smoked marijuana.

There were some laughs, some good times back then. But you never knew when Ike would just suddenly turn on you. So I mostly felt trapped in that life. I guess some people in my position might have turned to drugs, or drinking, but I never did. I didn't like the idea of putting these poisons into my body; and I didn't like the way it looked when people got high or whatever—especially women. So I was never interested in those things. There was the Benzedrine, of course: Ike used to give me bennies when we were recording for a long time and my voice got hoarse. He'd say, "Take this pill and you'll be able to sing." Then I'd sing over the hoarseness, and the next day I wouldn't have any voice at all, and my jaws would hurt from the clenching and tension. But when Ike was recording, I had to sing, sore throat or not, and so I had to take the bennies. But I never took them because I wanted them or enjoyed them. I knew I needed something to help me deal with what my life had become, to help me find a way out; but I knew that drugs weren't it.

While Ike and Tina singles continued stiffing, the Ikettes suddenly started taking off. Revived as a separate recording entity, they notched a Top 40 pop hit in April 1965 with "Peaches 'n' Cream," featuring Jessie Smith's lead vocal. In the fall, their follow-up, "I'm So Thankful," began charting. Suddenly, the Ikettes were a hot act, in

demand on their own for such traveling rock 'n' roll road
shows as the Dick Clark *Caravan of Stars*. Ike wasn't
about to let the Ikettes slip away from the Revue, though.
He hired various sets of other black women—mostly scuf-
fling L.A. session singers—and sent them out as the Ikettes,
keeping the originals close at hand. For Jessie, Robbie,
and Venetta, this was one humiliation too many. They'd
never seen any profits from the Ikettes records—Ike paid
them only a salary as Revue members—and now he was
denying them not only the spoils of stardom but their
moment in the pop spotlight as well. And paying his fake
Ikettes more than the real ones to boot.

Venetta: He was such a powerful man, we knew
we couldn't hurt him if we left one at a time. Because
we'd all left at one time or another, and he never cared.
Sometimes he'd threaten to fire us, and he'd have three
other girls at the show that night, watchin' us so they
could take over our gig. Well, after "Peaches 'n' Cream,"
when everybody wanted to hire the Ikettes and he started
sending these little three-girl groups out, we decided it was
time to leave. In one way, it had been the happiest time of
my life—being with a band, getting to know Tina. She
taught me how to be a woman and how to carry myself as
a lady. Always told me, "You can't work and party, too."
And she lived by that—never drank, never smoked,
always went to bed after very show. She was so strong—
which I guess she had to be, the way Ike was. When he
wanted to lash out at her, he'd just lash out; he didn't try
to keep nothin' private. I loved Tina. But after what Ike
did to us with "Peaches 'n' Cream," enough was enough.

In September 1965, with "I'm So Thankful" on its way
into the pop charts, the Ikettes walked. Rhonda Graam was
swiftly dispatched to retrieve their maracas.

Tina's sister, Alline, who'd been working on the busi-

ness side of Ike's organization on and off for the past three years, left with the disgruntled Ikettes, eager to manage a group in such demand for personal appearances. In no time, a sixty-day tour was set up. Stardom seemed imminent. Ike quickly quashed such notions, however.

Alline: These were the real Ikettes, but we found out they couldn't use the name, because Ike owned it. He had marshals to keep us from going onstage—subpoenas, restraining orders—on every trip. Then we tried "The Mariettes, formerly the Ikettes," but he didn't want that either. Finally we just dropped it.

"River Deep"

By the summer of 1965 Ike and Tina Turner were signed to Loma Records, a small R & B label recently started by Warner Bros. and being run by Bob Krasnow. Krasnow, a tall, affable aficionado of black music in all its forms, had encountered the Turners during an earlier visit to San Francisco, where he had been working at the time for another label. In the interim, the transplanted New Yorker had become involved with James Brown, but with the eruption of the Watts riots in August, Brown had decided that it was impolitic to be working so closely with a white man, and Krasnow was on the lookout for a black act of similar stature when he discovered that Ike and Tina were available.

"They were touring three hundred sixty-five days a year," says Krasnow, "doing like seven shows a night—it was insane. The Revue was a money machine as far as Ike was concerned. It was James Brown relived, except on a much smaller scale. And also Tina had much better legs."

Krasnow recorded about half a dozen singles with the Turners, but none made the pop charts. One day Krasnow got a phone call.

* * *

Krasnow: It was Phil Spector. He said, "You guys have Ike and Tina?" I said, "Yeah, we do." He said, "Well, uh . . . I want to make a record. With Tina."

Like most record producers—at least those whose view wasn't distorted by professional envy—Krasnow was in awe of Spector. Spector was widely known then as the teen-pop king of the early sixties, the man who'd changed the sound of boy-girl rock 'n' roll with his celebrated "wall of sound" productions. Still shy of twenty-five, Spector already had had an extraordinary career producing the Crystals, the Ronettes, Darlene Love, and, at the end of 1964, the Righteous Brothers.

It was with a wild, twanged-out version of a Walt Disney soundtrack tune, "Zip-A-Dee-Doo-Dah," which made the Top 10 in January 1963, that Spector began employing an inflated studio band: three guitars, two basses, and two pianos. His purpose was to take all these instruments and squash them down into one majestic rock 'n' roll roar. This recording approach—the wall of sound—became Spector's hallmark.

Spector had four Top 10 hits with the Righteous Brothers, but at the end of 1965, perhaps because they were weary of Spector's painstaking and autocratic ways in the studio, the duo left to sign with Verve. Now what? the industry wondered. Spector began searching for a new voice, something special. At an L.A. club called the Galaxy, on Sunset Boulevard, he heard Tina Turner. "Somebody told me to see them," he later said, "and their in-person act just killed me. I mean, they were just sensational." Spector recruited the Revue for *The Big TNT Show*, a teen spectacular filmed at a Los Angeles club called the Moulin Rouge. Spector himself conducted the onstage orchestra, and the show featured performances by

the likes of the Byrds, the Lovin' Spoonful, Ray Charles, Petula Clark, and Donovan—a motley agglomeration.

And then there was Ike and Tina Turner. With the band pumping out riffs honed razor-sharp from years of road work, and Ike dipping and stepping in time to the beat, Tina took the stage and proceeded to all but demolish the Cal-teen crowd. Decked out in a short tight skirt, white go-go boots, and a weird piece of head gear—it looked like a sleeping cap—she tore through "Think It's Gonna Work Out Fine" and brought down the house with an extended version of "Please, Please, Please." After witnessing this scorching performance, Phil realized that he had found his new voice. Now all he needed was a song.

One day in early 1966, Spector returned from a trip to New York bearing a tune he'd just co-written with the extraordinary Brill Building pop team of Jeff Barry and Ellie Greenwich.

Darlene Love: In those days, I didn't get emotionally involved with Phil's records—we looked at them as bubble-gum music. This new song he had was the only one that had ever really meant something to me. I wanted to do the record so bad. But he said, "No, no, this one's not for you." It was "River Deep-Mountain High."

Bob Krasnow handled the negotiations for Tina's services, shuttling between Ike, who made all business decisions for the Turner organization, and Spector, who lived in a castlelike building above Sunset Boulevard. Spector was a diminutive character—five feet four inches tall, the same height as Tina—and, in public, he affected mod fashions exclusively. Despite his outré gear and mysterious manner, Spector was no flake—when it came to creating records, he knew exactly what he wanted. He reportedly offered twenty-five thousand dollars for the use of Tina's voice. Whatever the exact sum, it was, as Krasnow

recalls, "big money for those days. There was only one caveat—that Ike would not walk into the studio."

The deal was struck, and for the next few weeks, Tina was allowed to drive herself up to Spector's house each day in the sleek black Lincoln Ike had bought her. There she would immerse herself in Phil's conception of "River Deep-Mountain High," a record with which he intended to surpass even the peaks he'd previously reached with the Righteous Brothers.

Tina: I hadn't even known who Phil Spector was when I first met him backstage at the Galaxy. The things he did seemed strange to me. He would pick up an apple core from an ashtray and *eat it*—I thought that was nasty! He was very small, and extremely pale—he looked unhealthy—and he had this funny hair and this little cap always sitting on his head. Anyway, after *The TNT Show*, Phil was excited. He said he wanted to produce me, and so he and Ike worked out the details—I never had anything to do with the business. And I didn't know what a "producer" did in those days, anyway. Then I was told there would be two weeks of rehearsals, from twelve to two every afternoon. Ike was not to be there. I liked that. For the first time, I really felt like a professional.

Phil's house was a mansion—high ceilings, winding staircases. He'd buzz me in through the intercom, and then inside near the door there'd be this myna bird—nobody else in sight. So I'd stand and talk to the bird for a while, then I'd walk around this huge living room, waiting for Phil to appear. There were no servants to offer you coffee or tea; if you wanted anything, Phil would go and get it. He was very shy and withdrawn. This was the first time I'd been given the freedom to go anywhere alone. I was only allowed to go to the studio or the airport. Anyway, the first day, Phil came down wearing a T-shirt and jeans, and he just said, "Hi." Then he said, "This is the song," and he sat down and started playing it on the piano,

running from key to key to find out which one was best for my voice. He sang it for me, and I had to laugh to myself—he had a bit of a lisp, and there would always be these little dribbles of spittle in the corners of his mouth. He looked like a little boy, sitting there singing this song about "I had a rag doll" and all. He also had a voice like Sonny Bono. But the song was something. For the first week, we just worked on getting the melody for the verses right, nothing else—over and over and over. It was like carving furniture.

I loved that song. Because for the first time in my life, it wasn't just R and B—it had structure, it had a melody. You see, Ike would always have me screaming and shouting on his songs—selling them, you know? Because there wasn't really much to them: I'd always have to improvise and ad-lib. But with Phil . . . well, one day, when we were about finished rehearsing at his house, I started really feeling this song, and I went into my old routine— "Whoaaaahhhh"—the way I'd been taught by Ike. But Phil said, "No, no—I just want you to stick to the melody." And I thought that was great: He just wanted me to sing the song. It was my voice he liked, not the screaming. He told me I had an extremely unusual voice, that he had never heard a woman's voice like mine, and that that was why he wanted to record me. This was all so different for me, so psychologically affecting, that when I went home each night and Ike would ask, "What's the song like?"—I couldn't tell him. I just blanked out on it.

I only went to the studio once when Phil was doing the backing tracks. It was amazing to me, because I didn't know anything about Phil or the way he worked. It looked like there were about seventy-five musicians in there, and like twenty-five singers, and Phil went in and tore up every lead sheet in the studio, because they'd all been printed wrong. So he had to start from scratch. Finally, he got it right, and I just put a rough vocal down for him and went home. I didn't come back for maybe a week.

Ike had kept asking me what the song was like, and I still couldn't sing it for him, couldn't even describe it. But then one night before I went back to Gold Star to do the real vocal, Ike and I were driving up to Oakland to do a show, and the song just suddenly came to me. I started singing it, right there in the car: "When I was a little girl, I had a rag doll" And even hearing it like that with no accompaniment, Ike was very impressed.

A few days later, around two in the afternoon, I went in to do the final vocal. Nobody was at the studio but Phil and the engineer, Larry Levine. I was very comfortable with Phil, and he was very patient with me. But did he work my butt off! That intro—"When I was a little girl" —I must have sung that five hundred thousand times, and I don't know if I ever got it just the way he wanted it. I would sing it, and he would say, "That's very close, very close. We'll try it again." I don't remember him saying, "Got it." Pretty soon, I was drenched with sweat. I had to take off my shirt and stand there in my bra to sing, that's how hard I was working on that song. I didn't get out of there till late that night.

Larry Levine: The one thing that stands out in my memory about that session is Tina. When she came in, she was electric. We turned the lights down, just had a couple of side lights on each wall. And she couldn't swing with the song with all her clothes on, so she took her blouse off and sang it just wearing a bra. What a body! It was unbelievable, the way she moved around. Electric, electric.

Bob Krasnow: I watched every minute of the making of that record. At the early sessions, Phil had every big studio musician in Hollywood in there—Glen Campbell, Sonny Bono, Hal Blaine. I think Barney Kessel was one of the guitar players—there were like five of them. And Leon Russell on piano—there were all kinds of

piano players, too. There were like fifty guys in the studio—
the whole room was just jammed full of musicians. And
this went on for weeks. I mean, who knows what this
record cost—maybe twenty grand. In those days, you
could make five albums for twenty thousand dollars. And
this was just a single—*one side* of a single.

Okay, so finally it's time for me to bring Tina down to
do the vocal. And she gets in there and she hears these
completed tracks—and it's like: "Are you kidding?" This
is like hearing Bach for the first time; like hearing Wagner.
The tracks are so overwhelming, who could sing over
them, you know? Except Tina, right? So they go over it a
couple of times, and Tina's really working—she's there,
she's sweating, she's working hard. And they go over it
and over it and over it, and Tina can't quite get it. Finally,
she says, "Okay, Phil, one more time." And she ripped
her blouse off and grabbed that microphone, and she gave
a performance that . . . I mean, your hair was standing on
end. It was like the whole room exploded. I'll never forget
that as long as I live, man. It was a magic moment.

After the final vocal session, which took place March 7,
Spector began the arduous process of mixing down the
tracks. For one of these mixing sessions, he allowed Tina,
at last, to bring Ike along. As Larry Levine recalls: "You
felt a lot of hostility from Ike. I don't think he liked Phil
producing her all by himself. But what could he have done
with Ike? He needed the artist, not the bandleader. I'm
sure Ike felt attacked at the level of his capability."

Says Tina: "Ike was blown away. He sat there and
went, 'God, that's amazing.' You could tell that this was
the kind of thing that he wanted to do, too."

When the record was close to being mixed and ready for
release, Spector began inviting selected colleagues in for
previews.

* * *

Bob Krasnow: I had these two friends, Tommy LiPuma, who was a record producer, and Johnny Hayes, who was a disc jockey at KRLA, which was then the most important radio station in Los Angeles. And I said to Phil, "You've gotta let me bring these guys down to hear this, you've just gotta, please." Well, Phil knew Tommy, so finally he acquiesced. I brought them down, and I'm telling them, "You're in for something special. You've never heard anything like this." And I bring them into the studio, and Phil's in there fiddling around, getting everything set up, and Tommy and Johnny are just standing there in the middle of the room, waiting. Then that opening riff comes booming out of the monitors: *Da-da-da-da-dum! Da-da-da-da-dum!* And here comes the track—it was incredible. By the time the record is over, I turn around and Tommy and Johnny are backed up against the wall, and they are down on their knees, man—weeping!

"River Deep-Mountain High" was indeed a Spector masterpiece. The sound was so preternaturally deep and lustrous that one felt almost in danger of falling into it. With the enormous studio orchestra pounding away at the rumbling riffs, a soaring string section, and what sounded like a battalion of backup singers doot-do-dooting away, Tina gave the performance of her life. While some of Spector's early work has dated over the years, "River Deep," two decades later, can still take the top of your head off.

Spector spent weeks getting the master pressing he wanted. ("He would bring me into his office," Krasnow recalls, "and play me sixteen different test pressings that only dogs could hear the differences on.") Finally, in the late spring of 1966, "River Deep-Mountain High" was ready for release.

* * *

Tina: There was so much energy behind that record. Everybody was so excited about it. It was the biggest rush—like: "This is gonna break you guys wide open," and "You're gonna have your first number one with this one." Ha!

"River Deep-Mountain High" was—to the amazement of everyone involved with the record—a disaster.

Bob Krasnow: Just before the record came out, I slipped a copy of it to Johnny Hayes at KRLA, and they started headlining it: "At nine o'clock tonight you will hear the new Ike and Tina Turner record produced by Phil Spector." "In four hours you're gonna hear the new Phil Spector production." Like that. Well, as I say, KRLA was the most important radio station in Los Angeles at that time. But nationally, the most important thing was Drake-Chenault, a chain that programmed a slew of stations across the country. And Bill Drake, who ran Drake-Chenault, lived in L.A., where he had a station called KHJ. So maybe because KRLA previewed "River Deep" before KHJ or any other station, Drake-Chenault stations were not as enthusiastic about the record. Perhaps that's why it never realized its full potential.

Larry Levine: The trade publications gave "River Deep" mediocre reviews. Everybody had it in for Phil. He'd had, what, twenty-six straight chart records? So everybody took this opportunity to push him down. When the reviews came out, he came to me and said, "Can you believe this?"

"River Deep" was Phil's demise in the record business. You see, Phil was the personification of the kid who had vowed that he'd make something of himself because everybody had laughed at him in high school. And he did. But of course that never solves the problem. So, although

he tried to cover it with bravado, inside he was very vulnerable. And after the reviews of "River Deep" came out, Phil just withdrew into himself. He became a semirecluse, didn't want to do anything anymore. He retreated behind dark glasses.

"River Deep-Mountain High" climbed to number eighty-eight in the pop charts in the first week of June, then tumbled back down. Tina was dismayed, but she realized what had happened.

Tina: That record just never found a home. It was too black for the pop stations, and too pop for the black stations. Nobody gave it a chance. But I still felt real good about that record, felt it was something I could be proud of. Because "River Deep" proved I was capable of doing something other than what Ike had me doing. That's not to put Ike's work down; but this was different. I was a singer, and I knew I could do other things; I just never got the opportunity. "River Deep" showed people what I had in me.

While "River Deep" misfired in the States, it created a sensation across the Atlantic, rocketing to number three on the British charts in mid-June, and remaining in the Top 50 for thirteen weeks. George Harrison, guitarist with the then-regnant Beatles, was quoted as calling it "a perfect record from start to finish—you couldn't improve on it." America had deep-sixed the single, and here were the Brits, waxing ecstatic. "Benedict Arnold," Spector bitterly quipped, "was quite a guy."

"River Deep" 's reception in Britain—boosted by a live U.S. film clip aired on the *Top of the Pops* TV show—was no mystery, however. The new breed of British rock bands that ruled the charts was fascinated by black American

music. Lacking a native equivalent of blues and R & B, the British groups and their audiences had become connoisseurs of the American scene. Such pop-oriented acts as the Beatles and Manfred Mann and Herman's Hermits reveled in covering black girl-group hits. Grittier stuff became the province of the more blues-oriented Yardbirds, Animals, and, especially, the Rolling Stones, red-hot at the time with their number-one hit "Paint It Black."

The Stones were already well acquainted with the work of Ike and Tina Turner by the time "River Deep" arrived. As it happened, they were then gearing up for a fall tour of the U.K. Why not, they decided, invite the Ike and Tina Turner Revue along?

Bill Wyman: We realized that they were a great visual act, that that was the magic thing about them. And that's what we used to admire in people, if they could be really good visually as well as on records—which was what we tried to do. I mean, some people made great records, and then when you saw them, they were a load of old crap, you know? With Ike and Tina, the visual thing was as important as anything else about them. So we got them to come over.

By the time the Stones tour came up, the Revue was already on its second set of post-original Ikettes. After Robbie, Jessie, and Venetta walked out, Ike had quickly scooped up two inexperienced L.A. girls, Maxine Smith and Pat "P. P." Arnold, and a young club singer from Palo Alto named Gloria Scott. Ike, predictably, had eyes for the attractive Arnold. This particular lineup lasted only weeks.

Maxine Smith: We went up to their house to audition. We just sang a little bit, and then Tina said, "Okay, let's start rehearsing." And we rehearsed from

eleven o'clock in the morning till three in the morning for three whole days. The fourth day we were on the road, and that night we were onstage. Man, I was so scared. And from there we just kept on going, doing one-nighters,

Ike was kind of hard to get along with. He had a problem with fining people for every little thing, like if your shoes weren't clean, or if there was a snap missing on your dress. He'd walk up to you onstage, while you were singing, and he'd say, "I'm finin' you ten dollars for that snap on your dress." By the time we got back to L.A., I owed *him* money.

But he never bothered me sexually. I think Pat Arnold was his target. So Tina wanted her fired—said she was singing flat onstage. Well, we decided that since we had all come in together, if Pat was gonna be fired, then we'd all leave together. But then the night that none of us was supposed to arrive for work—Pat was the only one who showed up!

With Arnold still on board, Ike quickly recruited another singer, Rose Smith; to round out the Ikettes, he added his Bakersfield paramour, Ann Thomas, now turning twenty. He was undeterred by the fact that Thomas couldn't sing: One of the band's other backup singers—Bobby John or Jimmy Thomas, maybe—could always hit her notes for her. Tina, however, was becoming increasingly annoyed by Ike's blatant infidelity.

Tina: That's when I started falling out of love with Ike. It got to the point where I told him, "Just don't bring anybody into my bed." That was the one thing I asked. Then there was this short tour we did without Ike—he stayed home to start one of his little record companies, so I went out with the band and the girls. And when I got back, that was when I found out about this Gloria Garcia, and that he had really been seeing her steadily. It was so open

that Ike finally showed me a picture of her—what was I gonna say, you know? Well, I was shocked when I saw this picture—the girl looked like Sophia Loren. I thought, "I don't have a chance against her." So I was looking at the picture, really observing every inch of her, when I noticed the chair she was sitting on, and the wood in the background . . . she was sitting in my house! Then I found out from one of the children that Gloria had been living there while I was gone. And sleeping in my bed! I was so hurt by that, I can't tell you. And that's when I decided: Okay, I don't want this man anymore.

Ann Thomas was another one. Very pretty girl. Very *nice* girl. She had some Oriental blood, but she looked just like my stage image. Couldn't sing at all, but there she was—an Ikette. After I started letting go of Ike—letting go of the love I had felt for him in the beginning—Ann became my friend. That was the strange thing, over the years: All of his girlfriends became my friends. Because they were always in the same position I had been in: falling in love with Ike Turner. But where they were just getting into that transition, I was coming out of it. So we all had a lot in common. And who else did I have? There was no life outside of the house and the studio and the road. I mean, I couldn't even go to a movie on my own. If I had to go to the market or something, I'd have to tell him first—and he still might come and check up on me. So by this time, I was real unhappy. I didn't care about anything; on the road, I'd just go to the job, and then afterwards go back to the hotel and go to bed. I was miserable.

And then "River Deep" became a hit in England, and suddenly Ike and Tina were off to tour with the Rolling Stones.

The Stones tour, twelve dates in all, was booked to run from September 23 through October 9. In addition, the Ike and Tina Turner Revue would be playing another dozen or so dates on the side, many at the enormous Mecca clubs that then catered to British youth.

It was an uproarious excursion. The Rolling Stones launched their tour at the Albert Hall with tape recorders running to capture the show for a projected in-concert album, *Got Live if You Want It*. Six songs into their set, though, the house erupted into a near-riot, with fans clambering up onstage to grope their idols and being brusquely dumped back into the sea of roiling teens. For chitlins-circuit veterans who thought they'd seen it all, that opening night offered the Revue members a new kind of eyeful. And, for Ike and for Tina, an earful, too.

Tina: I remember I was in the dressing room and I heard somebody playing guitar—and were they ever playing it! I followed the sound out into the hallway, and I came to this other dressing room, and there was Jeff Beck, just sitting there, playing. He was the lead guitarist for the Yardbirds, who were also on the bill. Jeez, you should've heard him! I couldn't believe it.

Ike said, "Man, these guys can play over here!" He was really blown away. Ike was very strongly attracted to white people—he had a lot of white girlfriends, and white guys that idolized his playing. And I noticed he got a lot of licks from these English guys, too—because they were doin' a lot of stuff, believe me. I think maybe Ike should've just moved to England then, because he could've really got into a rush with those guys. But, well . . .

Mick Jagger: I think we worked much harder after Ike and Tina had been on, you know? Because they would really work the audience very, very hard. But that's the reason we had them on. There's no point in having some jerk band on before you—you have to have somebody that'll make you top what they do. And Ike and Tina Turner certainly did that job admirably. Tina's voice was very powerful, and also very idiosyncratic—easy to pick out. "River Deep-Mountain High" was an excellent

record because she had the voice to get out in front of Phil Spector's so-called wall of sound.

Tina definitely was not out every night boogying, but she wasn't a party pooper either. She'd hang around and have a good time with the girls—I mean, she was to some extent *with Ike,* you know? But she would recommend which Ikette I should go for, and I went out with P. P. Arnold for a while. We found out that Ike played piano on all those Howlin' Wolf tunes, so we got him to play them for us, what he could remember. This would be like in between sets, before we went on. We'd go, "Okay, you say you played on 'How Many More Years'—play it." And he would. He was very good. And he was a smart, smooth operator.

Bill Wyman: Ike was a brilliant piano player, but he didn't like to talk about those early records he'd done. He said he always used to get screwed in those days, no credits or anything, and he always had a chip on his shoulder about it. That's probably why he was such a bad guy to deal with later.

We were quite matey with the Ikettes. Rose and this other little one used to travel with me in my new one-year-old Mercedes with black windows. We had a little accident on the way from Glasgow to Newcastle; nobody got hurt, but we decided to go by coach after that. They were pretty poorly paid. They used to say they got about twenty-five or thirty dollars a week, and if they damaged their stage clothes—ruined their tights or anything—they'd have to pay for it themselves. We thought that was quite bizarre. Nobody was earning a lot of money in those days, but that was really scrapin' the barrel.

Tina: I never went out to watch the Stones perform. I didn't have time. Ike always had somebody to take care of "our" clothes on the road, but if that person started spending too much time helping me, well, I was going

to hear about it. So I would just tell them to take care of Ike and I'd take care of my own things. I could sew; I could iron. And so I was involved with keeping myself organized. I didn't have time to watch the Rolling Stones, or go out after shows, or meet new people. I was blind, in a way; I just didn't care about anything, because I was so bogged down with my life. Tina Turner, that woman who went out onstage—she was somebody else. I was like a shadow. I almost didn't exist.

Well, the first night of the Stones tour, at the Albert Hall, I was nervous—we'd never worked a hall that big. But we went out and did what we did, and the people loved it. They didn't like "Please, Please, Please"—we cut that immediately—but they accepted us. And from there on, I became more comfortable.

We were something a little different for British audiences then—four wild women up there onstage. I remember we made the front page of some newspaper with this photograph that was taken from a real low angle. We were doing the usual shag step and a kick, and my garter belt was showing. I thought, "This isn't a very good picture" —really naïve, right? But that photographer knew what he was doing. And I think that was the beginning of the sex-symbol thing—"Sexy Tina," "Wild Tina," all that. If the people had only known.

After a while, I started noticing this face offstage when the girls and I were out there. I said, "God, who's that boy with the big lips?" It was unusual to see a white person that looked like that, you know? He would just stand behind the speakers and all you could see would be this white face and these eyes and this mouth. Finally, Ike brought him into the dressing room one night—they were really fans of Ike Turner—and I said, "Ike, who's that boy standing there?" He said, "Oh, that's Mick." Mick went like, "Heyyy," and I was startled by the way he spoke. He had the English accent, of course, but you could also hear in his voice that he was really into black music and

black people. And then immediately—*doinnng!*—he had his eye on P. P. Arnold, and he zoomed in on her. I guess that was fine. I didn't pick up any bad vibes from Ike because of it.

After that, Mick would come into the dressing room and we would sing a lot together. He never knocked, so you'd always have to stay kind of dressed, because he was friendly enough with Ike that he could just walk in. But we'd sing and talk and laugh—everything was funny in those days, with Mick around. He'd be telling me about Keith Richards, too—I think Keith sort of had a crush on Tina Turner then—and it'd be Keith-this and Keith-that, and we'd laugh it up some more.

Mick wanted to learn the pony. He said, "How do you guys do that?" So we all started dancing—and I finally saw what he had been doing onstage. I said, "Look at the rhythm on this guy! God, Mick, come on!" I mean, we *laughed*. Because Mick was *serious*—he wanted to get it. He didn't care about us laughing at him. And finally he got it, in his own kind of way.

England was the beginning of everything for me—the beginning of my escape from Ike Turner, I guess you could say, and the beginning of me seeing a new way of life, a new style of living. In the middle of that tour, we took a few hours off to do this English TV show, *Ready! Steady! Go!*, and we got to be friends with a woman who worked there, Vicki Wickham. Now, at first Vicki and her friends were trying to figure out if I was lesbian. I think a lot of people have wondered about that over the years. In the early days, I used to look at other women a lot, always checking them out, trying to learn all I could about beauty and clothes and carriage. Because I used to hate myself back then, the way I looked in all those ugly publicity photos Ike and I took. So I'd look to other women to see how they were dressing and how they used makeup, to see what I could learn. I don't know if Vicki and her friends noticed this, but they did see that my relationship with Ike

was not overtly affectionate, and I guess they always saw me hanging out with the Ikettes, and so they thought maybe I was gay. Well, we talked about it, and we talked some more. And in those days, any friends I had would become my psychiatrists—I just blurted everything out. And so eventually Vicki found out how unhappy I was.

Not that it was that hard to figure out. We had a fight in London one night, a bad one—Ike really kept me down and gave me a good whammin'—and the next day I was all swollen. That's when Vicki started feeling sorry for me. She said she had this great lady that was a reader—read cards. Well, I hadn't gone to one of them since I was a little girl at the fairgrounds. But I went. Had to sneak, of course—told Ike I was going shopping. And Vicki took me to this woman. I forget her name, but I'll never forget what she told me. She said, "You will be among the biggest of stars . . . and your partner will fall away like a leaf from a tree." She also saw something about the number six.

Well: "among the biggest of stars"—I liked that! I felt kind of bad about the other part: like, "Oh, poor Ike," you know? Felt a little guilty. But that's how I was then. Sometimes Ike would beat me, and he'd get so crazy that afterwards, I'd feel *sorry* for him—can you imagine? I was *all* mixed up. But I held on to what that reader said. She had seen a six, so I held on for six months, and then I held on for six years, and after that I just kept holding on— seeing other readers every place we played, knowing my time would come, knowing that someday I'd be free of this life I was leading. Through it all I held on to what that lady in London told me: "You will be among the biggest of stars." And Ike would fall away,

When the tour with the Rolling Stones was over, we flew to France and Germany to do some press and TV appearances. That trip changed my whole life. I felt like I had come home—like I had never known my *real* home until I came to Europe. I loved France—loved the ambi-

ence of it, and how stylish the women were there, and the French accent. It was the first time I'd ever heard my name pronounced beautifully—this name I had hated up until then. With Ike it was always *Tee-nuh*. Real . . . kind of crude. But the French people said *Tee-nah*. It sounded pretty, and after that I started to like it. *Tee-nah*.

I couldn't speak a word of French, of course, and neither could Ike. But where he couldn't communicate with anybody, I could. I could get through to people somehow. And that was when I started thinking that maybe I had been there before—that maybe this *was* my real home. Now, don't misunderstand me: I'm black. I mean, nobody's hair is nappier than mine, you know? But I think being of mixed blood, and also being influenced by the white families I'd worked for back in Tennessee, helped me communicate with the French. So on that first trip to France, that's when I began to feel, deep down inside, that maybe I was French, too. Or had been—I didn't know about reincarnation then. And I got to thinking that maybe I was such a mixture of things that it was beyond black or white, beyond just cultures—that I was universal!

I had never had these feelings before, but they were real, and they felt right. Naturally, I didn't tell Ike about any of this—that kind of talk scared him, I think. He did let me go shopping in Europe, and on my own, too. This was a new experience, and I started taking full advantage of it. You could get high from shopping over there, there were so many beautiful things that you'd never seen before. And from then on, shopping became my "thing." Ike liked to display his women—liked to have them walk across a room so all the other men could see how fine they looked. So he would give me money and I would go out and spend it. Alone, or maybe with a girlfriend. But without Ike—that was the main thing. Shopping became my only escape from Ike and his awful world.

9.

Rock Bottom

Nineteen sixty-seven was the year of psychedelia: the Beatles, the Stones, the Strawberry Alarm Clock—all topped the U.S. pop charts with lysergically tinged singles. Even the Supremes had a number-one hit, with a trendily titled song called "The Happening." But for Ike and Tina Turner, 1967 was another year without a pop hit of any kind.

The Revue kept touring, though, and the money kept pouring in. Nothing changed—except Tina's status with the press. In the wake of "River Deep," she was coming to be seen, at least among the musically astute, as the indispensable half of the Ike-and-Tina partnership. This did not make Ike happy, exactly; but he was a background man by his own admission, and if Tina's head was liable to be turned by this sudden attention—well, Ike impressed upon her the importance of thinking twice before making any rash moves. For his part, he carried on as usual with his women and his party rooms, unaware that he was slowly reaching the limits of Tina's tolerance.

Tina: I had always told Ike that the only thing I asked was that he not bring his women into my home.

Well, he'd already broken that rule with Gloria Garcia;
and since then he'd brought Ann Cain pretty close, setting
her up in a separate room there at the house. Then, one
day, he sent me to the market for some reason—some
strange reason, it seemed to me. My intuition has always
been strong, and I just knew something was up. So I went,
and I got whatever it was he wanted real fast. Then I came
back *very quietly*. I slipped back into the house and walked
into our bedroom—and there they were, Ike and Ann.
Aaah! They weren't even in bed. It was porno time! I
mean, Ike was really shocked. I don't think he had ever
been caught in that position. I didn't say a word. I just
went, "Tsk," and went off and hid in some other part of
the house. Ike thought I had run outside somewhere, so he
put his clothes on and went out looking for me. After he
came back, and I came out into the living room, I told him
that Ann could no longer stay there in the house. I guess
he realized he really had better get her out of there,
because then she got her own apartment the next hill over
from us.

By this time I had really had it with Ann. One day I
came back to the house and she was there again, acting as
if nothing was wrong. Well, I really do have a temper, and
I got a hammer and I was gonna *kill* that son of a gun! The
only thing that stopped me was the house shoes I was
wearing and the slippery damn floor: I grabbed that girl
and I was reaching for the hammer, but I kept slipping and
sliding all over the place. Then Ike came back and broke it
up.

After that, it got to really be a pattern with him and the
women. Ike had no shame. And women liked him, you
know; because he was a generous man with presents and
gifts, and he would buy them things, pay their rent, even.
So he was always fooling around. Sometimes we'd all be
backstage and I'd glance up into a mirror and see him
standing with one of the musicians' wives, saying like, "I
wanna get laid." After a while I learned that when the

wives would come to visit the musicians on the road, and then they'd leave and the guys thought they had gone back home—Ike would actually have these women stuck in a hotel room somewhere, waiting for him. Imagine—his own musicians' wives! Then I started seeing that kind of thing with my own eyes, not just hearing about it. It was so awful, the life I was living. At first I had thought, "Well, Ike is my husband, and we have our children, and I'll make our life good, and happy." And now here I was trapped in this sadistic little *cult*, totally ashamed and totally without hope, it seemed. Finally, I caught Ike and Ann Thomas in the living room one day; I just gave up. I knew it would never end. I was so miserable by then, so tired of it all—so totally unhappy.

I actually had tried to leave Ike once, a few years earlier. There had been this wig I wanted, and Ike wouldn't buy it for me. But he had gone and bought something for one of the Ikettes, and I was hurt, so I went and bought the wig myself. Just doing that wasn't easy, because Ike would never let me have money. He would *spend* money on me—when he felt like it but I could never *have* money. I mean, once I had asked him for five dollars a week, just as an allowance—*five dollars*—and he had said no. So I had gotten real good at sneaking money out of this huge wad of cash he always carried around in his pocket to flash in front of people—I'd just slip a few bills out of the middle of the roll, and he wouldn't even notice, right? So I got the money that way, and I went out and just bought that wig I wanted. I didn't really think he'd mind. But he beat me up for it—and that was the first time I left him. I borrowed some money from the Ikettes, and from my sister, and I got on a bus to St. Louis, to go back to my mother. Well, Ike tracked down the bus, found out the connections—I should've known he'd be capable of doing something like that. I was asleep in my seat, and I heard this noise—somebody tapping on the window. I sat up and—*aaah!*—there he was. I had to get off the bus and go back with

him. And boy, I remember that was the first time I got it with the wire hangers. He said I was trying to ruin his life, that I was just like everybody else, all the other guys that had left him. And when we got back to our room, he beat me with this wire hanger all twisted up—that was the beginning of those. It was like a horror movie. That's what my life had become: a horror movie, with no intermissions.

Well, maybe one. Almost. At one point there, our band left us—the whole band just walked out. Because Ike couldn't get along with *anybody* by then. I was the only one who stuck by him, and he didn't even realize that. Anyway, we had to get a whole new band, and these guys that he found were different from the musicians Ike usually had. Usually, he surrounded himself with real street people— good players, always, but yes men, into the same low life that he was. But these new guys were different, a higher class of people—educated black men, musicians who could *read music*. I mean, this was something new. So while Ike was hiring these guys, he was having them come to the house to audition. And one day I went to answer the door and there was this *real good-looking man*. But not *just* good-looking, something else, too. And my heart started beating just the way it had with Harry Taylor in the old days. I liked everything about this guy: the way he walked, his hands, his feet, his taste in clothing! I saw every inch of him in a second, and my palms became very wet. I said, "Oh, come in."

His name was Johnny Williams, and he played baritone sax. The three of us sat down around a table and talked. Johnny read books, did yoga, was very health-conscious. And he was a gentleman. I think Ike must have known, right there, sitting at that table, that there was something that clicked between Johnny and me. He was just exactly my type: well mannered, light-skinned—just like Harry Taylor and his friends, those boys back in Brownsville. Well, Johnny took the job, and suddenly I had something

to look forward to every night—somebody traveling with us that I really liked.

Nothing ever happened between Johnny and me, but pretty soon it got to be known how I felt about him. We would always hear him warming up with his horn—going *ba-duh-duhhh*—and pretty soon the girls started calling me "Duh-Duh." I even told Ike one day—I must've really been feeling my Cheerios—I said, "God, I really like the baritone player." I didn't think Ike would care that much, and at first he didn't. But after a while he realized that I really *did* like the guy; and then he began starting fights with me about it. More beatings. I didn't care. It almost seemed as if Johnny had been *sent* to me; as if God was giving me something to live for. He was always very respectful—"Good *morning*, Tina, how are you today?" Very polite, nothing physical. But it was Johnny who started giving me back some of my self-confidence. He'd always be saying things like, "Tina, you look *very* beautiful today." And if somebody made a remark—about "Tina's legs," or something like that—Johnny would be right there: "Tina's legs? I've never *seen* legs like Tina's." That was his way of complimenting me. He was really for real.

I was very much in love with Johnny, but I was never one to fool around, so we didn't get together. One time, though, I got to be alone with him for a few minutes, and God, it was so exciting. We were on the road and Ike was out somewhere, so I decided to sneak into Johnny's room. I walked in and I went right into his arms. It was the first and last time we ever touched. I felt like I was in a dream of happiness. We just sat there and giggled and looked at each other and laughed. I couldn't stay, of course. I was so afraid Ike might return that I ran back to my room. But that one embrace with Johnny lasted me for years.

Of course, he wasn't around for long—a guy like that wouldn't stay with Ike Turner. On night, Ike and I had this big fight—he had brought up Johnny and 1966 (when I'd

recorded "River Deep" without him) again. And when I arrived at work my face was puffed up out to *here:* The lip was cut, the eye was swollen almost shut—the usual. And I'll never forget: Johnny literally cried, right there in front of Ike. And he set his horn down and he walked off the stage.

He gave his notice after that. He said, "I will not work for anyone like this." What could Ike say? He *should* have felt like the scum of the earth, but you can bet that he didn't.

Things were getting bad around then, too, because the drug thing had started. The first time I remember seeing Ike do cocaine was in San Francisco. He was doing it on a hundred-dollar bill—that was supposed to be the classy thing, right? I didn't know. I thought to myself, "I wonder why they're doing it on money?" I think he had been taking cocaine for a while, quietly, but then he started getting bold about it. Pretty soon he had the little containers of it around, and then people started giving him these little boxes . . . after a while it became like just a pack of cigarettes in his pocket. Cocaine—that's one thing I never tried. I've never been able to put anything up my nose. I can't swim because the water gets up there and hurts my sinuses, and I was afraid if I put some powder up my nose, I wouldn't be able to breathe, you know?

Ike didn't have that problem. Cocaine made him . . . well, he was always violent, but cocaine made him worse. Everything came quicker—getting mad, the fighting, the impatience with whatever business problems there were. It got so you were scared to say a word to him, never knowing how he'd react. If I thought he was bad before, the cocaine started making him evil.

Tina's depression deepened as 1967 gave way to 1968. In the spring, the Revue flew to England for another tour, and it was there that Tina received what she felt was the

ultimate humiliation. Its source, at least indirectly, was Ann Thomas, still a nonsinging Ikette, and more than ever the object of Ike's most heated attentions.

Ann Cain: I was also along on the tour. Tina and Ann Thomas were like twins. When we got to London, they both found out they were pregnant—and both by Ike, of course. So Tina said to Ann, "I'm not having another one for him—forget that, honey. If you want it, *you* have it." And Tina terminated that pregnancy.

Tina: When I found out that Ann was pregnant by Ike, I lost all feeling for him as my husband. That was *it*. I really wished that Ike would just marry her, and then we could become like brother and sister again—just be strictly business. But he had to have both—the wife over here, the mistress over there. When we were on the road, he would always have her in a room right next to ours. He didn't bother trying to hide it anymore. One time, he got out of our bed, walked through the doors connecting the two rooms—didn't even bother to close them—and got in bed with her, had sex, and then came back to bed with me.

What made it even harder was that Ann and I were the closest of friends, always sitting up talking and laughing. All we had was each other. She had been just a young girl, a fan at first, who shouldn't have gotten involved with this guy. But now it was too late, and she was in the same position as me. When we traveled . . . well, Ike hated to fly, and he'd never fly first class—cost too much money. So we had to fly economy, the three of us. He'd book three seats together, and I'd sit on one side, Ann would sit on the other, and Ike would be in the middle. Then, once we got off the ground, he'd stretch out and go to sleep—with his head in Ann's lap and his feet on me. And that's how we had to sit there.

She got her licks, too, Ann Thomas did. Nobody that was involved with Ike ever had an easy life, believe me.

And just like me in the early days, Ann was afraid to say anything. *Me*, on the other hand, I was getting to the point where I was ready to start talking back—because I was just tired of being scared, tired of being hit and tortured, tired of everything. We were touring all over Europe by then, and I remember one time, in Switzerland, we were driving along in this car—me and Ann in the backseat, with Ike in the middle, naturally, asleep—when this great red Ferrari came up alongside, passing us. And the guy driving it looked over and saw Ann, and instead of continuing to pass, he just kind of stayed on the side there, staring at her—love at first sight, I guess. Well, the hotel we were going to be staying at was only a little ways up ahead. When we got there, we found that this guy in the red Ferrari had checked at the desk to see what entertainers might be registered and discovered it was Ike and Tina Turner. And it turned out that he had left this message for the girl he'd seen "riding with Ike and Tina."

Well, *Ike* got the message. Us, we didn't think anything about it. Some of the girls started joking about this guy that was looking for Ann, but we all knew she was too smart to ever even *think* about looking at another man. Later that night, though, when I was asleep in my room, this awful noise woke me up. I heard all this screaming, and this "*Ow! Ow!*" I didn't know what was going on. I knocked on Ann's door to ask her, but she wasn't in her room. So I listened some more—it was really scary, that screaming; you could hear it everywhere. And then I realized it was Ann—and I got mad. She hadn't done anything; why was she getting beaten? So I opened my door, and I saw another one of the girls standing there in the hall. She went, "*Shhh!*" Then she explained what had happened. Apparently, this guy in the red Ferrari had showed up at Ike's party room looking for Ann. So Ike went and got her: He threatened to take her up and make her strip naked in front of the guy. Then he dragged her out of the room, half naked, and he had her on the steps in

the exit stairwell and he was beating her up. Well, I went and opened that stairwell door, and there he stood, and there was Ann, all beat up and crying and embarrassed. And I just looked at her, then I looked at him, and I said, "Ike, you should be ashamed." And right then I think he did feel ashamed, because he realized everybody could hear what he was doing to her. *Embarrassed* was more the word, actually. With Ike, shame didn't often enter into things.

Ann Cain bailed out of Ike's orbit shortly after it was discovered that Ann Thomas was going to have his baby. Cain, at least, had finally had enough.

Ann Cain: In all the years I had been with them, Ike Turner had never beat on me. Because I'm the kind of person that'll have you put in *jail* if you beat on me, and Ike knew that. But then there was this one tour we did, down through the South, and that's when I realized that Ike wasn't screwed together too tight anymore. We were in Atlanta, at this restaurant in the hotel we were staying at, and he said something I didn't like. Ike would always pick at people, trying to start a fight. So I said something back and I got up and left, went up to my room. I knew I had really teed him off, and that he was gonna come after me, so I just left the door open. Sure enough, here he comes. And he's going, "Now what's that you say? You think you smart, bitch, huh?" He had this acoustic guitar with him, and he got me cornered in the bathroom and started swinging it at me, hitting me with it. I had my arms up, trying to protect my head, and he finally broke the back of the guitar on my elbow. Then he *really* got mad. It was like, "You done fucked up my guitar," you know? And I thought to myself: "This man is changing. This man is *crazy*."

We had to leave Atlanta that night to drive to another

show. I was real dark under one of my eyes, and Tina looked at me and said, "Ike hit you, didn't he?" I said, "Yes, how did you know?" She didn't answer. She said, "You should go to a doctor. You might have a concussion."

Tina was always concerned about other people, you know?

Ann Cain was supplanted by Rhonda Graam as business manager. Tina was twenty-eight years old now, going on twenty-nine, and there seemed no way out of the endless cycle of overwork and abuse in which she found herself trapped. The touring never stopped. The rehearsals—after shows, in the car, at the Olympiad Drive house, where Ike had set up a little demo-taping unit in the living room—were incessant. And in what free time she had, Tina was becoming a familiar battered face at local hospitals. Nathan Schulsinger, an emergency-room nurse at nearby Daniel Freeman Hospital in Inglewood, remembers Tina well from those days.

Nathan Schulsinger: She would come in in pretty bad shape, all beat up and bruised, face swollen, bloody noses, hematoma on the eyes, all puffed out and black. One time she was brought in by limo, by a chauffeur. I would just clean her wounds and wait for the doctor to examine her. She would never be admitted—except this one time when I took care of her on an overdose. With an overdose, you have to be admitted.

Tina: Yes it finally got to the point where I was ready to die. Ike was beating me with phones, with shoes, with the hangers. Choking me, punching me—it wasn't just slapping anymore. One time, right before a show, he punched me in the face and broke my jaw—and I had to go on and sing anyway, with the blood just gushing in my mouth. I felt like I could not take any more.

So I planned what I was going to do. I went to my family doctor and I told him I wasn't sleeping, that I needed some pills—strong ones. Well, the doctor knew I could use some tranquilizers to calm down. I had already gone to him to find out about cocaine—what it did, and what it was doing to Ike. So he gave me a bottle of the strongest Valiums there were. Fifty of them.

That night, we had a show to do in L.A., at a new black club called the Apartment, on Crenshaw Boulevard. We had just gotten back from another trip to Europe a little while before, and the girls were flying around with their new minidresses—those were in then—and their wigs were looking really good: the same old illusion, right? And I was packing my things to leave for the club, and I'm looking around and thinking: "Goodbye, damn it—I'm leaving you guys with it all." And I went in the bathroom and got a big glass of water and I took out my little bottle of Valiums and I took all fifty of them. Then we left for the date.

Rhonda Graam: I was out on the door, clocking the crowd, and somebody came out from the dressing room and said, "You better come see Tina, she's not right." Ike wasn't there yet, so I went back. Tina was there putting eyeliner on, and running it all the way down her cheekbone. I said, "Duh-Duh, what did you do?" I couldn't really get an answer from her—it was like, "*I took shum shleepin' pillzhhh,*" you know? She thought if she could just make it onstage, and collapse there, Ike would still get his money for the show—that was how considerate she was; I couldn't believe it. Then Ike came in, and he got mad. He tried to get her to throw up; then he said, "Get the car, we're takin' her to the hospital." So we got her in the Cadillac, and I drove. I was going through stoplights and signs and everything, flyin'. I mean, Tina was *dying* in the backseat. And Ike was slapping her on the face, trying to keep her awake, sticking his finger

down her throat. We got to the hospital—it was right at the bottom of La Brea—and they said, ''We can't take emergency cases.'' I said, ''Whatta you mean? This woman is dying and you can't take emergencies?'' They said, ''Sorry. Take her to Daniel Freeman.'' Well, Daniel Freeman Hospital was way out by the Forum, toward the airport—fifteen, twenty minutes away. But what could we do? We got Tina back in the car and tore off for Inglewood. I wasn't seeing any traffic—if a cop would've come up behind us, he would've had to chase me, because I wasn't stopping.

So we got her to Daniel Freeman, got her into the emergency room, and they pumped her stomach. Ike went out to talk to the doctor and he says, ''You stay in here with her.'' It was the eeriest feeling. The room was enormous and there was nobody else in there but me and Tina, lying on a gurney. No nurses, nobody. And I was trying to bring her around, but she kept saying, ''I just wanna die, I just wanna die. . . .''

Tina: When I had arrived at the club, the pills were already starting to take effect. Now, what I had wanted to do was to get dressed and get onstage and *then* pass out. Because I knew there was some clause in the contract that if the group didn't go onstage, Ike didn't get his money; but if we went on and then I got sick, the club still had to pay him. You can see that Ike had really instilled this thing in my head about ever costing him money, right? So all I wanted to do was get on that stage—but I didn't make it. Because when I got into the dressing room, I was already acting strange; and the girls knew something was wrong, because they knew I didn't drink or smoke or anything. And they said, ''What's with you, Tina?'' I didn't say anything. I started putting on my makeup, and what a mess—I had the eyebrows crawling all the way up my forehead, great big long lines. One of the girls looked at me and she went, ''Uh-oh.''

By the time Ike arrived, I couldn't even stand up. He

was *mad*. He said, "What'd you do this for?" I didn't say anything. Couldn't, by then.

Well, they got me to the hospital, and they pumped my stomach out—but then they couldn't get any pulse on me. Nothing. The doctor thought I was gone. He went out and told Ike, and Ike said—my doctor told me this later—Ike said, "Let me talk to her." And he comes in and he starts talking, and the doctor told him to keep it up and then they started getting a pulse. Later we joked that Ike must have said, "You motherfucker, you better not die, I'll kill you." That's how insanely afraid of that man I was.

So, I finally started coming around a little. I don't know how long it took. When I came to, the first thing I realized was that I was without my hair—the only thing on my head was my *real* hair, which I kept in little braids to clip the wigs onto. I thought, "Oh, no." Then I opened my eyes a little, and the first thing I saw was these white hospital curtains. I thought, "Oh, maybe I'm in heaven. In heaven without my hair." Then, the second thing I saw, I looked over and there was Ike. And I thought, "Well, this sure ain't heaven, then." I saw his face and I said, "Oh, no"—right out loud—and I just turned and looked the other way. But boy, he had some words for me: "You motherfucker, you tryin' to ruin my life. . . ." I couldn't believe I was still here on earth, still having to hear this stuff.

As soon as I got out of the hospital, Ike made me go right back to work. My stomach still wasn't right, but he didn't care. He forced me. I went onstage trying to sing, and hurting so bad, and when I came off I was coughing and throwing up. I didn't even make it back to the dressing room; I was standing in the hallway, all sick and choking, and Ike came up and he said, "It serves you right. You wanna die? Then *die*!" I think that's when even his girlfriends—the secretaries, the various Ikettes, all those women that were so crazy about him—even *they* started

wondering just what kind of guy this was that they were involved with.

And that's when I started to hate Ike Turner. At first I had just liked him—liked him as a friend: I was a young girl straight out of high school and he was the person who was bringing me along in the business, helping me to realize my dreams. Then that became love—or what was supposed to be love, for all I knew about love in those days. Then, with the women, and the beatings, I had started losing that love for Ike. And now, after the pills and the hospital, I was starting to *hate* him.

10.

"Loving You Too Long"

Nineteen-sixty-nine was a watershed year for the Revue, and for Tina herself too. They'd finally begun to get class gigs in Las Vegas the year before—opening in the lounge at the International Hotel, where headliner Elvis Presley, fresh from an electrifying, back-to-his-roots TV special, was consolidating his comeback in the main room. Vegas! The Strip! Ike loved it—loved living the lush life in one of the garish high rollers' suites up on the thirty-third floor; loved raking in small fortunes (and as often as not, losing them again) at the craps tables; loved hobnobbing with Vegas nobility. Sammy Davis, Jr.!

Tina thought Vegas was okay—it was certainly classier than most of the small-time dives she'd played through previous eras. And the people were nice. Ann-Margret, for instance—there was a hardworking woman after Tina's own heart. And, yeah, Sammy Davis was great too.

Tina was becoming interested in hit records as well. Her life with Ike was as tormented as ever, but by now she'd given up expecting any improvement. At this point, their relationship was strictly business. Still, business—in terms of record sales, at least—hadn't been all that good.

Enter—once again—Bob Krasnow. Since the Turners' stunt with him in the mid-sixties, Krasnow had gone on to become a producer with Buddah Records, and now was ready to start a new enterprise of his own. In need of acts to record, Krasnow once again approached his old pal Ike Turner.

Bob Krasnow: I had this great idea of recording Tina on "I've Been Loving You Too Long," the Otis Redding song. Ike says, "I don't wanna record that." I said, "Hey, you've gotta—Otis Redding's the greatest songwriter around today." Ike says, "He's not that great." I said, "Hey, believe me, he's *that great.*"

Krasnow's point was eloquently proved when Ike and Tina Turner's rendition of "I've Been Loving You Too Long" became their most substantial pop hit in years, rising to number sixty-eight on the charts in May 1969. The single was featured on an accompanying album, *Outta Season,* which collected powerful readings of blues and R & B standards by Lowell Fulson, Jimmy Reed, Elmore James, Little Walter, and B.B. King, and featured cover photos of Ike and Tina in whiteface makeup, chomping down on slices of watermelon. This startling conceit was not found to be particularly amusing by many black observers. Says Krasnow, whose idea it was: "It was a parody. All the white guys were doing blues records then, so I thought, 'Hey, the only way a black act can do the blues now would be to put 'em in whiteface,' you know? We had plenty of problems with that cover. I mean, I had people threatening my life."

Aside from its musical virtues, *Outta Season* included an intriguing production credit on the inside jacket. There, beneath a full-length photo of Tina—defining the term *hot* in a chic black miniskirt—was the small-print note: "Produced by Tina Turner and Bob Krasnow." She was also—as

label-gazers were quick to note—the composer of the last track on the album's first side, a brooding guitar blues called "I Am a Motherless Child." Clearly, Tina Turner was making some kind of move.

The Turners followed *Outta Season* with another successful LP for Krasnow, *The Hunter*, which yielded two more Top 100 hit singles in the title track and "Bold Soul Sister." As they entered their second decade together, things were definitely happening for the duo. But for Tina, the music she was recording with Ike still seemed too tied to R & B, to the old ways and the old world that she longed to grow out of. She began paying attention to the pop charts—something she'd never done before—and she started getting excited by what she heard. In August 1969, the Rolling Stones, her old tour buddies, went to number one with the walloping "Honky Tonk Women." In the fall, there appeared an extraordinary Beatles single, "Come Together" which also topped the charts. Tina became very interested in all this new rock 'n' roll music.

Tina: I had never really had time to *listen* to music before, because I was always working—in the studio, on the road, nonstop. Ike had almost made me *hate* music, because that's all there was with him: "Let's go buy records," "Let's jam," "Let's write a song." Always music, music, music, and nothing else. Well, we were in Seattle one day, and he took me into this record shop, and that's where I first heard "Come Together." I said, "Oh, what's that?" The guy in the store said it was the Beatles. I truly don't think I had ever really heard them before. But I loved that song. I said to Ike, "Please, *please* let me do that song onstage." I was begging him. Then I heard "Honky Tonk Women," and I just had to do that, too. Well, we had always done covers anyway, so Ike said all right. Then there was "Proud Mary." In the beginning Ike hated the Creedence Clearwater Revival song, but then he heard the version by the Checkmates and took notice. We

started working on it in the backseat of the car, and continued to work on it for quite some time before we started to play it onstage.

That was the beginning of me liking rock music. It wasn't like we planned it—"Now we're gonna start doing white rock 'n' roll songs." But those groups were *interpreting* black music to begin with. They touched on R and B, in a way, but it wasn't obvious. I mean, it wasn't the old thing. It was "Honky Tonk Women"—wow! I could relate to that.

The Revue soon got a chance to try out their new black-rock material on an ideal crowd. In September, it was announced that the Rolling Stones, with new guitarist Mick Taylor replacing the recently deceased Brian Jones, would mount a thirteen-city, eighteen-show tour of the United States in November. The excursion would be filmed for subsequent theatrical release. On the bill, along with the reigning bad boys of English rock, would be British guitarist Terry Reid and, as usual, two of the Stones' favorite acts: B.B. King and Ike and Tina Turner.

The Stones tour, staged in part to promote their new LP, *Let It Bleed,* drew scattered criticism for setting a new high in top-ticket prices: $12.50. The fans, however, weren't complaining. The kickoff show, at the Los Angeles Forum on November 8, was a riotous success. The next night's date, at the Oakland Coliseum, drew similarly enthusiastic responses. Ralph Gleason, the esteemed jazz and pop critic of the *San Francisco Chronicle* and co-founder of the new *Rolling Stone* magazine, wrote that the Oakland extravaganza "may very well have been the best rock show ever presented." He did not attribute this success solely to the Stones and certainly not to Terry Reid, whom he slagged as a bore. After praising B.B. King—who, among other things, performed a twenty-year-old Louis Jordan tune—Gleason wrote:

After B.B. King's set came World War III. Or rather Ike and Tina Turner. In the context of today's show business, Tina Turner must be the most sensational female performer on stage. . . . She comes on like a hurricane. . . . She dances and twists and shakes and sings and the impact is instant and total. . . . She did blues, of course, but the number that really wiped out the house was her version of "Come Together," the John Lennon song from the Abbey Road album. It was a most surprising and effective performance. Absolutely right. . . . Jagger ought to get a medal for courage in following B.B. King and Tina Turner.

In passing, Gleason also noted of Tina's performance that "the climax to her act was the most blatantly sexual number I have ever seen at a concert. Tina Turner caressed the microphone as if it were a high-tension erogenous area, all the while squirming and twisting and emitting a series of vocal sounds that came closer to simulating a sexual climax than any record ever barred from any radio station."

This, of course, was the stupefyingly raunchy rendition of "I've Been Loving You Too Long," Ike and Tina's hit of the previous spring. Later immortalized in *Gimme Shelter*, the film of their tour with the Stones, it was a number that would plague Tina for years to come.

Tina: When we started doing "I've Been Loving You Too Long" onstage, it was Jimmy Thomas who sang it. And he started that thing with the *"Oh, baby, oh, ah . . ."* Then when Jimmy left, I started singing the song, because it was a very good show song, and I started mimicking Jimmy, but putting my own female thing into it. I was really involved with that song in the beginning. Then I became bored with it, but Ike wouldn't let me stop. He started making those noises in the background, and it

became really pornographic. Embarrassing. But the people loved it.

The Rolling Stones tour wound up at the West Palm Beach Pop Festival on November 30. The Ike and Tina Turner Revue returned to its regular routine—fortuitously missing a free concert mounted by the Stones at the Altamont Speedway outside of San Francisco on December 6, at which four people died (one of knife wounds); an era of peace and love, formally proclaimed only three months earlier at the Woodstock festival, was decreed by pundits to have passed.

As a new decade dawned, the Revue was still abuzz from the Stones tour, which had exposed the Turners to a massive white rock audience. "Bold Soul Sister" peaked at number fifty-nine on the pop charts in January 1970, heralding the start of an upwardly mobile recording year. Ike signed with Minit Records, an R & B label owned by the larger Liberty/United Artists combine, which thus acquired the Turners for the duration of their career. In April, Tina's intense reading of "Come Together," backed with an incendiary version of the Stones' "Honky Tonk Women," hit number fifty-seven. The album of the same name stayed on the charts for nineteen weeks, a good run, but never made the Top 100. More successful was a wild rendition of Sly and the Family Stone's Woodstock hit, "I Want to Take You Higher," which climbed to number thirty-four on the singles chart in August. Happy days. Ike found himself afloat in an ocean of money—from the highly lucrative Liberty/UA recording deal; from the constant touring, which yielded post-show briefcases packed with cash. In the midst of this upward swing in the Turners' fortunes, however, Tina's constitution, previously indomitable, suddenly fell apart.

* * *

Tina: I got a cold, and it turned into bronchitis. My doctor said, "Stop working." Ike said forget it. So I kept working, and it turned into pneumonia. Then I was onstage one night, with really bad fever, and I looked out at the audience and it seemed as if nobody had faces—it was just a sea of heads. I thought, "God, I'm really sick." But I had to keep going onstage with that fever for two weeks. I took aspirin every night before the show as I also had awful headaches, and I think that must have burned a lot of things out inside of me. One night I woke up and I said to Ike, "I have to go to the hospital." He didn't want to know about that, because he knew it meant he'd have to cancel dates. But he also probably knew that I was going to die if I didn't go and get treatment. So I went to the hospital. Had to drive myself, of course, in a limousine. I'd never driven a limousine before, but I thought, "Well, I'm not going to let this man kill me."

The hospital admitted me, but I got worse and worse. Every night they had to pack me in ice to try to keep the fever down. Finally, I had them call my family doctor, and he came and examined me, and he said it wasn't pneumonia anymore—it was tuberculosis. He did biopsies and he gave me a spinal tap—God, that hurt. And he found glandular infection, lumps in my legs. My right lung had collapsed. I was half dead. And I had been traveling with all this.

One day, when I was still really sick, I woke up in my hospital bed, and my room was full of flowers. But one arrangement in particular stood out and the card on it said, "From Mick Jagger and the Rolling Stones." That was the happiest moment for me. I began to think about who I was, and to *feel* like who I was. Then there were all kinds of flowers coming in, from friends, from fans. And I began to think about the fact that people really cared, you know?

No flowers from Ike, of course. Are you kidding?

Years later I still had bad repercussions from that ill-

ness. Every hotel I stayed at, I'd have to see a local doctor for medication. I just thought I had low resistance to colds, but what I didn't realize was that I'd never really been cured of the tuberculosis; I still had it. Finally, on a trip to London, my friend Judy Cheeks suggested that I see her homeopathic doctor, Dr. Chandra Sharma.

He told me that the medications had held the disease in the body rather than getting rid of it. I went into his hospital for three days on a strict diet. He told me it would take three years of special diet and his homeopathic remedies before I would be completely well.

It wasn't until around 1980 that I felt I had properly overcome the illness, eight years after contracting it. Dr. Sharma became a wonderful friend, although it was sometimes difficult living in L.A. with my local doctor in London. Dr. Sharma passed on in 1986, and I miss him more than I can say. Fortunately, his son, Rajandra, was his protégé and is carrying on his work.

Tina returned home from the hospital after a few weeks to find that Ike, in her absence, had had the Olympiad Drive house completely remodeled. She nearly had a relapse. The place looked like a bordello in hell, a Las Vegas nightmare of deep-pile red carpeting, flocked walls, and some of the most bizarre decorative appointments she had ever seen: a custom-made blue velvet couch with arms that turned into tentacles, a coffee table in the shape of a bass guitar, a waterfall in the family room. Televisions were now housed in cabinets carved to resemble giant snail shells, and there was a mirror on the ceiling in the master bedroom. In fact, there were mirrors everywhere, and lots of stained glass, red and gold velvet, eggshell-white wood, plastic plants, burbling aquariums—all of it screaming splendor.

Ike had already shown off his expensively bought handiwork to his old pal Bob Krasnow, and Krasnow had been

impressed. "You mean you actually can spend seventy thousand dollars at Woolworth's?" he said. Tina's reaction was more visceral.

Tina: Ike had some interior decorator that was helping him, and I guess all this stuff reflected his taste, too. The colors surrounded you. One room was all blue. The kitchen was green. He thought I'd be happy, because, yeah, I did like green. But not necessarily in my kitchen. In that way, everything had been done first class, custom-made at the house—I mean, it cost a fortune. But it was poor taste. I got home from the hospital and took one look at it and I said, "God." That's all. Ike was so upset, but he couldn't fight with me, because I was still very sick. So he just left—the only time *that* ever happened, let me tell you. I never said anything else about it after that. I just lived there. I was just the maid, essentially.

Tina's post-tubercular weakness lingered, but she was soon back on the road again, buoyed by antibiotics, playing Vegas one night, a smoke-filled provincial dive the next, the gigs still inevitably spaced several hundred miles apart, with—whenever Ike could arrange it—a quickie show squeezed in "on the fly" between one scheduled appearance and the next. The pace was brutal. Vegas was best: The Turners' annual stays at the International and the Hilton allowed them to bring the kids along. Sometimes, when they were opening for Elvis Presley at the International, they'd take all four of them to the big room to catch the King's extravaganza, and Elvis would have the whole family stand for a round of applause. And when the Revue guested in an episode of a TV series, *The Name of the Game*, that was being filmed in Las Vegas and centered on Sammy Davis, Jr., Davis was lavishly appreciative.

* * *

Rhonda Graam: The episode just had some stage shots of Ike and Tina, but for doing it, Sammy wanted to buy Tina a Mercedes. I said, "Tina doesn't want a Mercedes. Tina is dying for a Jaguar." He said he didn't know if there were any around. I told him I'd already seen the one. It was in this dealer's showroom—a white XJ6, four-door. Sammy says okay, how much is it? I think it was six thousand dollars at the time.

Tina didn't know anything about this. So Sammy and I got the whole thing together, and he got the car and brought it to the hotel that night and parked it right outside the front door. Then, after the show, he told Tina to come out, he wanted to show her something. And she walked out the door and there it was—this gorgeous white 1970 Jag. Tina ran over and jumped right up on the hood, leaping up and down on it, she was so excited. Then she took some of us for a ride, and let each of us drive it around the parking lot. She was so happy.

Tina: That really was a high point, because after that, I could leave the hotel at night sometimes and go for a little drive. It was wonderful, just that little bit of freedom.

Ike enjoyed Las Vegas, too.

Ike: I'm lucky at the dice table, and in Vegas, I was *real* lucky. Man, I won four hundred seventy-some thousand dollars at the Hilton one night. Won a hundred twenty thousand another time, same place.

Rhonda Graam: It was a big deal to go to Vegas, step up to a totally different audience. But it was a killer. On weekends you'd have to play five shows a night—the last one started at like five o'clock in the morning. And we had to fight to keep from doing five shows during the week. We played the lounge with Wayne

Cochran, this white soul man who had about ninety horn players, he was just unbelievable.

Ike, of course, got one of the thirtieth-floor suites, the ones you can't rent—they're just for high rollers. Ike would play nothing but black chips—those're the hundred-dollar ones. And he was lucky sometimes: I'd walk out in the casino and his whole end of the table would be covered with those black chips. One time when he had just picked up this great new car, a Langusta di Tomaso, he left Tina and me in the coffee shop while he went to gamble. Said he'd be right back. We waited there for about an hour, no sign of Ike. Finally he comes in with a whole armload of chips and throws them all up in the air—it must have been like fifteen thousand dollars. He says, "Go pay off the di Tomaso!"

But then sometimes he wasn't so lucky. Sometimes I'd have to fly back to L.A. and hit the vault, get some more money. I remember the entertainment coordinator at the Hilton really liked Ike, and wanted him to stop gambling. He said, "I'll get you a piano, I'll put it in the suite, anything. Just stay out of the casino." He told Ike, "You're gonna end up like the others, playing to work off your debts." Ike never let it get that far out of control, though.

Perhaps the most valuable connection Tina made in Las Vegas was to Ann-Margret, the similarly hard-working singer.

Rhonda Graam: I got Tina to take me with her to see Ann-Margret's show at the Tropicana one night. We had to really run to make it, because Tina just finished her show as Ann-Margret's started. We only caught the last five minutes or so. Afterwards we went backstage, and Ann-Margret's husband, Roger Smith, was there. He said, "Oh, come in." He says, "Ann-Margret is one of your biggest fans." Well, this is news to Tina, right? So she's

there with a turban on her head, still wringing wet from being onstage, and then Ann-Margret comes out, and she's all wet and wearing a turban, too. Roger says, "You're not gonna believe this—Ann, get the records." And she went behind the bar in their living quarters there and she brought out every record Tina had ever made. And they didn't even know she was coming to see the show that night. Ann-Margret said that the first date she and Roger ever had, they had gone to see Ike and Tina Turner.

Passing through Florida toward the end of 1970, Ike took Tina into a studio to record the version of "Proud Mary" that they had been perfecting onstage for the past two years. It was a radical reworking of the original hit by Creedence Clearwater Revival. "We made that song our own," says Tina. "I loved the Creedence version, but I liked ours better after we got it down, with the talking and all. I thought it was more rock 'n' roll."

Released in January 1971, Ike and Tina's "Proud Mary" quickly became their biggest U.S. hit. By mid-March, it had reached number four on the pop chart—the highest-charting record they would ever have—and by May it had sold a million copies. (The record would ultimately win Tina her first Grammy Award, for Best R & B Vocal Performance.)

Ike was rolling in dough, so he decided to fulfill a long-delayed dream: to have his own recording studio. No more rehearsing in the living room of the Olympiad house. No more hurrying through sessions at hundred-dollar-an-hour commercial studios. Ike would have his own hit factory, and there allow, at last, his genius to unfurl. He bought a modest single-story building at 1310 La Brea Avenue, just a winding five-minute drive down the mountain from View Park Hills. Then he tore the place apart, soundproofed it, and began pouring money into state-of-the-art sound-recording equipment. Since the state of the

art changed constantly, these expenditures added up. (One control board cost ninety thousand dollars.) But Ike figured his investment would pay for itself. He had built two fully equipped studios inside the La Brea building: a small one, which Ike reserved for himself, and a larger room to rent out. While other acts paid him for the use of the big studio, Ike reasoned, he would be free to create with his musicians in the smaller one. In the back of the building, beyond an unbreachable security door, he created private-party quarters, an apartment–cum–sex-den decorated in a style similar to that recently inflicted upon the Olympiad house. (An imposing feature of this gaudy hideaway was a wall-long floor-to-ceiling mural depicting a black man and woman, both naked, clutched in a passionate embrace.) Here at last was a kingdom Ike could call his own—a place where he could write and record all day and all night too, and party afterward in his private retreat with any of the dozens of women who seemed always available to satisfy his satyric appetites. He dubbed the studio Bolic Sound—a designation that strongly recalled the name Bullock.

At Bolic, Ike was in total control. He installed an elaborate closed-circuit TV system to monitor every cranny, from the outside front door to the back bedroom. (A similar system was wired into the Olympiad house.) Ensconced in his control room, he could dial up the action in any quarter of his empire. Should trouble arise, he was prepared: There were several pistols on the premises, one right by the telephone, and a machine gun—a gift from some admirer—was stowed under a control board. The only thing lacking on site was Tina. But she was close by and could be summoned whenever her presence was required to overlay vocals onto the multitude of tracks Ike and his band were constantly at work on. These calls might come at any time of the day or night. Because now, along with being freed from constraints of time and money,

Ike felt freed as well from the need for rest, for sleep. Now there was cocaine. Lots of it.

Ike's introduction to cocaine had apparently taken place sometime in the late sixties. According to Ann Cain, it had been effected by Larry Williams, a New Orleans piano player who had scored several classic rock hits in the late fifties: "Short Fat Fannie," "Bony Moronie," "Dizzy, Miss Lizzy." It was a short streak, but the Beatles later covered "Dizzy, Miss Lizzie" and John Lennon did a solo version of "Bony Moronie," and the resultant songwriter's royalties kept Williams, now resident in L.A., afloat in grand style. It also allowed him to indulge heavily in drugs.

Ann Cain: Larry Williams was a millionaire, and he was a drug dealer. He kept his own yacht moored at Marina del Rey, which was where I knew him from, because I used to live down there and he dealt the drugs off this boat. Larry was a nice guy, but he was always with the drug set, always wheeling and dealing the cocaine. Larry knew Ike, and he told me that the one thing he most regretted was that he had been the one that turned Ike Turner on to drugs. He said Ike was a really nice man until he introduced him to coke.

Some years later, in January 1980, Williams was found dead with a bullet in his head in his Laurel Canyon home. Police ruled it a suicide; others weren't so sure.

An alternative version of Ike's initiation into the seductive pleasures of cocaine was offered by Bob Krasnow to *Rolling Stone* writer Ben Fong-Torres late in the summer of 1971.

"One night in Vegas," Krasnow said, "we were sitting around and got started talking about coke. He didn't care about it . . . and Ike, you know, is about forty or so . . . and I said, 'One thing that's great about coke is that you

can stay hard—you can screw for years behind that stuff.' That's the first time Ike did coke.

"That night he made his first deal—bought $3000 of cocaine from King Curtis, and he bought it and showed me, and I laughed and said, 'That's no coke, that's *Drano!*' Since then, he's learned."

Fong-Torres's cover story on Ike and Tina Turner appeared in the October 14 issue of *Rolling Stone* magazine. *Rolling Stone* was something new on the music scene at that time—a biweekly that dug beneath the glamour and the publicity handouts to report on the real world of the stars that it covered. The result was an extraordinary peek behind the newly groovy façade of husband-and-wife rockers Ike and Tina Turner.

The *Rolling Stone* feature was the first public suggestion of what Tina's life with Ike was really like. According to one associate quoted in the story. "Ike would storm into the office with a troop of people, six-foot chicks, a bag of cocaine. Really, really crazy. He'd carry around $25,000 in cash in his pocket—with a gun. He'd drive around town, man, sometimes to Watts, sometimes Laurel Canyon, in his new Rolls-Royce to pick up coke."

"In Las Vegas," Krasnow added, "I brought some friends into the dressing room, and Ike pulled out this big .45—just putting them on. Another time he came into the front room at Blue Thumb and threw $70,000 on the floor, in cash, and dared anyone to touch it. Just to blow everybody's mind."

A young woman named Melinda was quoted on the subject of "that dirty ol' Ike hounding me. I sat through the first half of the second show with him and he kept telling me he want to give me a fit and just 'cause he had Tina didn't mean he couldn't want me, too."

Said Ike, in response to this anecdote: "Melinda who?"

* * *

Ike was deeply steamed about the *Rolling Stone* story, but his anger was tempered by the Turners' burgeoning success. Nineteen-seventy-one was turning out to be a bonanza year. By July, another live Revue album, *What You See Is What You Get*, was perched at number twenty-five on the charts. The Turners were now turning up in films, too: most visibly in *Soul to Soul*, an all-black concert documentary that had been filmed March 6 and 7 in Ghana, on the fourteenth anniversary of that African nation's independence (Ike and Tina did the title track); more briefly in Milos Forman's *Taking Off*, in which they were seen whipping out a hot version of "Goodbye So Long," their 1965 R & B hit.

By this point in the Revue's evolution, a certain sartorial outrageousness had set in, with Ike disporting himself in enormous mink coats and handbags and skin-tight hot pants worn over black panty hose. It was a flamboyant act, propped up with mountains of cocaine, and Ike—along with the similarly hot-panted band members who emulated him—took it everywhere. One number of the entourage at this time—we'll call him Bill James, since he now desires anonymity—was amazed.

Bill James: I went back to L.A. with them and I stayed awake six days straight. I didn't know what was going on. I lived in the studio for a while. With the paranoia and the coke and just staying awake so long, you got to think that somebody was watching you all the time. And of course somebody *was*. There was a TV camera trained on every room, and while Ike was recording he'd click the dials and switch around from room to room to see what was happening. I was there once or twice when some of the band boys would get a girl naked in the apartment in the back, and we'd all be in the other room watching it on TV. It was an incredible place. The door to the apartment in the back just had a clock on it—it looked like the end of a hallway. But if you dialed a certain telephone number,

that would set off a relay and the door would pop open. There was no key or latch, just that phone number. And only Ike knew it.

The amounts of money around were amazing. They got paid in cash every night—and they were making up to like twenty thousand dollars a night then. So they'd go out for two weeks and come back with two hundred thousand in cash. Rhonda just carried it around in her briefcase. I think this was around the time when the party suites really got started seriously. I remember after a show in Miami, there were all these big Miami coke dealers in there trying to meet Ike. Each of them had a plate with like an ounce or two ounces of coke on it, and they're going, "Try mine! Try mine!" Ike says to me, "Here, have some," and he takes a straw and sticks it in the plate. I snorted it and got like two grams of pure coke in each nostril, and all of a sudden I was out of my mind. I thought, "What the hell is goin' on?" I don't know how anybody lived through all that.

But Ike wasn't some sort of cocaine Svengali. He wasn't at all into dealing. He would give it away, but he wouldn't sell a nickel. It just wasn't a conversation he would have. He bought it to use it, not to sell it. And he had incredible coke, boy.

When they played St. Louis, Ike rented a plane to fly down to Clarksdale. That was pretty intense. Some of Ike's earlier wives were there, and I remember this big guy who I thought was his brother but wasn't. And the kid had a big Cadillac! Then a lot of family people started turning up, laying trips on Ike and putting him in a bad mood. No wonder: None of us had slept in several weeks. And when Ike didn't sleep for a long time, he'd be real intense and have a lot of trouble getting his thoughts out; then he'd get angry about things. So he split, and the rest of us all went to this funky little roadside place to eat. The band was all excited, because they were gonna get chitlins and ham hocks and all kinds of Southern stuff. So my wife, Elaine,

and I are sitting there with Rhonda and Tina, and the band is there, all wearing these like hot-pants jumpsuits and stockings—in the middle of Mississippi, right?—and suddenly these local people start drifting in. I mean like old, poor black people coming to see what the excitement was, and some serious farm boys—big scars, half a limb missing, you know? And they lined up around the walls until the whole joint was full. And there we were in the middle, with the band all wearing these little L.A. outfits. I wanted to go out to the car to get my camera, but Rhonda said to be careful, don't go alone. Well, two of the guys in the band were really big: Leon Blue, the bassist, and Soko Richardson, the drummer. I asked Leon to go with me, but he was suddenly too busy eating. I asked Soko—this guy was two hundred fifty pounds, Mr. Monster—but he said he wasn't going anywhere. They were supposed to be macho guys, but it turned out they were just musicians from L.A.

When we got in the car to go back to the plane, Tina was mumbling something about, "God, don't ever send me back to Mississippi."

Back home, Tina came to look upon Ike's new studio with similar distaste.

Tina: I always really wished that Ike could get what he wanted—a string of hit records. Because when he did, I was going to leave him. I didn't know how, but I knew by then that one day, *some* way, I would. So when he built that studio, I thought: "Wonderful—I'll be rid of him." But then the phone calls started—three o'clock in the morning: "Tina, Ike wants you." And I'd have to get up and drive down there and sing, or sometimes just bring them food. That's when I started drinking coffee, to stay awake.

I used to walk into that studio and Ike and the band would be there, and let me tell you, every one of those suckers would be in a totally different place. They'd be

walking around snorting and yapping, with that white stuff all over their faces, rocking back and forth. And I would see all those creeps and I'd just think, "Well look at you." They looked so silly, and they thought they were so cool. Then Ike would come up to me and start talking, and I wouldn't understand a thing he said. It was like: "Now, the float on this is that . . . you hit it . . . and then you—bounce off!" I mean, what? Then he would get on my case because I wasn't singing his song the way he heard it. He'd say, "You bitch, you're not into this, you're not tryin' to learn it." I would be standing there *crying*, trying to sing it whatever way he wanted, but it was never right. I was always singing out of fear.

Ronnie Turner: Sometimes my mother would take me along when she had to go down there. That way she'd have an excuse not to stay all night. My father didn't realize other people needed sleep. I was the youngest son, so Mother and I were pretty close. I'd always comb her hair in her room, and we'd talk. I knew how unhappy she was. My father was so unpredictable—you never knew what kind of mood he'd be in. You'd have to try to figure out how many days he had been up recording. After three or four days, he'd be real irritable. Then he might stay up another two nights—and *then* he was liable to get mad if he didn't like the way your eye twitched.

Craig Turner: Sometimes he would just be out of his mind. I remember once my mother told me to go back in their room and get something for her from her jewelry box. I was back there looking through it and he came in. He was with some friend of his from St. Louis. He said, "Boy, whatchoo doin' back here?" I said I was looking for something for Mother. He said, "Git your ass outta here," and then he started slapping me across the head. This friend of his just stood there looking, you know? I went and told my mother, and that made it worse. He said,

"Boy, you got your nerve, tellin' on me." After that, there was always friction between us.

Ann Thomas was back on the scene too; had been since the birth of her baby. Thomas was working wardrobe with the Revue and living in one of a block of apartments Ike had recently purchased behind the Bolic studio. She and little Mia were an integral part of the Turner household.

Craig Turner: I used to wonder why Ann Thomas was around all the time. I presumed she was like another housekeeper. Eventually I found out she was my stepfather's mistress.

Ronnie Turner: All I knew was that Ann Thomas was working for my father, and that her and my mother were best friends. So I wondered when Ann had a baby, you know? It wasn't until later that it was explained to me.

Tina: Ann and I were real close. Everything I was going through, she was going through, too. She used to always hide these walking canes that Ike had, because he'd use them to beat her or to beat the secretaries with. He broke her arm once, and she was walking around with a cast on it. So Ann and I were great friends; we kept each other company. There was nothing we could do about our situation, so we tried to laugh about it—to laugh about the fact that we were prisoners, you know?

Finding Strength

By now the Turners' glory days of chart stardom were coming to an end. The Turners' next album, *'Nuff Said*, failed to reach the Top 100. Their first single of 1972, "Up in Heah," only made it as far as number eighty-three. That summer, two albums were released: *Feel Good*, the more successful of the pair, fell short of the Top 100 by an even greater margin than its predecessor.

Tina: By this time we were playing places like the Fillmore in San Francisco, and Ike was starting to meet these white hippie girls. They'd be turning him on to cults and things, and telling him he was like a god—it got real crazy. Ike would be walking around saying things like, "Caesar did cocaine!" And I'd be thinking, "Great, Ike—Caesar's dead."

Despite all the studio time Ike and his band were putting in, the eighteen months that followed "Up in Heah," the Turners' previous chart single, proved a dry season for hits. It had been more than twenty years since Ike had

made his first record, and as Tina says, "He never changed his show and he never changed his style." But the times in which he now found himself were very much changed. For one thing, there was a new feminism in the air, and much talk of "women's liberation."

Tina: The first I heard of women's lib was when *Time* magazine ran this picture of some women waving their bras in the air. Great picture, but I didn't really get it. Was it supposed to mean that just because you took off your bra you were now using your mind? I couldn't really relate to that "movement" kind of thing. They were talking about "liberation"—but liberation from, like, housework. That was the least of my problems. My problem was simply survival.

By fall, Ike and Tina Turner did have another hit. "Nutbush City Limits," a hot dance number, which reached number twenty-two in the pop charts in November 1973. It was the last Top 30 record the Turners would ever have together. In Britain, the single was an even bigger smash, spending two weeks in the number-two chart position. It was also enormous on the Continent, particularly in Germany and France. To longtime observers, "Nutbush" seemed like yet another remarkable bounce back for Ike and Tina. The most interesting thing about the record, though, was suggested by its title: "Nutbush City Limits" was written by the former Anna Mae Bullock, from Nut Bush, Tennessee.

Tina: Ike was so desperate for a hit, and I wanted him to have one, too. I was doing everything I could—touring with him, staying up all night in the studio with him and all his friends with the frozen noses. I had got him to change his look over the years—getting a new hairstyle, wearing better clothes. I helped him dye his hair when it

started turning gray. I gave him manicures, pedicures, massages whenever he wanted them. And now I was even writing songs. But it was never enough. Ike was in a bad mood one day and he looked at me and said, "What do you do for me?" I said, "Ike, you must be blind." Just like that. I was starting to talk back to him now. At first, Ike hardly even noticed.

The only thing that kept me going in those years was the readers. Whatever cities we played—here, in Europe, wherever—I would always try to find a reader to go to. I'd have to sneak, of course, because Ike didn't approve of me doing anything like that. But there was always somebody with the record company or the local promoter that would help me out, that would have a name. Then I'd tell Ike I was going shopping, and I'd head straight for that reader. Some of these people read cards, some read palms, some read the stars. Some read tea leaves and coffee sediments. Some of them weren't for real, but others gave me something to hold on to, some insight into what was going on in my life. I was exploring my soul, for the first time. I had always held on to the Bible and the things I'd learned as a little girl—the Lord's Prayer, the Ten Commandments. And I prayed every night, you can believe that. But now I was really seeking a change, and I knew that it had to come from the inside out—that I had to understand myself, and accept myself, before anything else could be accomplished. The readers—the good ones— helped me do that. I'm not talking about fortune-telling or witchcraft. I was looking for the truth of a future that I could feel inside of me.

Well, by the time "Nutbush City Limits" hit, I was turning thirty-four years old. I think when a woman reaches those mid-thirties, her thinking starts to change; I know mine did. I started thinking about this career I had, about how when I'd started out I thought it would be such a glamorous life. But there was nothing glamorous about it. It wasn't even *my* career—it was *Ike's* career. And it was

Ike's songs, mostly, and they were always about Ike's life—and *I* had to sing them. I was just his tool.

Then I started thinking about my marriage. And I remembered what marriage had meant to me when I was a girl—the loving husband and wife, the happy children. My God, I thought, how had things gone so wrong? The kids would all run and hide when Ike came home, the man was so mean. He had his own problems, too, of course: He was getting older, and thick in the waist; and I know he was worried about his nose—the cocaine was starting to eat through the tissue between his nostrils. But he wouldn't stop taking the stuff. He got so crazy with that scene in the studio that me and the kids couldn't even celebrate the holidays anymore. At Christmas, it was like, "Don't buy me any motherfuckin' presents." You'd be wrapping gifts in the bedroom and he'd come in and kick them all over the floor—"Get this shit offa this bed! All these fuckin' holidays . . ." Ike never had a way with words, as you can tell.

So this was my life, and I was starting to see it real clearly now.

One day, Ike brought this pretty woman home. He was always doing that, bringing people to the house to "meet Tina." Well, when I was at home, I was a mother, period—I didn't want to be meeting any of his friends. But that didn't matter to Ike. So he brought this woman in, and he says to me, "Know anything about *chantin'?*" I said no, but didn't it have something to do with witchcraft? That's when he introduced the girl. Her name was Valerie Bishop, and she was a Jewish woman who was married to a black jazz musician. There was a group of mixed-marriage couples in L.A.—Herbie Hancock's wife, Gigi, who was German; Wayne Shorter's wife, Anna, who was Portuguese; and also my friend Maria Booker was married to a black musician. Valerie was one of those. And she was also a chanter. I don't know how Ike met her, but he was interested in all these kind of occult things, and he thought

chanting was just another one, just something to play with, then forget about. He hired Valerie to work at the studio as a secretary for a while, but she didn't stay long—she wasn't the type to put up with Ike. I sometimes feel that she came into my life just to touch me, to teach me about chanting. She explained that it wasn't witchcraft, that it was Buddhism—Nichiren Shoshu Buddhism. And she told me about *shakubuku,* which is the first phase of teaching somebody. I listened to this and something inside me went *bling!* I guess it was intuition—I knew that this was something that was being given to me. Before she left, Valerie gave me a book, and the beads you use, and she taught me the chant: *nam-myo-ho-renge-kyo.* I wrote it down.

Then, whenever Ike wasn't around, I started testing it. After I would say the Lord's Prayer, I'd do five repetitions of the chant—*nam-myo-ho-renge-kyo, nam-myo-ho-renge-kyo.* . . . Like that. I was really excited about it. The first little thing that happened . . . well, I had a problem with the makeup I was using. I was allergic to it, breaking out in a rash. I needed to get this other brand of makeup, and I had been looking all over for it, but I couldn't find it. Then, right after I started chanting, I got a phone call from a girl I knew. She was at Bloomingdale's. She said, "You know that makeup you were looking for? Well, they have it here." And it was on sale! Now, this sounds kind of silly, but I knew it was the chant—that it was helping me to rearrange my place in the universe. Makeup—I know: a small thing. But it was a start. I said, "I don't believe this."

After that I got a *butsudan,* which is a beautiful little cabinet. Inside you put things that represent the necessities of life: little candles for light, incense for smell, water, fruit, and so on. And you hang your *gohonzon* in there, too—a scripture, rolled up on a scroll. The *butsudan* looks like a little altar; but the idea is not that you're *worshiping* this piece of paper or anything. These things allow you to

focus, to be in the right frame of mind to *receive*, and they are a form of respect.

I kept the *butsudan* in an empty room we had, and when Ike was out I would do the chant and read the book Valerie had given me, and I could feel myself becoming stronger—becoming less and less afraid. Then Ike discovered the *butsudan*, and he blew up—"Get that motherfucker out of this house!" Because it scared him a lot. Ike would get scared about anything he couldn't understand or control. I saw it once when we were in a plane that almost went down—saw the fear in his eyes and in these little red veins that popped out on his nose. And the *butsudan* really scared him for some reason; I thought he was going to faint.

So I had to get rid of it. But that didn't stop me from chanting whenever I could. Because now I could feel the power deep inside me, stirring up after all these years. And I would think about Ike's face, and how funny it was to finally see *him* scared: to know at last that he wasn't all-powerful, that he wasn't God, that there was a little piece of God inside each of us—inside of me, too—and that I could find it, and it could set me free.

That's when I *really* started chanting.

At least one good thing happened straightaway. Early in 1974, the Turner organization got a call from record producer Robert Stigwood's office. Stigwood wanted Tina for a part in a movie he was helping to finance for Ken Russell, the flamboyant director of *The Devils* and *Women in Love*. The movie, to be made in London, would be a visual realization of *Tommy*, the 1969 rock opera by the Who. It would star such popular musicians as Eric Clapton, Elton John, and, of course, the Who themselves, as well as actors Oliver Reed, Jack Nicholson, and Tina's pal Ann-Margret, playing Tommy's mother. Tina was to play a character called the Acid Queen, and to sing a song by

the same name. There was no part in the production for
Ike.

Tina: They said it had been a choice between me
and David Bowie—and they picked me! Actually, I wasn't
too interested at first, because I wasn't interested in *anything*
by then. And I didn't know the story, hadn't even heard
the Who's record, but Dave Bendett, who was Ike's agent,
kept after me to read the script, and I finally did, and I got
excited. This wasn't just a singing spot in a movie; this
was like *acting*. And I'd always wanted to act.

Ken Russell wasn't too sure about me at first. He said,
"I didn't know you had that much hair. And I thought you
were taller." I mean, what was I supposed to do—grow?
He said he wanted me in black, so I came in wearing this
nice Yves St. Laurent skirt, which came to about mid-calf.
He said, "No, no, no, no." So they went out and got this
horrible little short skirt and these awful platform shoes,
which made me instantly tall, and then I figured we might
as well go all the way, so I dug out these old fishnet
stockings I had worn years before, and bright red nail
polish and lipstick. But Ken Russell was still sort of
pessimistic. Then I started making this madwoman face—I
was trying to look like Vincent Price, with the bulging
eyes and the quivering head, you know?—and Ken started
getting real excited. He said, "Yes, yes! More! More!"

Well, after a few days, I was really getting into it. I still
didn't know anything about the story of *Tommy*, but I
loved being involved in the making of a movie. Then we
came to my big scene, and this pair of twins walked in
with a pink pillow—and there's this *huge* hypodermic
needle on it! I was shocked—I didn't know anything about
this. I said right out loud, "My God, is this movie promot-
ing drugs?" I don't know why I'm so naïve about those
things. I mean, even the name of my character—the Acid
Queen—hadn't tipped me off. Ken Russell just laughed,
though.

I loved doing *Tommy*. My part was small, but it was *my part*. It gave me strength. I could feel myself growing.

Following the *Tommy* filming, Tina was invited by costar Ann-Margret to remain in London to take part in the taping of the singer's latest television special. Once again, Ike's presence was not requested. When the show aired in the U.S. the following year, Tina's guest-star spot—duetting with Ann-Margret on "Proud Mary," "Nutbush City Limits," and "Honky Tonk Women"—proved to be the high point of the show. It also proved that Tina, a total professional, could be mesmerizing in any context.

Back home, Ike and Tina Turner were hitless for most of 1974, although not for lack of tracks. Ike practically lived in the studio by now—recording himself, recording the band, recording the same songs over and over and over. With the proliferation of high-tech equipment—Bolic had been boosted from twenty-four-track to thirty-two-track capacity, for example—there came an exponential increase in the number of recording choices to be made: which track to pick, which part to redo, which mix to use, and so forth. Within this thicket of possibilities, Ike, wired on cocaine, was becoming paralyzed by indecision.

Ronnie Turner: He was doing the same songs over and over. He'd have a good song, and everybody'd be grooving to it, but then he'd stay up working on it for four days, and after a while he couldn't figure it out—all the tracks and stuff—and he'd start adding things that really didn't go with the song.

Ike Junior: He was surrounded by leeches, too. That's where all the trouble came from. Because my father used to be real strict. But then it got to be that we'd be working on something together and he'd just leave, go up to his apartment there and be partyin' or freakin' out or

whatever, and I'd be sittin' there till six or seven or eight in the morning. Cocaine'll do you like that. It makes you evil. You don't want to talk to nobody, you don't want to take care of business—you really don't want to be bothered with anything.

Ike's marathon stints in the studio were fine with Tina, however, as long as she didn't have to participate. By now it was his presence at home that she dreaded.

Tina: It was real hard by then. Ike got worse and worse. You never knew what you were getting hit for; only Ike knew. He'd just say you were "messing" with him. He'd lock the door, and then you knew you were gonna get it. One night in the studio, he threw boiling hot coffee in my face. Said I wasn't singing the way he wanted, that I wasn't trying. When the coffee hit me, it felt like ice—and then it started *burning,* and I started screaming. I grabbed at my neck, where most of it had hit, and the skin just peeled right off. I had third-degree burns on my face. That scared Ike. And you know what he did? He started *beating me.* It was like, "Goddam it, *she* made me do this," you know?

Well, I had tried talking to him, telling him how I felt. Now I started writing him letters, because I wanted him to understand that I just couldn't take the beatings anymore. That was his whole life: He'd beat you and have sex with you and argue and fight, and then go play his music. And I didn't even *like* his miserable music. So I tried writing letters, and leaving them where I knew he'd find them. But then two days later I'd have a black eye again. My left eye pretty much stayed black, and my nose was always swollen.

It wasn't just me, of course. He'd beat the secretaries we had, he'd beat Ann Thomas. We'd be in the car with Rhonda driving and he'd be calling her foul names and

pulling whole handfuls of her hair out. It was like when he got angry, he became *anger itself*. And he wouldn't let any of his women go, even if he wasn't interested in them anymore. He'd keep them hanging on. And they couldn't mess around with other men, either. If he even *thought* you were gonna mess around, you were gonna get beat up and probably screwed—and then you weren't gonna get screwed *any more*, you know? He was an evil, possessed person. It got to where if I happened to roll away from him in bed at night—because he always had to lie in the crook of my arm—and he woke up and noticed, he would start punching me in my sleep. *In my sleep!* Then, in the mornings, I wasn't allowed out of bed until he woke up. I'm a Sagittarian—I want to get up in the morning and throw the drapes open and let the sunshine in. But I couldn't move. I had to just lie there while he slept. It was like living in hell's domain.

Ann Cain returned at this point. She had stayed in touch from another state, and now, with a broken marriage behind her, she was back in L.A. However, she had also become a Jehovah's Witness, and when Ike approached her about resuming her managerial role with the Turner organization, Cain immediately made it clear that, if she did return, she would no longer perform double duty as one of Ike's on-call playmates.

Ann Cain: I told him how my life had changed, and that things that maybe I did before, I would not do them now. That was our agreement. That, and an understanding that he would not talk to me while he was on the drugs.

Ike needed somebody then, because the office was a mess—there were hundreds of thousands of dollars in checks lying around. I had set up Ike's business system originally, so I tried to untangle things. The way he

worked—with no manager or anything—he could make millions from one hit record. And he had access to lots more. He'd take bank loans just to establish credit—start with a twenty-thousand-dollar loan, maybe, take the money and put it in his office safe for a month, then take it back. He kept doing this with bigger and bigger loans. After a while, he could walk into Wells Fargo and get a million dollars easy. So he had all this money. But he made all these bad investments with it. Well, he had the studio, and the apartment building behind it where Ann Thomas lived. That was a good piece of property. And he had a share in this two-hundred-fifty-unit apartment complex out in Anaheim. But then he had all this money in cows and animals and things, and bad stocks. When I started checking this stuff out, it turned out to be worthless. Zero.

A couple of the kids were starting to get into drugs by then, too. No wonder. Ike shined a flashlight up his nose once to show me how cocaine had eaten away the inside. That whole wall between his nostrils was totally gone. He'd stay up four or five days in the studio, with the drugs.

When he was taking that stuff, you couldn't get to him. He'd sit in the studio sometime, just staring straight ahead, and the door would be bolted and you'd be looking in and he'd pretend not to see you. It got so bad at that place, with all the cocaine there, that good musicians stopped using Bolic. For one thing, there was so much coke around that it had gotten down inside the control board and was messing up the sound. Ike had good equipment in there, and he screwed it up with coffee and cocaine.

Tina's situation, well . . . think deep down inside, Ike really did love Tina. But he was always afraid of losing her—of losing *control* of her. And he felt that the only way he could keep her was to lock her up. Well, I was a different person when I came back to work for Ike; I had found Jesus. And now I felt so bad about all the pain we had put Tina through over the years—me and Rhonda and

Gloria and Ann and all the others. She was so *innocent*, basically. I'd look at her and I'd always think about that country song "Don't It Make My Brown Eyes Blue." Because those were Tina's eyes, for years and years.

Country was the angle for Tina's first "solo" album, *Tina Turns the Country On*, which ranged from covers of Hank Snow and Dolly Parton to Bob Dylan, Kris Kristofferson, and James Taylor. Tina actually liked the *Country* LP (it was recorded at Bolic, but with an outside producer and musicians), even though it didn't sell well. The rest of 1974 was similarly barren: The Turners' only remotely successful pop single, "Sexy Ida (Part One)," died at number sixty-five in December. This marked the beginning of the duo's final decline.

Tommy was released early in 1975. It was a characteristically over-the-top Ken Russell production, bloated and frenetic but with passages of undeniable pizzazz. (Ann-Margret was subsequently nominated for an Academy Award for her portrayal of Nora, Tommy's mother.) *Melody Maker*, the English pop-music weekly, overstated the film's case considerably in a review that called *Tommy* "a major work of art." The review's individual performance assessments were equally hyperbolic: "Tina Turner and Elton John," said writer Tony Palmer, "emerge as movie superstars, and their two sequences will live forever among the most dazzling inventions of the cinema." Heady words—but others too were quick to note the natural power, amid all the directorial bombast, of Tina's big-screen persona. Not Ike and Tina. Just Tina. With *Tommy*, as with "River Deep-Mountain High," Tina had taken a major step forward on her own.

Ike, whose decision it had been to rent Tina out for *Tommy*, nevertheless grew irritated as the critical plaudits mounted.

* * *

Tina: After the movie came out, the press started asking a lot of questions about Tina-this and Tina-that—nothing about Ike. And from then on, whenever he wanted to fight with me, that's what he would focus on. If he wanted to get *really* mad, he'd start bringing up "River Deep," too. "I'm goin' back to 1966 now," he'd say—to that record that was a hit without him. But that record, and now this movie—they were both deals he had made. I was never consulted. I guess that probably made him even madder.

In June 1975, "Baby—Get It On" became the last pop-chart single Ike and Tina Turner would ever have. It reached number eighty-eight. The hit records were at an end.

So, at last, was Tina's patience. She considered her situation anew. The Turner kids—her main reason for sticking around—would soon be grown: Craig and Ike junior were turning seventeen, Michael was almost sixteen. Ronnie fifteen. The readers and astrologists she continued to see in her search for a way out spoke more and more about a better life ahead, a bigger career—and both decidedly Ikeless. She was chanting more than ever, growing stronger, coming into her own. She began to see her life in sevens. From birth to age seven, childhood. From seven to fourteen, school years, girlhood. Fourteen to twenty-one, first love—ah, Harry Taylor—and then meeting Ike, becoming a singer. From twenty-one to twenty eight, falling in love with Ike, then becoming his prisoner and feeling that love begin to ebb. In the years from twenty-eight to thirty-five, she had finally come to hate the man. Now, on the verge of thirty-six, she felt that a massive transition was at hand, an end to all old things and a beginning of the new.

In considering the imminence of this potentially danger-

ous passage, Tina could only feel inspirited. All the years of fear had left her, finally, fearless.

Tina: I realized that I could take his best lick, and that was when I started leaving him again. The first time I went to a cousin's house. After three days he found out where I was and I had to go back again. He beat me up, of course. Then he picked up this iron poker from the fireplace, and I thought he was going to hit me with it. By then, I'd had it all—the broken ribs, the broken jaw. This would have been another blow to the head; the blood would have come, and the pain—and I just didn't care anymore. But he didn't hit me with it, for some reason. He just held it in front of my face and bent it—just to show me what he *could* do.

Then I left again. This time I was gone almost two weeks, and I even took the kids. There was a woman who helped me, Maria Booker, who was Anna Maria Shorter's sister. Maria was somebody that Ike knew, naturally—he brought everybody into my life; I could never make friends of my own. But Maria felt sorry for me when she found out what my life was like. So she let me and the kids stay at her house in Malibu, where Ike would never think to look for me. I think my leaving this time scared him a little. When I did go back—because this thing had to be settled somehow—he didn't even fight with me. He just listened. I told him, "Ike, I really cannot stay with you any longer. We have to get some kind of agreement. I don't want your money; you take it. But just leave me alone. I know how you are. I *understand* how you are. I'll do my best with the singing, but I can't take the beatings anymore." And after that, the fights were fewer. Oh, he'd still beat me, and sometimes pretty badly, too, but not as often. I think he was frightened, in a way. Because he'd never heard me talk to him like this before.

* * *

In August, Bob Gruen, the photographer and filmmaker, reappeared in L.A. A few years earlier, Gruen and his wife, Nadja, had shot fifty hours of film of the Revue, but it had never been put to use. Gruen had more recently been working with John Lennon and Yoko Ono, from whom Bob had begun learning about feminist precepts and the dead ends of the rock 'n' roll life-style. Lennon, after a booze-addled separation from Ono, had recently returned to her, given up drugs and drink, and taken up the role of "househusband," jettisoning his own career in order to raise their infant son, Sean. Gruen, recently become a father himself, was contemplating similar changes in his own life, but too late—by the time he arrived in L.A. after a trip to Japan with Ono, he and Nadja had split. At loose ends, he decided to pay a visit to Ike.

Bob Gruen: Ike said that Tina was leaving him. I said Nadja was leaving me, so we sort of had that in common, and we were discussing it. He said he didn't understand why. I said, well, women today don't want to be a shadow to a man—they want to be their own individual person and pursue their own destiny. And if you're not up to making those life-style changes . . . I mean, instead of being home with my wife and kid, I was always out somewhere drinking with some band. And so we were splitting. But I understood that Nadja wanted to live a more stable life, one that had more feeling and more meaning than a rock 'n' roll–show biz kind of scene. I knew how happy John was about coming back to Yoko and stopping the drinking and the drugging, and those were things I was starting to learn, too—although it took me five years, and in the meantime I lost my wife. But at least I knew why. And I was trying to explain this to Ike—about this new feminist movement, that you can't just boss a woman around and expect to be considered a powerful man. That you have to respect a woman, and really believe that she is an equal partner in life. This was

something that he had never heard before, and it didn't make much sense to him. Particularly since he was so successful in using women as sex objects, and having many of them enjoy it. It just didn't make sense for him when all of a sudden his own wife says, "You can't treat me like that." He was saying that she had never acted like she was feeling bad before, and that this was the way guys were. He just didn't get it.

Ike attempted to carry on as usual. The recording continued, and the touring as well, although on a more constricted scale. With the decline in U.S. hit records, the live dates had started thinning out, too. But the Revue could always make money abroad—in England, Germany, France; in Australia and the Far East. And so, at the end of 1975, abroad was where Ike headed.

This final world excursion was ill-omened from the outset. In Paris, in December, a briefcase containing eighty-six thousand dollars was misplaced and never recovered. According to Ann Cain, the suspicious Ike later attempted to submit every member of his band and entourage to a lie-detector test. Cain, who stayed in L.A. to mind the store during that tour, nevertheless says, "From what I understand, Ike had the briefcase and he walked off and left it somewhere. I'm glad I wasn't around." By January 1976, the group was in Indonesia, where Ike's refusal to play five Djakarta dates with the substandard sound system provided led to a confrontation with gun-brandishing police goons. He managed to spirit the Revue out of the country on a plane to Hong Kong, but not before forfeiting twenty-two-thousand dollars' worth of band equipment,

On returning to L.A., Ike went right back into the studio, oblivious to the interpersonal shifts that were beginning to shake his world. Rhonda Graam finally left in March 1976, weary of Ike's abuse. As a parting shot, he repossessed the house she was living in—a house she had

understood to be a gift from Ike in compensation for all her years of underpaid service. As his cocaine intake and his isolation grew, his thought processes became increasingly twisted.

Ann Cain: Ike always said that I was a dangerous person. He thought that I might hang him, get him in big trouble one day, because of all the things I knew. He told me that he had once plotted my death, and how he was going to murder me. He was going to run over my body, over and over, until he smashed my guts. He used to sit up and think of how he'd do stuff to people, you know? That's the kind of mind he has. He was already leaning toward sadism anyway; with the drugs, he was into the deep, deep things of Satan. Of the Devil.

The Great Escape

On July 1, 1976, President Gerald Ford, waxing patriotic at the opening of the National Air and Space Museum in Washington, D.C., implored Americans to "keep reaching into the unknown." It was the year of the U.S. Bicentennial, and along with the expected excavations of the American past, there was much talk, in the wake of the Watergate scandal, of new beginnings, new dreams, new horizons toward which to set sail.

For the Ike and Tina Turner Revue, the Fourth of July was to be observed by kicking off another of its territorial tours of the U.S., and the opening engagement, that festive weekend, was at a Hilton hotel in downtown Dallas. The excursion got off to a bad start before the group even reached the L.A. airport, and then it got worse. For Ike and Tina, Dallas was to be the end of the road.

Tina: By then, the jobs were getting very thin and the crowds were getting scarce, and Ike was getting very uptight and putting a lot of blame on me, as usual. If I would just sing the way he wanted me to sing—whatever way that was—then we would have hit records. It was

hopeless. I still didn't know where I could go—my mother lived in Ike's house in St. Louis, looking after that, so I couldn't go back to her; and Alline, who lived in Baldwin Hills, was just as scared of Ike as everybody else, so I couldn't go to her either. But I knew I was going somewhere—by now, my determination was outweighing my fear of this man. What did I have to lose anymore?

So we got in the limo to go to the airport—me and Ike and Ann Thomas and Claude Williams, who was the bandleader at the time, and this little white girl from Canada that Ike had just started dating, I forget her name. Ike was eating this chocolate candy. I was wearing a white Yves Saint Laurent suit. He handed me one of his chocolates—it was all melting and gooey—and he said, "You want it?" I said, "*Ick,*" you know? That's all. And he hit me—*whack!* One of those backhand licks. And this time, I got mad. I didn't think, "Uh-oh, better be careful, I'm gonna get it." I thought, "Today, I'm fighting back." And from there, everything I'd been holding in for sixteen years started coming out.

We got to the plane and got on board, and of course he wanted the usual seating arrangement, with me and Ann on either side and him lying across us. We had always had to put up with this whether he slept or not, just so he could lie there like some kind of king, right? And he'd been up in the studio for five days, so this time he really did want to sleep. But not today—I told him I just didn't feel like it. Well, he picked up right away that something was going on, and he kicked me. I just looked at him—and he looked back at me with *dagger* eyes, boy. Then he started *really* getting mad—and I was nudging him, too.

The plane arrived at the Dallas–Fort Worth airport, and we were walking out the gate and Ike was just staring at me—one of these real evil looks, trying to work on my mind. There was a car and driver waiting there to take us to the Hilton, and as soon as we got in, Ike hit me again—*whap!* Another one of those backhand licks. And

then I started fighting back. He kept hitting me, but I didn't cry once. I was cursing him out: He was going, "Fuck you," and all of that, and I'd keep talking right back to him. He was amazed! He was punching me and saying, "You son of a bitch, you never talked to me like this!" I said, "That's right—but I am now!" And then *pow*, he'd hit me again. And then he reached down and got his shoe off his foot and *pow, pow, pow!* But I kept fighting him. I didn't care what he did, because I was *flying*—I knew I was gone.

By the time we got to the Hilton, the left side of my face was swollen out past my ear and blood was everywhere—running out of my mouth, splattered all over my suit. Ike used his usual story; said we'd had an accident. The people at the Hilton looked at me and I could tell they were wondering how I'd ever get onstage that night looking the way I did, all beat-up and battered, with my one eye swollen almost shut. I think Ike knew, too, that this was really the end. But he'd been up so long, he was just too tired to deal with it. We went up to our room and I heard him mumble something like, "Lord have mercy" —something really not typical of Ike at all—and then he went and lay facedown on the bed. I didn't want him to get any ideas about what I was thinking, so I acted like nothing had changed. I said, "Can I order you something to eat, Ike?" Same as always, still playing the maid. It was a little hard to get the words out this time, because my mouth was so cut and swollen, but I tried to make everything seem normal. Then I went over to the bed and started massaging him, as usual. I was afraid he would hear my heart, it was beating so loud—because I knew it was time to walk. But I kept massaging him and rubbing his head, and soon he started snoring. I slowly took my hands away, just to see if he really was asleep. I heard this deep, *dead* kind of snoring sound that he made after he'd been up for several days, and I knew he was out. I looked at him for a second and I thought, "You just beat me for the last time,

you sucker." Then I got up, and I put a cape over my bloody clothes—didn't even change them. I had to leave my wig there because my head was too swollen to wear it, so I just tied one of these stretch wraps around my head. I figured he could get somebody else to wear that wig—he could wear it him*self*, for all I cared. I put on a pair of sunglasses, picked up one little piece of hand luggage with just some toiletry things in it, and I was gone.

I had to be real careful, because luggage was still being brought up to the rooms, and I didn't want any of Ike's people to see me in the lobby. So I wound up sneaking out through the back of the hotel—I was running by then, I was so afraid. I ran outside into an alley and threw myself in among some trash cans and just hid there for a while. After a couple of minutes, I composed myself. I said, "Okay." It was dark now, about nine o'clock—time for us to be going onstage, actually. I knew everybody would be looking for me to go on, because they were all too afraid of Ike to call the room and wake him up after he'd been in the studio for five days. So I got up and I started running down that alley. I wound up on a freeway and I ran across that and into this Ramada Inn. You can imagine how I looked by then. And all I had with me was a Mobil credit card and thirty-six cents—honest to God, it was like a quarter, a dime, and a penny. So I asked to see the manager, and he came and I said, "I'm Tina Turner. I have had a fight with my husband, as you can see"— and I took off my glasses. He could see. I said, "Will you give me a room? I can't pay you right now, but I promise that I will." And out of the goodness of that man's heart—I mean, this was *Texas,* you know?—he said, "All right." And he took me upstairs and gave me the best suite he had. Put security on the door, too—I guess from all the blood on my clothes he could tell this was serious. He asked me if I wanted food, but I couldn't eat anything really solid because of the condition my face was in; so he

brought soup and some crackers to tide me over. I was blessed to find that man, I'll tell you—blessed.

After he left, I took my suit off and washed it and put it on the radiator to dry. I was trying to think what to do next—and my poor little head wasn't really up to it. I didn't have any friends I could call, really. I'd gone to Maria Booker's house the last time I left; I couldn't go there again, because that would be the first place Ike would look.

So, finally, I called Mel Johnson, which was a big mistake, as I found out later. Mel was a friend of Ike's from the St. Louis days, and now he was a Cadillac salesman in L.A.

Well, I called him—and the minute I hung up, I just knew he was going to call Ike and tell him he'd heard from me. So then I called Ike's attorney, Nate Tabor. Nate was an older man, very nice, and he knew what the situation was between Ike and me. I called him in Los Angeles, and he said he knew some people in that part of Texas, and that he would have them come pick me up the next day and give me some money and take me to the airport, where Nate would have a ticket back to L.A. waiting for me.

The next morning, I had cleaned myself up, and put on lots of makeup, and the dark glasses again, and I was looking a little better. These people arrived, an older couple, and they turned out to be really prejudiced. Just what I needed. But I thought, "Fine—I know what that's about." We didn't exchange one word on the way to the airport, and when we got there, they didn't want to sit with me; they stood off at a distance. Finally, I thanked them. My plane was ready to board. I got on and thought, "Whew!" But then, the closer we got to L.A., the harder my heart started pounding. I thought, "God, suppose Ike has gotten home ahead of me? Suppose he's waiting for me when I arrive?" I kept thinking about that time he found me on the bus to St. Louis, and I was really getting

scared, because I didn't underestimate him at all. Then I thought, "Well, if he is there, I'm just going to scream and yell until the police come—because there's *no way* I'm going back to him again."

By the time the plane landed I was ready for anything. If Ike *wasn't* waiting for me, I figured I'd be okay, because with this wrap on my head, and the sunglasses—and without the wig—nobody would recognize me. So the door opened and I got off and I started running slowly across that tarmac and didn't stop until I reached a cab. "Safe," I thought. And the taxi driver turned ~~around~~ and looked at me, and the first thing he said was: "Are you Tina Turner?"

I thought, "Oh, shit."

13.

Independence Day

Tina: So I spent the Fourth of July weekend at the Nate Tabor family house and we started talking. He said, "Well, Tina, what do you want to do?" I said, "I'm not going back. I have to get a divorce, whatever that will mean." So after a week, Nate called Ike, because this had to be handled. And oh, honey, Ike started threatening Nate and threatening his family. Nate got really scared. So I said, "Never mind, Nate, I'm not going to put your family through this." And I went back to Maria Booker's.

I was really chanting a lot by then—chanting was the only tool I had. And Maria would chant with me. But we both realized I couldn't stay there, because Ike would come looking for me any minute. So Maria sent me off to her sister, Anna Maria, who lived on Lookout Mountain. Anna Maria was a chanter, too, and her husband, Wayne Shorter, of the group Weather Report, was away for the summer, so her place was perfect. I stayed there for a while, then I moved in with this college girl, another chanter, who also worked as a masseuse. I forget her name now. Finally, though, I moved back to Anna Maria's,

because she decided she was going to stand by me through this period.

I moved from place to place for two months, working my way at each one—housekeeping and cleaning, just like I had for the white woman back in Tennessee. And I know how to clean. I moved junk and stored stuff away and put out the trash and cleaned cupboards and washed dishes and scrubbed stoves—because that was the only way I could repay these people. I didn't have any money. I didn't have anything at all. So I paid my rent by cleaning. And it was more than just cleaning. It was things that they never would have imagined—organizing their closets, creative things. Sometimes they'd say, "Oh no, Tina, you shouldn't be doing that, the maid . . ." And I'd say, "The maid didn't do it, so I did. So just shut up." They learned to accept that I needed to work that way. I was working off my energy. I had to think and I just couldn't *sit* there and think, I needed to think on my feet! And I look back on it with fond memories. I don't think less of myself for it, because it helped me survive. I'm proud of it!

I slept in whatever kind of cubbyhole they had—slept in Wayne's office at Anna Maria's—and I'll tell you, I didn't miss what you call "the trappings of stardom" at all. Because I finally had my freedom—God, how I'd dreamed about it, for sixteen years. And my own friends, too, for the very first time.

All of these women were into the rhythm of chanting, and by the time I arrived back at Anna Maria's, I was chanting four *hours* every day. The chant brings you into harmony with the hum of the universe, that kind of subtle buzz at the center of all being. Close your eyes and you can hear it all around you. Anna Maria had a *gohonzon*, so I stayed indoors all day and just chanted and chanted, building up my spirit for the trials I knew still lay ahead.

One day, Anna Maria asked me to go to the market with her. I shouldn't have done it, but I didn't think anyone would recognize me. I had gotten my son Craig's girlfriend,

Bernadette, to sneak into the Olympiad house and get some clothes for me—and my thirty-eight, too—and so I finally had my clothes to wear, and these head wraps so no one would recognize me. What harm could a quick trip to the market do?

Well, we got out on the road in Anna Maria's Mercedes, and this guy in another car pulled up on the passenger side, trying to get a look at me. I slumped down in my seat real quick, but I knew immediately that Ike had this guy staked out to look for me. Ike knew Maria, and he knew about Anna Maria, and he probably knew Wayne Shorter was away, too. I mean, Ike's not stupid—he knew approximately where to look for me. So we got to the market and did some shopping, and I saw this guy again in a confectionary store. And this time, I knew he saw me, too.

That night, Anna and I were doing our evening *gongyo* to the *gohonzon*, when she stops and says, "You know, Tina, I think I'm gonna put the sprinklers on." I knew what she was thinking—chanting does that for you: It tunes you in, makes you alert. Anna's house was up on a hill, and there were all kinds of vines and shrubs around. With the sprinklers on, anybody who tried to sneak up to the side of the house through the bushes was going to get all wet. So she turned them on full force and we went back to chanting. Then somebody knocked on the front door. We stopped cold. I got up and went and got my thirty-eight from the other room and brought it back with me. Anna said, "No, no, Tina—you cannot bring a gun to the *gohonzon*." I said, "Anna, between the two of these things, I'm gonna be safe." ☺ The knocking continued. Finally, Anna said, "Who is it?" And do you know who it was? It was Robbie Montgomery—the ex-Ikette!

Robbie: I was still living in Los Angeles—since leaving the Revue I'd toured with Dr. John, Nancy Sinatra, I did sessions—and Ike knew how to find me. He got me together with Tina's mom, who was visiting, and her

sister, Alline, and he had us get this private eye to find her. When he found out where she was, up in Laurel Canyon, I had to go there with Ike and his friends and knock on the door while they tried to hide in the bushes. I said, "Ann, it's me, Robbie. Ike's out here, and he wants to talk to you." I didn't get an answer, though, so I walked away again. I wished I could have just disappeared.

Tina: I figured out what was going on right away. Ike knew I liked Robbie, and he thought he could get her to talk me out of the house. I didn't say a word. Since I'd left Ike in Dallas, I hadn't spoken to anyone on that side of my life—not Rhonda, not Alline, not my mother, nobody. Because I knew how much control he had over them all. So now I just kept quiet, and Anna Maria started going into this Portuguese-maid routine: "Sorrreee . . . ees no one home." Like that. And Robbie kept asking, "Is Tina there? Is *Ann* there?" I got up and real carefully peeked out the window. Just what I expected. Right across the street from the house was the Rolls-Royce. And there was Ike, in his jump suit and his boots and his big belt— looking real bad, right? And there were three or four straggly cars parked behind him, all filled with every kind of low-life guy you can imagine—wearing the bad hats and the belts and all that stuff, too. They looked like a bunch of Mexican *banditos*—all comin' to get little Tina!

Well, we simply called the police. They came and I said to them, "I am Tina. This is Ike. I left him, and I'm *not* goin' back." The cops went over to Ike and they firmly said, "Sorry, this is private property and the owner has asked you to leave."

But now Ike knew where I was. So he called Anna Maria's sister, and she called me asking if I would talk to him on the phone, which I did. Ike wanted to know if I would have a meeting with him. I said sure.

Oh, I was strong by then—*strong*. He showed up in a car with his driver, and I got in. He could've done any-

thing to me that he wanted—but he wasn't able to. He just sat there fumbling with his hat, and I saw fear in him. Real fear. I had always been under his thumb, but now I was strong, I was my own person, and he had never dealt with me on that level. He saw now that he had absolutely no control over me anymore, that I had outgrown my fear. And that scared him. We talked over coffee somewhere, but not about much, apart from the fact that I wasn't coming back to him. He drove me back to Anna Maria's, and I got out of the car and said good-bye.

Secluded in his Bolic Sound world, Ike brooded and raged over Tina's departure.

Ike Junior: When she left, he stayed up for four-teen days straight. He started doing more coke and stuff, and I got kind of bummed out. He was trying to cut an album on himself—I remember one of the songs he was working on was called "I Can't Believe What You Say." I kept trying to keep him at it, but every time the phone would ring and I'd answer it, he'd be sayin', "Who's that? Who's that? I wanna talk to 'em!"

I was trying to stick with him, you know? But then one night he beat me in the head with a forty-five—a *cocked* forty-five—for no reason. I never told nobody about this. I had to go to the hospital, and then the police were in-formed. They said, "Don't you want to press charges?" I said, "No, I don't wanna press charges. You guys can't protect me from him." But that's when I started getting away from that studio situation with my father. 'Cause I said to myself, "He's not gonna get any better."

Ronnie: After my mother left, we didn't hear from her for a while, because she was healing up. My father started drinking, then he started recording songs about her. One of them was about how he was "gonna go

down South, get me another one like that other one." He worked on that for ages, but he never put it out.

I remember I had to ask him for some money to get new pants for school. He said, "I don't have the money. I'm in a world of trouble." He even cried—kind of had like tears in his eyes, you know? Because she had left him.

Ann Cain: After Tina left, all the dates for that tour they were on had to be canceled, of course. And then the promoters started calling, and filing lawsuits. Ike's way of dealing with all this was *not* to deal with it. He just went into his little studio and locked the door. Pretty soon I left, too. But Ike would still come around my house in the middle of the night, ringing the buzzer, wanting to know if I was *sure* I hadn't seen Tina. Sometimes he'd really grill me about it. But I hadn't heard a word from her.

Two days after their meeting in the car, Ike sent all four of the children to live with Tina. He sent along their bedclothes, pets, and other impedimenta, but no furniture, and not a plate or a spoon. They would need such things soon: Encumbered with kids, Tina felt she could no longer impose on Anna Maria. At this point, to Tina's surprise, Ike gave her a thousand dollars to rent a small house for the kids on Sunset Crest Drive in Laurel Canyon. "It was strategy," she says of Ike's gesture. "He gave me enough money for one month's rent, and figured I'd have to start working with him again when the next month's came due. I was way ahead of him, though." Completely on her own now, she called back Rhonda Graam, unemployed since bailing out of Ike's world, to help her reestablish some semblance of a career. Their first order of business was to create cash flow. Since it had been Tina who walked off the final Revue tour, and not Ike, she suddenly found herself legally liable for reimbursing all the promoters who

had scheduled and advertised the tour's now-canceled dates. Court papers were pouring in, but Tina had no money to pay. Her professional situation was similarly grim. The Ike and Tina Turner name was now mud with promoters; and as a solo act, Tina herself was an unknown commodity. At the age of nearly thirty-seven, she found herself starting over at the bottom of the business.

Rhonda Graam: There was no band, and no money to put a band together with, so I started booking her onto every TV show I could. Guest appearances. I had to use a pseudonym—called myself "Shannon"—to make the bookings, because Ike had put out so many threats against anybody who tried to help Tina. She did a lot of *Hollywood Squares*, and I got her on this *Brady Bunch* variety show, and *Donny and Marie*, and the *Cher* show, and a *Laugh-In* revival. This was our only source of income. She was on food stamps and I was getting unemployment every two weeks, and between checks we'd charge things on my credit cards: I had a Mobil, a Diner's Club, a bank card. Then each time we got some money, I'd say, "Okay, dear, we've got five hundred dollars here and we've gotta pay the rent, the gas, the water." Tina's so funny. I remember one time, after we'd paid all the bills, she said, "Well, there's twelve dollars left over—here's six for you, and six for me." She split it with me, twelve bucks.

It must have been late August when we went up to Las Vegas to see Ann-Margret. We just wanted to get away from L.A. and the Ike thing for a couple of days. But after Ann's show, we were back in her dressing room and the phone rang. "Tina, it's Ike." Well, you could've heard a pin drop. We thought: "Oh, no—he's even tracked her down here."

* * *

Tina realized that Ike was not going to exit the scene gracefully. Her initial petition for divorce, on grounds of "irreconcilable differences," had been filed at Los Angeles Superior Court on July 27, less than one month after the Turners' Dallas blowout. But now, with Nate Tabor driven off the case, she was without counsel. Fortunately, Roger Smith, Ann-Margret's husband, knew of a tough divorce lawyer named Arthur Leeds. Tina got in touch.

When Leeds, of the Los Angeles law firm of Gottlieb, Locke and Leeds, entered the divorce proceeding on Tina's behalf at the end of August, he was startled by the state of her suit. Under California law, she was entitled to half of the Turners' community property, which was considerable. But when Tina had tried to picture Ike liquidating his assets and peacefully turning half of the proceeds over to her . . . well, she couldn't. And to haggle with him, she knew, would be to remain tied to the man for as long as he could manage to stall and stymie her. Thus, her only ultimate, nonnegotiable demand, she informed Leeds, was her freedom.

Tina's divorce petition asked for four thousand dollars a month in alimony and one thousand dollars a month for child support. Along with continued custody of her own son, Craig, she also asked for legal custody of Ronnie, her son by Ike. Tina doubted she'd ever see such sums, but Arthur Leeds was determined to try. This attitude did not endear him to Ike.

Tina: Ike called Arthur "that motherfuckin' Leeds." He did not like him. Because Arthur couldn't be scared away. We had a couple of meetings in his office, and Ike was raising all kinds of hell, but Arthur talked right back to him. Finally, we went to court, and I testified for about five minutes—just stated my name, the details of the marriage. I was prepared to give everything away if I had to, and when the judge found this out, he called Arthur and me into his chamber. He said, "Young lady, are you

sure?'' I said, "I'm *positive,* Judge.'' Then I said, "Actually, there is something he has that I want.'' You see, Ike always kept the presents that people gave me, and he had some crystal jewelry that belonged to me in his safe at the studio. But then Ike said he didn't know anything about it, that that safe was empty. That son of a gun! I immediately said, "Forget it.'' He said, "No, no, Ann, uh . . .'' I said, "No—*forget* it!'' I wasn't about to go through any game with him about what was in that safe. The judge was looking at the two of us like, "God*damn,*'' you know? I walked out of that courtroom and Ike was giving me this stare that said, "You bitch, you haven't seen the last of me yet.'' I looked right back at him, and I was thinking, "Oh yes I have.''

So the next thing Ike did was call Mike Stewart, the head of United Artists, our former record company. Ike was negotiating a new record deal, as we were not under contract to anyone at the time of the split. Mike asked me to come to his office to meet with Ike and discuss what was going to be done. I went, and that's where I told Ike that not only was I never coming back to live with him, I wasn't going to record with him, perform with him, or anything else, either. Ever. And that's when the trouble started.

Rhonda Graam: I had been living in Reseda, and after I started working with Tina, my house was set on fire twice. Then I spent a few days at the Sunset Crest Drive house, helping her fix the place up, and when I got back to my house again, the windows had been blown out with a shotgun. So Tina told me to come back and stay with her and the kids. There was a hill behind her house that was covered with ivy, and to make sure nobody could sneak up that back way, her son Craig had strung Coke bottles on a string and hung it across the yard. We were all pretty scared. Then one night we heard all these gunshots out front—everybody hit the floor. We called the police

and went to look, and all the windows in my car had been blown out. We all slept on the floor that night. Tina's room had a skylight right over the bed—no way she was gonna sleep under that—so she moved into this walk-in closet and slept in there.

Tina: One night, Craig answered the door and a policeman was standing there. I came out and said, "Yes?" He told me they had heard that Ike was hiring a gunman to "take me to the ballpark," as he put it. Craig almost died. I mean, here was the *police* saying this man's gonna murder his mother. I figured Ike had probably just started this rumor himself, to scare me, so I said I'd deal with it. But I was afraid: I could deal with Ike, but if he really did have a hit man after me . . . well, you can't deal with those guys.

Arthur Leeds: Some detectives from the homicide squad came to see me, too. They said an undercover agent had heard that Ike had hired a guy to kill Tina and to kill or scare me. But they never arrested him. Tina never *wanted* him arrested.

Tina: I just started traveling with a gun. I began taking my thirty-eight with me every place I went. But then, I guess it must have been early December, I got stopped for running a red light in West Hollywood, and the traffic cop spotted the pistol in my handbag. Boy, he grabbed his gun and pulled me out of the car and told me to get my hands up—I was terrified. I'm going, *"What? What?"*

He took me down to the station to book me, but when they found out who I was . . . well, they knew all about Ike Turner. So they kept my gun, but they let me go.

* * *

During their previous meeting at UA, Ike had suggested that Tina enlist label chief Mike Stewart as her new manager. Although she realized that Ike's intention in recommending this course was to keep her on familiar territory where he could monitor her activities, she nevertheless did need management badly if she was going to rebuild her shattered career; and Stewart, friend though he still was to Ike as well, was the only contact she really had in the business. Stewart agreed to help, and advanced her a sizable sum of money to mount a stage show. Since the most easily accessible market, given Tina's solo status and immediate financial requirements, was the cabaret circuit—Vegas, Tahoe, big hotels like those of the Fairmont chain—that was the tack she took. A band was hired, complete with horn section. A quartet of dancers—two male, two female—were enlisted to cavort by her side. Jack Good, the erstwhile *Shindig* producer, was contracted to design the new act, and Bob Mackie, couturier to Ann-Margret and numerous other glittery headliners, was engaged to whip up costumes. Considering the period—1977 was the year disco exploded with *Saturday Night Fever*—Tina's glitzy new show was a wise business move. If she felt compelled to cover a trendy hit like the Trammps' "Disco Inferno," well, she covered it with *oomph*. And she retained some of the more Tina-identified oldies—"River Deep," "Proud Mary," "Honky Tonk Women." No more "A Fool in Love," though. No "Poor Fool" or "I Idolize You." And never again would she stroke and groan her way through "I've Been Loving You Too Long."

Tina debuted the new act at an obscure club up in Vancouver, British Columbia, on a night that was not without glitches.

Rhonda Graam: We had this kind of "Hey, Big Spender" number, and Bob Mackie had designed a breakaway suit for Tina to wear when she sang it—a vest, a black shirt, a hot-pink tie with a big diamond stickpin, a

white fedora. The whole inside seam of the pants and the back of the vest were held together with Velcro and snaps, and when the two male dancers grabbed them, they were supposed to fly away and leave her standing there in this lace leotard and a garter belt with one stocking—just one—attached to it. Well, we had never done stuff like this before. One leg of the pants didn't come off, she had to sort of kick it away. Then I saw that the stocking wasn't hooked to the garter belt, it was just hanging down around her ankle. I thought I was gonna have a coronary. But Tina is always totally collected and together. She just nudged one of the dancers down on his knees, propped her foot on him, and pulled the stocking up and fastened it. I don't think anybody realized it wasn't part of the show.

Tina: I never tried to be anything else but what I was. I never tried to sing jazz or classical songs. I sang rock 'n' roll, and R & B, and blues the whole time. What I did do—something I always wanted to do when I was with Ike—was get the new show to make a little bit more sense. I wanted to sing some ballads. I always wanted to show people that I could sing.

Now, when I say I can sing, I know that I don't have a "pretty" voice. My voice is not the voice of a woman, so to speak. That's why when I choose my music, I think of men. I can relate to their delivery, I'm attracted to it. When I first started working with Ike, it was all men and just me, and I had to sort of keep up. So I had to take a lot of my training and my patterns of singing from the guys. It wasn't about girls and beauty and femininity.

Well, now I had my own band—a big band. It was a dream come true. The guys were in tuxedos, but it was fun. We made fun of it like, yeah, we can dress up in tuxedos but let's wear bow ties to sort of look like waiters. And the music was the total opposite of how we were dressed.

The show made sense because that's where we were

working—in the cabaret places that needed this type of production. I got great reviews. I got standing ovations for the first time in my life. I don't remember standing ovations when I was with Ike. So I felt I was doing something right—and *I* was the one who did it.

Back in L.A. after this Canadian sojourn, Tina continued feeling heat from Ike and his many minions. Ike was unhappy. Tina's attorney, Leeds, was becoming annoyingly inquisitive about the actual value of Ike's 55 percent interest in the Anaheim apartment complex, and had taken legal steps to ensure that Ike couldn't sell it. Leeds was also casting covetous eyes at Ike's other assets: a piece of property out in the Valley, his four music-publishing companies, his Bentley, his Rolls, his brand-new Cadillac Seville. Ike was deeply reluctant to part with any of these possessions. His phone calls to Tina conveyed increasing displeasure. But she had rent to pay—for both house and furniture, about a thousand dollars a month—and four teenagers to feed and clothe. She was starting to make money on the cabaret circuit, but whatever wasn't plowed back into band salaries and production costs had to be earmarked for payback to the promoters of the last, never-launched Ike and Tina tour, whose subpoenas were now greeting her at every gig. The first thing to be done, she decided, was to relocate. In a moment of shrewdness, she put the touch on BMI, the song-licensing organization that collected royalties for Ike and Tina material, for an advance on several songs she had written. With this money, essentially snatched from under Ike's nose, she moved into another little house, this one nestled in Sherman Oaks. Her new whereabouts, however, were only briefly a secret.

Tina: It was late one night, and Craig and his girlfriend, Bernadette, were staying over. We heard this gunfire, and everybody woke up and ran to the side win-

dow and looked out at the carport. Bernadette's car was on fire, and the back window of my car had been blown out with a shotgun, and somebody had fired into the house, too. Whoever did it—ha!—had only poured gasoline *around* Bernadette's car, but then the tires had caught fire and we were afraid the gas tank was going to explode. Craig went out—he was *mad*—and moved the car down the driveway to the street and put out the fire. Then we called the police, and they sent a SWAT team over to pick the pellets out of the place. By this time, the cops were getting real interested in this Ike Turner guy.

That little incident did it for me. I really did need money then, because I had nothing but losses coming in. And I had worked for sixteen years to build up Ike and Tina Turner, and all that that partnership had become. Now Ike had it all. It wasn't fair, but no amount of money was worth *this*. I just gave up.

The divorce dragged on for a while longer though, with Ike continuing to butt heads with Arthur Leeds, and going through five different lawyers of his own in the process. Tina continued touring provincial clubs to pay off her debts—to all the stiffed tour promoters, to Mike Stewart—and to maintain her band, her crew, her house, and her kids' upkeep.

Tina: I still went shopping even though I didn't have a dime. I went into Charles Gallay, a shop I had found when I was with Ike. Charles definitely had what I wanted—quality things that cost a lot of money. Yeah, I gotta tell you—I love it when the clothes are expensive. You know why? They look right and they last. It's not just about price—there's got to be quality there.

Now, I've got to tell you about Janet. I love Janet. She could understand me and relate to me. There was never a time when I walked into that shop when she thought, "Oh

no, Tina doesn't have any money." Janet was smarter than that.

Well, there came a time when there was a very expensive dress that I had to have. I loved it and I wanted it. It felt like gold in my hands, but I said to myself, there's no way I can spend that kind of money. So I said to Janet, "Janet, kinda—don't sell this dress." Now, how can you say that to a saleswoman? But Janet wasn't just a saleswoman, she was Charles's ace boon top saleswoman and buyer. So she could hold the dress and she knew I was going to find a way to buy it. She had a few buyers that came in, but Janet didn't push it; she didn't tell them you can wear it this way and do this with it.

And finally—a year later—I did find a way to get that dress!

For the four boys, life with Mother was a strange new world. All their lives they'd been surrounded by the glittery tokens of their parents' show-biz success—the lavish house, the big cars. And of course there had always been housekeepers to tidy up. Tina's new circumstances were Spartan by comparison, and she even expected them to help with the housework. The kids, especially Michael—the hardest hit by Ike and Tina's split—were disoriented and rebellious. In her increasing absences, Tina knew she was losing control of them. Finally, she placed a call to her old housekeeper and onetime nemesis, Ann Cain.

Ann Cain: Tina said that she needed me, that I was the only person she knew who could handle her boys. They were turning her house into a nightclub whenever she was working out of town. She said, "I won't throw my kids out. These are my kids, and if I've got a place, they've got a place. But I've got to have this worry about what's going on at the house." She said to treat the place as my own, to move into her bedroom when she was

away. She said, "I cannot afford to pay you now. But if you will do this, one day I *will* pay you. Because one day, I know, I'm gonna be back up there."

Tina: I was already going to all kinds of readers all over the world before I left Ike, and a lot of them kept seeing this same thing: that I would one day be successful on my own. I was happy to hear this, of course. And there was more. One reader in California, Ginny Matrone, used to read for me two or three times a week, even when I didn't have any money. She said there would be a divorce; that I would be afraid, but that it would work out well.

I also saw some better-known readers. Jacqueline Eastland was quite precise, but she was really expensive and I couldn't afford her very often. Peter Herkos would pick up things, but he'd rationalize a lot, too. One day, a few years before I finally left Ike, this girl that he was producing a record for, Judy Cheeks, came to me and said, "Tina, there's this woman you should meet, she's fantastic. Her name is Carol Dryer. She's a soul reader."

Well, I had to wait three years—until 1977—before I finally got to see Carol, but when I did, she changed my life. She told me about my *other* life. She told me about Egypt.

It was so strange. One time, years before, I had been walking through an airport with Ike and I saw this picture book for sale, *Ancient Egypt*. The minute I laid eyes on it, it took my breath away. I had to have it, even if it did cost seventy-five dollars. Ike said, "What the hell you want that for?" But he bought it for me. Paging through that book on the plane, I could feel my pulse pounding, and I didn't know why. I just knew there was a buzz, a connection, some feeling I'd never encountered before. Carol Dryer told me what it was: my Egyptian lifetime.

* * *

Dryer related to Tina the saga of the great Egyptian Queen Hatshepsut, a favored daughter of the Pharaoh Thutmose I, born some fifteen hundred years before Christ. Hatshepsut had married her half brother, who reigned for a brief eight years as Thutmose II. At his death, with his son (by a lesser wife) and successor, Thutmose III, being only ten years old, Hatshepsut governed the empire as regent, and soon was proclaimed Pharaoh herself, dominating what subsequently became a joint reign with her stepson until her death two decades later. Although purportedly a peace-fostering monarch, Hatshepsut was said to have appeared in battle with her warriors, and was sometimes depicted in statuary as a man.

For Tina, this tale offered metaphorical parallels with her own life—particularly her tormented relationship with Ike. Dryer saw Tina as the warrior woman Hatshepsut, succeeding her brother-husband to power and ultimately outshining him, then dominating her stepson's reign. Such a prior-life scenario, according to Dryer, suggested what had gone wrong for Tina in *this* lifetime.

Tina: Carol told me that Hatshepsut had taken the throne from her brother because he was very perverted, and she knew that he would destroy Egypt. But that I had had no right to take the throne from him because no one has a right to *take* from others, and so there was karma, guilt from that other lifetime, that I had to live through in this one. Ike was the brother, of course, and this time I had to *let* him destroy his empire—which is what he finally did, lost everything he had. He had also vowed that he would torture me as I had tortured him in that other life—and he sure did deliver on that promise. When Carol told me all this, I started to cry. I had come through it. I had lived through all the pain and finally I was just about free of him. The lives with him were over. But according to Carol, the story of *my* life still had quite a bit to go.

* * *

With Ann Cain once again enlisted to supervise the kids, Tina braced herself for the windup of her divorce suit against Ike. By the fall of 1977, it had become the usual maze of contested possessions and indignant assertions. In leaving him, Ike contended, Tina was taking with her the principal asset of their marriage: the "good will" inherent in the entity of "Ike and Tina Turner." Ike valued the loss to him of this "good will" at $750,000. (He also claimed that he and Tina had never actually been married all those years ago—a point that, under California common law, was by now moot.) Leeds valued Tina's furs and jewelry, still under Ike's control, at $100,000. Ike said they were worth $500,000. (His own jewelry, Ike declared, amounted to only $30,000.) He put the worth of the Anaheim apartment complex at between $200,000 and $400,000 (Leeds suspected it was closer to $1 million), and on Bolic Sound he placed a decidedly conservative value of $200,000.

Tina's head was reeling. To continue wheedling over all of this might take years, and who knew to what heights his harassment might escalate? No more, she decided. She told Arthur Leeds to throw in the towel.

Leeds: She just gave it all away, over my objections. We were supposed to get the Anaheim property appraised and then get some other piece of property equal to half of that appraised value. But she ultimately gave that up—made a gift to him of between two hundred thousand and five hundred thousand dollars. He kept the studio, he kept his publishing companies, his four cars, the North Valley property—he took all of the property, but none of the debt. He was supposed to pay all their community debts; we took a security interest—like a mortgage—in the Anaheim property to make sure he paid this debt and couldn't just sell the property and keep the money. But she

gave up that security interest, and that allowed him not to pay.

Tina got these two Jaguars that she had, a 1970 and a 1971. Ike was supposed to give her her furs and jewelry, but he probably never did. She retained her writer's royalties from songs she had written, but Ike got the publishing royalties for both his compositions and hers. Tina walked out with what was on her back, essentially. But she said, "My life's more important."

Tina's divorce from Ike was effectively sealed by November 1977, but not decreed final until March 29, 1978. In the interim, Tina hired bodyguards and began considering what to do about the final Ike-related aspect of her life—the kids. Craig and Ike junior would soon be twenty, Michael would be nineteen, and little Ronnie would turn eighteen. The time had come, Tina concluded, for each of them to decide what he wanted to do in life. Ronnie was musical—he'd played bass in a junior high school band called Manufactured Funk—and Ike junior, having apprenticed at Bolic Sound, was now a talented sound engineer. Perhaps Tina could involve them in her new career. She started with Ike junior, who had been commuting between her house and Bolic to work. In the wake of the pistol-whipping incident with his father, Ike junior was looking for a new job. Tina hired him to engineer the sound for her stage show. When Ike found out about his son's new employment, however, he was greatly irritated.

Ike Junior: He was mad because he had been paying me eight or nine hundred dollars a week to work at Bolic, and I was working for her for four hundred dollars a week. I'd come to the studio and he'd be fussin', and I'd say, "All I'm tryin' to do is work." I was caught between the two of them. It really messed it up for me.

* * *

Tina: Ike was just trying to harass me in any way that he could. Ike junior was doing great with me. Then Ike told him he couldn't work for me anymore. I said fine: I could not afford to let Ike creep back into my life again over something like this. So I got a new sound man, and that was that, I thought.

Well, when we arrived at the airport to catch a plane for my next show—me, Rhonda, the band, my bodyguard—who should be waiting for us but Ike Turner. We pulled up and there he was, standing with two of his musicians, wearing a white suit and a red shirt. I thought, "Your *taste* sure is going downhill, Ike." He looked just like a little Mafia guy. He was there to check up on Ike junior. I said, "He's no longer with me," simple as that. There was nothing else for him to say to me, so he walked up to this big bodyguard I had and he said, "Let me just tell you something: You just make sure I don't ever see your fat ass *no*where, do you understand that?" And this poor guy—he had been expecting to deal with screaming fans or something, not this. He was scared to *death*. Airport security showed up at that point, and we rushed off to catch the plane. Ike and his boys got back in their Rolls-Royce and the driver cranked it up, and as we looked back we saw the car start shaking and sputtering, and then smoke started pouring out from under the hood. And there they sat, the godfather and his thugs, stuck in their smokin' Rolls. What a cartoon.

Convinced that Ike would continue using the four sons as pawns in his feud with her, Tina was faced with a difficult decision. The boys might be unsure of their own vocations, but they were older now than she had been when she started singing with the Kings of Rhythm, and so, she decided, they were old enough to start searching. She knew what *she* had to do now—work, first of all, and perhaps finally pursue some long-delayed dreams.

<p style="text-align:center">* * *</p>

Tina: I always like to say that I graduated from the
Ike Turner Academy, and that I took care of all my
homework before I left him. I had sworn I wouldn't leave
until he got his studio, and the chance to live out his
dreams, and he got that. And I promised I would stick
around until the boys were grown, and they were now. It
had bothered me to see them raised by housekeepers so
much, but Ike kept us out on the road constantly and there
was no other choice. But when I *was* home, I tried to be a
good mother to those kids—made sure they ate good food,
had all the vitamins and everything, saw the best doctors if
they were sick. If they had a ball game at school or
something, I always went, because Ike didn't want to
know about any of that stuff. So I had *done it*. I had been
their mother, I had been his wife. Now it was time to be
me.

There had already been problems, which was why I
finally asked Ann Cain to come back. I knew what was
going on. I would come back to L.A. from working
somewhere and the house would be a mess. They would
say, "Well, we're used to a housekeeper." I said, "So am
I!" One time I went out and rented a carpet cleaner and
came back and told them to start cleaning the rugs and
washing the windows, the place was a disgrace. Ike junior
said, "I'm not doing it." I said, "Then you get out."
Because I was not going to live his life-style in my own
home. So that's when Ike junior went back to live with his
father for a while.

Then there was Michael. Michael would sit home every
day and just play his guitar. I didn't know what was
happening then, but it turned out that he had emotional
problems. I think it had hurt him the most that Ike and I
were getting divorced.

The doctor finally decided that Michael wanted to be
with his father. I had always felt that, too—that he sort of
resented having to live with me because I wasn't really his

mother. So he went to live with Ike, too. Fine. Nobody was out on the street. Then I discovered that Ronnie had a serious drug problem—I didn't know how bad it was until I had a few meetings at his school. So I put him into a strict private school up in Oregon, and he got into Scientology there and seemed to really be cleaning his life up. After a year, I brought him back to L.A. and put him in this Scientology school he wanted to go to. Bought him a new wardrobe, a new bedroom suite, took him in again, gave him a car to drive to school in. But then he got back into the drugs and he stopped going to this school I was paying for. Finally, when he was supposed to be helping me move into the Sherman Oaks house, I found him sitting around with his tape recorder, talking on the phone, getting high. And here I was moving and cleaning and doing all this work. That really did it. I packed his stuff up. I was *so mad* with him. I just decided that this was the only way he was ever going to learn. I kept tabs on him, though, and after a while, when he moved into an apartment with a friend of his, whose mother was paying *his* rent, I contacted her and just quietly started paying for Ronnie to live there, too, although we didn't let him know that at the time.

Okay. Craig was always working at one job or another, and he eventually went into the navy—I couldn't afford college for him then—so he was no problem. He was always more of a family boy. But I did become a little bit estranged from the other boys, I know. I think it had to be that way. Because they had loved Bolic Sound, and they loved the image of Ike and the cars and the women. They needed to get to know what that life was really about, and what their father was really like. I already *knew*. So with Ronnie and Michael and Ike junior, I had no options. I had to work to support myself and to support them—but I couldn't support their habits and their laziness, too. They were used to that other kind of life, but that life was over for me. I had to adjust to a new way of living, and so did

they, if they intended to stay with me. It wasn't a matter of being strict with them. It was a matter of surviving.

Tina released her first post-Ike solo album in 1978, a record called *Rough*. Hints of her future direction were evident on this LP—especially in her cover of Bob Seger's hard-rock gem, "Fire Down Below." But the musical backup was uninspired, and when *Rough* went nowhere, United Artists, Tina's financially troubled label, dropped her—in the U.S. at any rate. UA at the time was slowly being taken over by Capitol/EMI, the British-based recording consortium; and EMI, convinced that loyal U.K. fans would always buy her records, decided to keep Tina under contract for the British market. Festival Records in Australia maintained a similar commitment. For the rest of the world, though—the U.S., Europe, the Far East—Tina was suddenly labelless.

Ike put out a UA album in 1978, too. Titled *Airwaves* and billed as an Ike and Tina Turner release, it was a collection of tracks Ike had cut before Tina's departure, including such suggestive titles as "Two Is a Couple," "We Need an Understanding," and "Just Want Your Love Sometime." It too quickly disappeared.

By 1979, Tina was becoming restless with the state of her career. She was working regularly again, but always in cabaret, the boneyard of burned-out entertainers. She would soon be forty, and felt that her creative fires had yet to reach full flame. The cabaret circuit, particularly Vegas and Tahoe, paid good money—and money was a crucial concern. But Tina wanted more. She didn't like her new lounge-act image. And frankly, cabaret was never going to be her kind of thing.

The unexpected key to Tina's transformation was *Hollywood Nights*, a 1979 television special mounted for Olivia Newton-John, the Grammy-winning Australian singer who was red-hot from her starring role the year before in the

movie *Grease*. Olivia was in every way the opposite of Tina—blond, polished, totally pop. And it was perhaps for this very reason that she invited Tina to appear in a cameo on her TV show. The timing was fortuitous. Rava Daly, one of Tina's dancers, had already been suggesting that she get in touch with Olivia's manager and erstwhile boyfriend, Lee Kramer. Daly said he was in the market for new acts to manage. After the TV special, Tina became interested and decided to pay Lee Kramer a visit.

The Road Back

Lee Kramer was a wealthy Englishman who had moved to Los Angeles some years before with his girlfriend, Olivia, and begun managing her career. In the summer of 1979, through Olivia, he met Roger Davies, a twenty-seven-year-old Australian who had arrived in L.A. only a few months before, intent on making it in management himself. A native of Melbourne, Davies—burly, blond, and endlessly affable—was a typical product of the music-mad sixties. He'd played bass in school bands, wrote record reviews for local papers, imported foreign rock albums to sell to his friends, and in general aspired to a life in music. After one year at university studying politics and economics with the vague intention of becoming a journalist, he'd dropped out to work as a roadie for a Melbourne band, with whom he soon moved north to Sydney, Australia's sunbathed gateway city. There he hooked up with Consolidated Rock, a major band-booking agency, and before long he left to form his own management company, Sunrise Management, which guided the careers of many of the country's top rock acts—Daddy Cool, the La De Das, Billy Thorpe and the Aztecs, and a

band called Sherbet. The Sherbs, as they later became known in America, turned into his primary interest, and by the mid-seventies he had left Sunrise to manage the group exclusively.

But, on New Year's Eve, 1978, Sherbet told Davies they'd decided to semiretire. By February 1979, Davies, now gigless but intrigued by an earlier taste of the States, had relocated to L.A.

By this point, Davies had done it all: worked as a musician, a roadie, a rock journalist, a booking agent, a manager. He knew the music business cold. But getting started in L.A. wasn't easy. He had some contacts among the local community of expatriate Aussies, and soon began managing one of them, songwriter Steve Kipner, who later provided the 1981 hit "Physical" for Olivia Newton-John. Olivia was an acquaintance from earlier days, and through her Davies met Lee Kramer. When Kramer subsequently offered him a job, he took it, even though it entailed no salary, only the use of an office in Kramer's management suite and the right to continue working with his own clients while pursuing unspecified projects for Kramer's expanding operation. A week or two after Davies started working there, Kramer and Olivia ended their romantic attachment, and Davies was detailed to supervise her affairs.

One day, Kramer told Davies that Tina Turner was coming in to discuss management. Davies was surprised to hear that she was still around. Tina had been enormously popular in Australia, but it had been ten years since he'd seen her perform, and that, of course, had been with the Revue. Tina arrived with Rhonda Graam in tow and proceeded to explain her situation, which was in many ways difficult. By now, Tina was in debt to Mike Stewart, the backer of her show, to the tune of about $200,000. Then there was the Internal Revenue Service, to which Tina owed some $100,000 in back taxes, plus penalties—a total, more or less, of another $200,000.

* * *

Tina: I walked in and Lee took me back to meet Roger. Roger's office was *full* of stuff (and it's still full of stuff). His explanation for that is that you're a genius when your desk is cluttered. It worries Roger when he walks into someone's office and their desk is clean. If you know Roger, it's pretty funny.

So to make a long story short, the reason I went with Roger was because of his eyes—the way he sat there and looked at us. We were jamming on a demo tape I'd brought in. It sounded very much like Ike's productions because that's where I still was—and that's the truth. And Roger did not hear a hit record there or even anything that would get airplay. He just sat there and his eyes said "un-unh."

Now, I don't like yes men and I don't want someone to hold my hand. Roger wasn't overly mushy. He would simply say what he had to say and we'd go on from there. Roger knew that in order to do anything with me, things would have to be changed. And the way Roger communicated that to me felt right.

Tina was certain she could be big again with the right management, and was willing to work hard—was there any other way?—if Kramer would take her on. Kramer was enthusiastic, but that was his natural bent. Davies was more skeptical, and suggested they see Tina perform before making any commitment. Rhonda suggested they fly up to San Francisco the following week, where Tina would be starting a two-week residency at the Fairmont Hotel. After several postponements, Kramer and Davies eventually made the trip in time to catch the final night of Tina's engagement.

Roger Davies: We arrived at the Fairmont and I

thought, "Jeez, what a strange place." We went into the Venetian Room, this big ballroom, and there were chandeliers and people in tuxedos. I said, "This can't be the right room." Then Tina's band came on, and they were all in tuxedos, too. I thought, "This is very weird." But then Tina came on, and she had so much energy, she blew me away. It was amazing. I mean, she did "Disco Inferno" with smoke bombs, and the two male dancers ripped part of her dress away—it was bizarre. But underneath all that stuff, she was still really great. I thought, "Well, the second show can't be as good." But it was *better*. People were standing on tables; the chandeliers were shaking.

Kramer, likewise impressed, agreed to take Tina on, and assigned her too to Davies's care. But getting her work outside the cabaret circuit, he soon discovered, was virtually impossible. So they played Canada a lot, and Davies began making mental notes about certain aspects of her act he thought needed changing. Essentially, this included the band, the dancers, the clothes, and the music she was performing. A radical revamp was definitely in order if she was ever to rise up out of cabaret purgatory.

Toward the end of 1979, Davies received a startling offer for Tina's services—$150,000 for a five-week tour of South Africa. This was an astonishing amount of money at the time, and would make a significant dent in Tina's aggregate debt to Mike Stewart and the I.R.S. (The promoters of the scuttled Ike and Tina tour of 1976 had by then for the most part been repaid.)

But: South Africa? The country's policy of apartheid—institutionalized racial segregation—was a matter of universal international opprobrium. On the other hand, many black acts played South Africa without incident—just as many American companies did other kinds of business with the country—and the tour being offered to Tina was of venues in which all audiences would be mixed, black

and white. Davies laid out the pros and cons of the proposed venture for Tina. South Africa was segregated? Well, she had been born and raised in a segregated country—the United States of America. But the venues would be integrated? Okay, she said. "Maybe we'll bring people together a little bit."

Davies, however, would be unable to accompany Tina halfway around the world. He would shortly be required to escort Olivia, still his principal managerial interest, to London for the opening of her new film, *Xanadu*. Thus, Tina would have to be consigned to the care of Chip Lightman, a young Floridian who'd recently appeared on Lee Kramer's doorstep in response to an earlier-made promise of employment. Lightman had never been out of the country before—had never been *anywhere* in this kind of capacity—but Davies suggested that Rhonda might show him the ropes out on the road. The South African offer was accepted.

Tina: I didn't even know who Chip was, and Rhonda wasn't about to teach him anything that would weaken her position as road manager, so Chip wound up mostly sweeping the floor, brushing the stage off. I had my son Ronnie along on that trip—it was one of our good periods, before we had the big blowup—and he was playing bass. We played Johannesburg, Durban, Capetown. Sun City, the big entertainment center, hadn't even been completed at that time, so of course we didn't play there. It was the usual touring situation, so I didn't get to see much. I remember someone said to me, "Do you know what's happening in this country?" And I said, "No." Because I really didn't, beyond the basic fact that it was segregated. I didn't know how bad things really were. I had this new management, and no record company, and I was kind of caught up in my own problems. A few years later, South Africa became this big political thing, and I got a lot of criticism for playing there. I've since been

invited to play at Sun City, and turned it down. I played South Africa in 1979, and at that time, it was not such a big deal, as far as I knew.

Rhonda Graam: I remember one bus driver didn't want our two dancers, Annie and Lejeune, to get on his bus together because one was black and one was white. But other than that, we weren't involved with the racial situation. We played three-thousand- or four-thousand-seat theaters, and Tina got incredible press down there. Blacks and whites saw the shows together, and they enjoyed them. At the time, there was nothing at all controversial about us being there.

Ronnie: There were lots of blacks at the shows, and there was not one place where the audience was all white. South Africa was real quiet—it was like everybody had to get off the streets at ten o'clock or something. And of course the black people there had less than blacks even *usually* have. It was not the kind of place I would want to live. But our shows there were real mixed.

Following the South African swing, Tina and company returned briefly to the States, then left again for an extensive tour of Australia and Southeast Asia. It was an eventful outing. In Singapore, the scanty costumes worn by Tina and her dancers were impounded by straitlaced local customs officers and didn't arrive at the venue—an oversized Chinese restaurant, as it turned out—until shortly before showtime—with a customs clearance stamp impressed in black ink on the crotch of each outfit. In Manila, where the Beatles had once been deported in the middle of the night after refusing to meet with dictator Ferdinand Marcos and his wife, Tina was instructed to avoid a similar fate by hauling herself off to the palace after her show to make nice with the Marcoses and their rich friends.

It was in Bangkok that Roger Davies's dissatisfaction with Tina's show—which had brought her back from oblivion to at least the level of cabaret stardom—came to a head.

Roger Davies: I had been changing the act a little bit all along, because I thought it was too disco, too Vegas. By now, this band she had was starting to drive me crazy. She was paying them all far too much money; we seemed to be working just to pay the band. And they weren't rock 'n' roll, which I knew that Tina needed to be. It was breaking my heart. So in Bangkok, Tina and I finally had a real heart-to-heart. I said, "Listen, if we're ever gonna change this act, Tina, we've got to change everything—fire everybody. You've got to get rid of this band, get rid of the dancers, get rid of Rhonda, the sound guy, the lighting guy." They'd all been there for years, and they all complained and whined. I said, "You've gotta get young guys, make it rock 'n' roll. Get rid of these tuxedos and the silver-lamé sequins—I can't stand it, you know?" And Tina said, "Okay, I'll do it."

Tina: Roger said, "There's no way you're going to rock 'n' roll with those people you've got. You've got to get some young guys who can really play, with a lot of energy. And get rid of the Bob Mackie costumes—and get rid of that long hair you're wearing." Because I was still wearing these real long wigs. Well, I guess it was about the beginning of 1981 that I finally did it. I called Rhonda and told her I was letting her go—I couldn't have two people trying to manage me. Then I called the guys in the band and told them. I kept the two girls, but I let the male dancers go. And then we got on the ball and started auditioning.

* * *

Tina's new band came together in 1980 during yet another stand at the Fairmont Hotel in San Francisco. First she called in Kenny Moore, a gospel-schooled piano player and singer. Through auditions she found guitarist James Ralston, who in turn brought in Boston drummer Jack Bruno, and together they recommended Bob Feit, a New Yorker, to play bass. These four men became the core of Tina's touring band. Money was tight, but the tuxedos had to go. Tina decided to outfit her boys in karate suits, which were cheap and somewhat stylish.

From the Fairmont, they returned to foreign parts. Even without a record to promote, Tina could still sell out three nights at London's Hammersmith Odeon—the Brits had never abandoned her. She played Poland, Czechoslovakia, Yugoslavia. Roger rooted out gigs in Bahrain, Abu Dhabi, Dubai. But Stateside dates were still sparse, and usually tacky. What to do?

Davies was pondering this problem when he got a call from Olivia Newton-John. She had totally split from Lee Kramer and wanted Roger to likewise leave Lee and manage her. Roger called Lee, who said fine. Tina was stunned. How could she stay with Lee Kramer? She never saw the man. It was Roger with whom she had slogged some of the most forlorn quarters of the globe, Roger who was aiming her back into rock 'n' roll, where she wanted to be. And it was Roger with whom she would stick.

Davies now found himself managing the two most dissimilar female singers in the music business. At the time, this was no easy task. The record industry, reeling from disco boom to sudden postdisco bust, was undergoing its worst-ever economic slump. Radio formats were at their most restrictively dull and predictable. Young bands with new sounds withered unheard. One ray of hope appeared with MTV—Music Television—a new national cable channel that on August 1 began airing rock 'n' roll promotional clips, or videos, twenty-four hours a day. This sudden enormous demand for videos was filled in large part by

imaginative product from two countries where video was already an established broadcast form—England and Australia. Roger Davies, a Melbourne native, already had a highly developed appreciation of video's promotional powers.

Right now, though, Tina still needed a proper showcase—a place to present her anew to the rock public and its attendant reviewers, writers, and record-company executives, all of whom would have to be won over if she were to reclaim a recording contract. Roger had some tapes to shop—Tina had mortgaged her Mercedes for a twenty-five-thousand-dollar bank loan and cut some tracks with L.A. session musicians; among the titles, Murray Head's "Say It Ain't So, Joe," the Rolling Stones' "Out of Time," and an old Sherbs tune called "Crazy in the Night." These tracks weren't great, but Tina—who'd walked into the studio and belted them out live—sounded strong.

But none of the record companies wanted to know about Tina Turner. "River Deep"? The Revue? The band in the hot pants? History. Roger knew he needed prestige dates, places for Tina to play where the record execs and the writers and the new generation of fans would already be in attendance. He needed a place where a buzz could be built.

Roger Davies: That was the first time we went into the Ritz, in New York, in the summer of 1981. And the Ritz was where everything started to happen for us. It was the hippest club in the city at the time, and I called Jerry Brandt, the owner, and I told him, "Look, I want to play the Ritz. I don't care if you give us any money, but I've got to get her into New York." Tina hadn't played New York in ten years! I told Jerry we'd play the date for the price of accommodations and band salaries, and Jerry, God bless him, got real excited. He decided to take this on as a personal challenge. He took out fall-page ads in *The Village Voice,* and he got every celebrity he knew to come

along—Jagger came, Warhol, De Niro, Diana Ross, Mary Tyler Moore. It was incredible. And Tina was great. We sold out and wound up doing three nights there, S.R.O. The reviews were just unbelievable.

The buzz had begun. Roger Davies began pestering Carl Arrington, an editor at *People* magazine—the arbiter of mainstream pop-cultural importance—for a cover story: "The Return of Tina Turner." Davies also took note of an impending U.S. tour by the Rolling Stones, which was scheduled to kick off in Philadelphia in late September, play its way out to the West Coast, and then wind up with five massive dates in the New York City area in early November. Tina was still buddies with the Stones—who knew what might happen? Roger lined up a return engagement at the Ritz for October.

This second stint at the Ritz was equally triumphant. In an era of cooled-out "new wave" performers, Tina created a critical melt-down. Whirling across the stage with her Ikettes-like dancers, lashing the rhythms of her new rock band with a voice that could still rattle ice cubes in the most distant mezzanines, she seemed to summon up all the best energies of a more untamed musical past. In the best rock 'n' roll tradition, Tina made the ageless power of the blues seem brand new again.

Rod Stewart turned up at one of these second Ritz shows, with Richard Perry, the record producer, in tow. Stewart was scheduled to appear on *Saturday Night Live*, the popular NBC-TV show, that very weekend. Would Tina join him? She would. That Saturday, they duetted on a three-year-old Stewart hit called "Hot Legs." Tina had an audience of millions.

Back home in L.A., Richard Perry took Tina into his Studio 55 to record "Help." But the song's eerie onstage fervor proved difficult to capture, and the sessions came to naught.

One night, Roger escorted Tina to the Rolling Stones' show at the L.A. Forum. Backstage afterward, the boys were as usual delighted to see her, and offered congratulations on her recent *Saturday Night Live* spot with Stewart. "But why," asked Keith Richards, "aren't you touring with us?" Tina said, "You never asked me."

This situation was quickly rectified: Tina and her band were slotted in as an opening act for the Stones' three November shows at New Jersey's twenty-thousand-seat Brendan Byrne Arena, about twelve miles from New York City. This was it—the ultimate gig. Every record executive, critic, and scene-maker that mattered would be on hand for these dates. To top it all off, Mick Jagger asked Tina if she would join him onstage for a duet during the Stones' set. "Sure," said Tina, nailing this longtime dream before it could slip away. "What song would you like to do—I know 'em all!" Jagger suggested "Honky Tonk Women," and when Tina roared out onstage in her black leather pants and leopard-print boots those three nights in New Jersey, the crowd went wild.

Tina: A lot of people have complimented my musicians by calling them a "hot" band, and they are. When I hired the new band—James Ralston on guitar, Jack Bruno on drums, and Bob Feit on bass—I needed musicians who could do the cabaret shows, but who could also communicate the rock-'n'-roll side of myself, and they've been able to adjust to everything I've had to do. When we performed with the Rolling Stones, it gave us a chance for the first time to think about how we wanted to look onstage in a rock setting—tight leather jeans for one, baggy jeans for another. I remember us all working on that and the feeling of unity we got.

That was something which bound us together, we all felt the excitement of working with the Stones.

I remember one night in Chicago soon after these guys started working with me, we were in the middle of a show

and all the electricity went out, so there was just the drums and me. Jack kept playing and I kept singing for quite a few songs until the electricity came back on. After the show Jack came to me and tapped me on the shoulder and just said, "You're all right." That meant a lot to me.

Around this time Tina found herself facing new challenges in her personal life, too.

Tina: When I was with Ike, the entire sixteen years, another man never touched me. And I don't think it had anything to do with fear. I can truly say that; even if I'd had the freedom or the desire, I would have had to have left Ike first.

Just after I left Ike, I felt in the back of my head that I might need a boyfriend-manager, but I realized I would have been stepping back into the same old situation.

I'd already tried my luck with American men, so I decided to look into the European variety. There was a Dutchman, an Italian, and a young Greek. Why am I attracted to European men? They're so sensitive to women. I'm not putting down American men, but European men have a different attitude when it comes to women. You can feel it. He comes with flowers—he comes with one flower—it doesn't matter if he got it out of your front yard. He came with it. He was thinking of you. European men realize that we are special, that we are different.

I love being a woman. I love every oil, every cream, every bottle of perfume, anything made for women. And we need that stuff. It really says something about us, and I think it's fantastic.

Although I had a bad relationship, it did not change my feelings about men. I love men. I love the way their bathrooms are not cluttered. I can't stand to walk into a man's bathroom and find out he's got more creams and cologne than I do.

I'm not crazy for very pretty men. Beauty in a man is not a weakness of mine. But I admire it if it comes with strength.

I date periodically, only when I truly care. I am not a person who can have a physical relationship without an emotional attachment, otherwise it's a waste of time and energy. I find most people don't realize that, so they go from one relationship to another, from marriage to divorce; it's a syndrome that it seems some people find hard to break.

My favorite parts of a man are his hands and feet. Why? I can't explain about feet, but hands are vitally important as a man often can have grace in his hands in a masculine way, just as a woman's hands can have beauty in a feminine way.

After I left Ike, I began to wonder about equality—socially, racially, spiritually, and between men and women. Even knowing that men are physically stronger, I cannot believe that we women are not equal. But I think each couple must find its own balance of equality. This is why I have not given up on men. I find them stimulating, obviously because we are different. I did not rush into a relationship right away with the men I did meet because there were signs, warnings, that said, "These people are not willing to work on themselves for the equal balance." And it does require work. Until I find that I will continue as I am.

Still, I love masculine men, but even so I find "masculine" hard to define. I find it in many different types of men. It's simply a matter of taste for all of us, of course. For men, a man must hold his ground while still respecting me and my strengths as a woman. I will allow him to be a man if he allows me to be a woman. It all comes back again to equality.

I came to look at the man of my life as my dessert. He's coming. Everything else has come, all the main courses. And my dessert is on the way. I can wait.

* * *

In May, the Central London chapter of the British Musicians Union proposed to ban the use of synthesizers and drum machines from both recording sessions and live performances. This knuckleheaded notion, apparently advanced with an eye toward preserving jobs for the union's moldy older members, was doomed to languish. The new generation of young synth-diddlers and garage recording acts was by now unstoppable. Two of the style's most imaginative exponents, Martyn Ware and Ian Craig Marsh, had settled on an ambitious first project for their B.E.F. production group: an album of their favorite pop songs—a motley agglomeration ranging from "These Boots Are Made for Walking" to David Bowie's "Secret Life of Arabia"— sung by some of their favorite singers over synthesized B.E.F. backing tracks. Sixties pop icon Sandie Shaw would get a tune, as would Gary Glitter, the glam-rock progenitor. When Ware and Marsh recorded an elaborate track for "Ball of Confusion," a 1970 funk hit by the Temptations, they decided to seek out the legendary Tina Turner and see if she would agree to sing it.

Roger Davies: Martyn sent us the instrumental track and it was pretty interesting. Tina didn't know what the song was yet, or that it was this old R and B number. Martyn said, "We'll give you two thousand dollars and two first-class air tickets to England," so we went. When we got there, Tina found out the song was "Ball of Confusion" and she freaked out. She was so afraid of being put back into any kind of category like "oldies" or "R and B." But we got her to cut it anyway, in one day. Martyn and Ian were impressed—I don't think they'd ever heard anyone sing like that before. They made us a standing offer to come back and do a record.

* * *

Slotted in among the other one-off tracks on the B.E.F. album, *Music of Quality and Distinction*, Tina's performance of "Ball of Confusion" blew away memories of the old Revue days and repositioned her as an up-to-the-minute artist before an adventurous young audience that revered black R & B but loved all the new musical technology as well. It marked the beginning not so much of a comeback as of the discovery of Tina's timelessness. Unfortunately, while the album was a hit in Britain, it was never released in the U.S.

By this time, Davies had decided to approach the Los Angeles headquarters of Capitol Records, the American company owned by England's EMI. Capitol's management was not particularly interested in Tina—she was another of the old UA acts that they'd already dropped from the label's roster. But Capitol's International branch, aware of her success with B.E.F., was enthusiastic, and so was staff producer John Carter. The possibility of a recording contract—a very minor recording contract—began to develop. As negotiations got under way, Carter took Tina into a studio and began cutting demo tracks with her—the Animals' "When I Was Young," the Motels' "Total Control," and a half dozen other songs. All systems seemed to be *GO*.

The actual hammering out of the Capitol contract took nine months, but by the spring of 1983, it was ready for signing. Then, suddenly, the company underwent an executive shake-up. New chiefs were brought in, and they were not inclined to complete any pending deals initiated by their discredited predecessors. Davies was astonished. John Carter had already spent fifty thousand dollars doing demos with Tina. She was finally getting the chance to prove herself as an artist, after seven years of struggle. And now Capitol wanted to scuttle it.

Still reeling from this apparent catastrophe, Davies returned with Tina to New York for another stint at the Ritz. Sitting in his hotel room before the show one night, he

received an unexpected phone call. It was from Capitol's New York office.

Roger Davies: They said, "Hello, we need to get some names on your guest list—there'll be sixty-three people from Capitol coming down to the show tonight." I said, "What! What's happening?" Well, what it was, all the Capitol and EMI people from America and Europe were in New York for a listening session for David Bowie's new album, *Let's Dance*. Bowie had just signed with EMI-America, a Capitol subsidiary here, and the listening party was a big event. Afterwards, they asked David what he was doing that night, and he told them, "I'm going to see my favorite female singer." They said, "Who's that?" He said, "Tina Turner." They went, "Tina Turner? Oh, yeah—she's on our label!" So they called me, I put them on the list, and they all came down: the executives, the A and R guys, the people from International. It was perfect for us. David brought Susan Sarandon, who'd starred with him in *The Hunger*, and he brought Keith Richards and John McEnroe—it was the weirdest combination of people. And the show that night was fantastic—Tina had the place standing on its head. Incredible. It was a real event, exactly what we needed.

Tina: I generally don't care about meeting "big stars." They parade through your dressing room trying to find out "what she's like," and you get face cramps from smiling back at all of them. Who needs it? I would always say to Roger, "I don't want to know who's in the audience, don't tell me. I just want to concentrate on my performance." But that night I could tell something really special was going on, because he was *flying*, he was so excited. I figured there must be some movie star in the house, but I put it out of my mind. Then when I walked onstage I looked out at the crowd and I swear, it was so packed there seemed to be people hanging off of the

rafters. I thought to myself, "What are they all doing here? I don't even have a record out." But I guess they were just into what I was doing, because it turned out to be a wonderful show.

Backstage afterwards, I walked into the reception room and there they all were: Keith and David and Ron Wood, all these people. I said, "Thank God I didn't know they were in the audience, I really *would* have been nervous." Then I spotted this tennis player I'd seen on TV. I shouted out, "McEnroe!" He got real embarrassed and started hiding his face. I went up to him and said, "Why, McEnroe, *you're shy*. I don't believe it—with all the hell you raise on the tennis court?" Then he started laughing, and I started laughing, too. And pretty soon I was laughing all over the place.

David and Keith and I posed for all kinds of pictures, and David asked when I'd be doing a new record. We started talking about material, and after a while he said, "Let's go back to Keith's and listen to some songs." So around three in the morning we all headed over to Keith Richards' apartment in the Plaza Hotel. He had this great big tape machine set up there, and you could see that he used it constantly. We had some champagne, and Keith cranked up his machine and started playing all this old music, and suddenly it dawned on me: This was what these guys did. They would go back to all this old music that they loved—blues and R and B—and they would change it around and make something of their own out of it. Because the feeling that was in that old music was something they felt, too. But they made it new again, and that was what had always attracted me to the Rolling Stones' songs. I had never actually realized it before. That was a magical evening.

Roger Davies: Keith started playing piano—he knows all these old songs from the twenties and thirties, Hoagy Carmichael stuff, real old R and B, it's amazing—

and then around five o'clock Ronnie Wood started playing
guitar. It was so loud, I can't believe nobody complained.
Room-service trolleys were rolling in right and left, cham-
pagne was flowing, and Tina and David were sitting there
singing all these old songs David remembered—one of
them was "I Keep Forgettin'," that old Chuck Jackson
song he wound up recording for his next album. It
really was a great night. Tina and I walked out of there
about eight-thirty in the morning and we were just going
out, "McEnroe!" He got real embarrassed,
"Whoaaa . . ."

In the wake of the star-infested Ritz event, Capitol
Records confirmed Tina's contract and was suddenly eager to
record her. Davies grew cautious. Capitol suggested Mick
Ronson, David Bowie's former guitarist, as a producer,
but this didn't seem the right match. And the demos Tina
had cut with John Carter sounded too mainstream, too
American, somehow. Tina needed distinctive treatment.
Davies implored Capitol to let him record in England. The
British loved Tina, they saw her as he did—as a world-
class and thoroughly contemporary performer. And B.E.F.
had already offered to produce her next single. Capitol was
dubious: B.E.F.—weren't they one of those "new wave"
groups? Get serious.

But Davies wouldn't relent. He called EMI in London,
to which Tina was still signed for the British market, and
pitched the possibility of working with B.E.F. again. EMI
got excited—B.E.F., in its alternate incarnation as Heaven
17, was one of the hottest new groups in the country. "Get
Tina over here," Davies was told.

To pay their way to England, Davies had to rustle up a
quick gig. The only one he could find was in Stockholm—an
outdoor fair where Tina, bandless for this trip, would have
to sing in front of a twenty-piece orchestra. Amazingly,
she managed to pull even this off—her indefatigable per-
formance garnered front-page press coverage the following

day. Then it was on to England to cut the single with B.E.F.

Roger and Tina arrived in London, and Davies booked recording time at EMI's Abbey Road studios. He still had no idea what sort of song Tina would be doing, but Ware had assured him by phone that he would write one. On the eve of the session, however, Ware informed Davies that, because of promotional commitments for his group's current record, they'd had no time to custom-craft a tune for Tina. Davies was frantic. Ware agreed to a crash meeting, and arrived at Davies's room in the Grosvenor House that night bearing stacks of his most treasured vintage singles. Unfortunately, these all turned out to be old R & B songs, unwelcome mementos of Tina's dead-and-buried past. She said, "Aren't you guys into any rock 'n' roll?" It is unknown whether Ware, a pop musician in his twenties, appreciated the irony of being asked this question by a woman of nearly forty-four. However, he did admit to an intense admiration for the work of David Bowie. Tina too was a Bowie fan. Roger ran out and bought every Bowie cassette he could find in local shops. One song, "1984," sounded worth a try, but nothing else seemed right. Finally, Roger told Tina they would have to come to some kind of compromise; the session was only hours away. He suggested that she attempt a version of "1984" and also cut "Let's Stay Together," an old Al Green hit that Ware had played earlier in the evening. Tina thought this over and said, "Yeah, I don't mind that one."

Roger Davies: We went into the studio the next day and of course there was no real band there—just a room full of computers and keyboards and this big Fairlight synthesizer. Tina said, "Where's the rhythm section?" Martyn pointed to this TV screen on the Fairlight and said, "Here it is!" Tina turned to me and said, "Roger, these guys are weird."

So Martyn and his engineer, Greg Walsh, began pro-

gramming the tracks on their computers—for hours and hours. Finally, they were all set up, they had the basic instrumental track down, and Tina walked in and sang "Let's Stay Together" live, in one take. It just *happened*. I got shivers down my back. These guys couldn't believe it. Tina said, "Let's do it again, I'm just getting warmed up." And they're going, "No, no—we'll keep this!" They went ahead and added all their little bits and pieces to it, and that take became the single.

"Let's Stay Together" was Tina's most nuanced and incandescent performance to date—a reading of the song as masterful, in its particular way, as Al Green's 1971 original. Cushioned on a bed of lushly synthesized strings, Tina threw a lock on the lyric from the opening line—"Let me say that *sii-ii-iince* . . . babeh . . . since we been *together*"—and claimed it, beyond dispute, as her own. Her delivery, never before so intuitively detailed, swooped and fluttered around the melody, darting up to nail a note, then winging away, feinting on a phrase, free-falling amid the gentle percussion, soaring heavenward again in an arc across the upper registers. Unique and instantly mesmerizing, Tina's rendition of "Let's Stay Together" stands as one of the most exhilarating love songs of the eighties.

EMI in England was delighted with the record. Capitol, back in Los Angeles, didn't want to know about it. "She's *wailing*," they said. They declined to release "Let's Stay Together" in the United States. Davies, dumbfounded, immediately began setting up a fall tour of Europe for Tina to coincide with the upcoming release of the British single.

"Let's Stay Together" was a near-instant smash in Europe.

Tina: I'd hoped something would happen, but I wasn't depending on it. I was depending on my performances. If you're a good performer you can always work

in the business—you'll be a little shining star, not a big one. And I had no problem with that because that's how I'd come up.

Anyway, there it was—a hit. I was working in the Persian Gulf. It was crazy over there. They were ringing me, saying, "Oh, guess what the charts are!" I was going, "Call Roger! Leave me alone!" So I came back to London and did a tour with the hit record. Was it huge! When I sang "Let's Stay Together," everybody sang it with me. And I looked out there and thought, "So this is what it feels like." Working Vegas was fine, there were standing ovations, everyone was into it, but when the rock kids get into you, it's a whole different feeling.

Roger had booked a few dates for Tina and her band at the Venue, a small club owned by Virgin Records, and wound up having to extend her stint to eleven nights to accommodate ticket demand. Celebrity attendees included Jeff Beck, the onetime Yardbirds guitarist, who bought his own ticket to get a good seat. The press was adulatory. Tina appeared on *Top of the Pops,* and Roger recruited the show's director, David Mallet—a Jack Good protégé from the *Shindig* days who earlier had filmed a promotional video for Tina's "Ball of Confusion"—to shoot a clip for "Let's Stay Together." Done on the quick-and-cheap, this video simply depicted Tina singing the song while her two dancers, Ann Behringer and Lejeune Richardson, swayed along, sinking to the floor at one point to embrace Tina's spread legs. This gesture, as everyone realized after it was too late to rectify, suggested some kind of lesbian subtext. Tina got a chuckle out of that, as did Ann and Lejeune. The press, though, *wanted to know.* Roger Davies, far from being annoyed, welcomed whatever attention his act could command. "There was this heavy rumor around that they were all gay," he recalls, "or that the two girls were

transvestites. We didn't deny it. I said, 'Sure, whatever you want.' "

By December 1983, "Let's Stay Together" was a Top 5 hit in Britain, and selling briskly on the Continent too. With its unusual aura of hope, warmth, and tender commitment, the song seemed to connect with people in a way that cut across boundaries of age, race, and nationality. In Los Angeles, however, Capitol Records still didn't want to know.

By this time, import copies of the "Let's Stay Together" single were pouring into New York. The record was a dance-club sensation. When Frankie Crocker, an influential Manhattan DJ, started pushing the tune on black radio station WBLS, Capitol Records, waking as if from a deep sleep, decided to rush-release the single in the U.S. "Let's Stay Together" entered the Top 40 in mid-February, but because of promotional complications, and perhaps the sales-sapping imports that had preceded it onto the market, it peaked at number nineteen. It went Top 5 on the black charts, though, and Capitol, watching the record explode, suddenly wanted an album.

Davies was flabbergasted. He had already booked thirty more British dates for Tina. She was by now incredibly hot there, and all these shows were sold out. Capitol told him to cancel the tour and get into a studio. Davies explained that Britain was the only market that had supported Tina during her dark years of exile from the charts: He would not cancel the dates. Capitol was insistent. At wits' end, Davies called John Carter, still in Capitol's A & R department, and explained his plight. Tina had to record in England, he said—the writers and producers and musicians who most loved her, who respected her talent, were all based there. London was full of fresh new ideas, new approaches. One way or another, Davies concluded, he and Tina were going to England. There, somehow, they would put together the most crucial album of her career. Carter, a staunch Tina supporter, concurred with Davies's

argument. He told him to go make the record in England, and he would sign Tina's recording bills as they trickled back to Los Angeles.

In England, Tina took her band out on the road to play dates while Roger remained in London to hustle material for the album. He had brought one song with him—"Better Be Good to Me," a tune off an album by an American band called Spider, written in part by group member Holly Knight. Tina and Roger both loved the song. Now all they needed was nine more. In some desperation, Davies called Terry Britten, an old Australian acquaintance. In the sixties, Britten had been the lead guitarist with a fabled Australian group called the Twilights (whose lead singer, Glenn Shorrock, had since achieved international success with the Little River Band). Britten was now a resident of London. Davies asked if he could whip up some songs for Tina. Britten proffered two possibilities. One was a tune called "Show Some Respect"; the other, co-written with his partner, Graham Lyle, was "What's Love Got to Do with It." Britten sent demo tapes. Davies noted that "What's Love Got to Do with It" was very pop—an interesting tune, even if not exactly Tina's style. After inveigling Britten into producing his two songs as well, Davies booked studio time for the recording session and then moved on to his next target: Rupert Hine.

Hine was the producer of the Fixx, a London-based "technopop" dance band that had charted three Top 40 hits in the U.S. the previous year. Davies admired the production sound that Hine imparted to Fixx records—cool, spacious, heavily electronic, and highly commercial. "I thought Rupert was a very good song guy," he said. "And Tina and I both wanted songs, not just dance riffs. We wanted to highlight her voice. Tina had been a screamer so long, people didn't realize what a great *singer* she is. It had never been captured on record. So we wanted strong songs, and producers who understood song construction. I wanted Rupert to produce 'Better Be Good to Me.' "

Hine liked the song, and agreed to help. Moreover, as a Tina admirer since the "River Deep" days, he offered to come up with another song for her—something special, something tailored to her spirit, to her soul. Hine asked if Tina would meet with Jeanette Obstoj, his girlfriend and songwriting partner. Obstoj listened as Tina narrated her life story, from the cotton-field years back in Nut Bush through Ike and the Revue—the whole saga of pain and oppression, right up to the present and her interest in Egypt, her belief in other lives. Jeanette then used this information to write the lyrics for a song she called "I Might Have Been Queen." "I remember the girl in the fields with no name," it went.

"When Tina got the demo," says Davies, "she had tears in her eyes. She was surprised at the story the lyric projected."

Around this time, Roger decided to play the two Terry Britten songs for Tina, "Show Some Respect" and "What's Love Got to Do with It." Disaster: "I can't sing these," Tina said. "They're wimpy."

Tina: I didn't know that "What's Love Got to Do with It" had been written for me. I just thought it was some old pop song, and I didn't like it. I didn't think it was my style. By that time, I felt that I had *become* all the songs that I was covering—by the Rolling Stones, Rod Stewart—that I had become rock 'n' roll. I had just never thought of singing pop. So when Roger played this song for me, I just said, "Oh, no, not that one." But he was really serious about it, about both of these songs, and he kept playing them for me. It got to the point where I'd run and hide behind a door whenever he put them on.

Roger Davies: Finally, I said, "Tina, you've got to at least meet Terry as I've booked the studio and I've got Terry to produce them." She said, "Oh, well, all right." So we go over to Mayfair Studios, and there's little

Terry with his guitar. He's petrified. He's idolized Tina for years. "Nutbush City Limits" is his favorite song, he's used those riffs a thousand times, you know? Tina walks in and says, "I don't like your songs." "Good start," I thought. She says, "They're not rough enough." Terry says, "Well, we can just change 'em around a bit." Then he starts fooling with them on his guitar—and he's a terrific guitarist. Tina starts getting excited. She says, "Well, I have to have them in a higher key." No problem—he fastens a capo onto the guitar and just slides it up the neck.

Davies next contacted another pal, Ed Bicknell, manager of the wildly popular Dire Straits and of Paul Brady, a singer unknown in the U.S. but nevertheless much admired by such American songwriters as Bob Dylan. From the Brady catalog, Bicknell offered Davies a powerful sociopolitical rock tune called "Steel Claw." Unfortunately, he said, there were no spare Dire Straits compositions lying around. And Mark Knopfler, the group's singer, songwriter, and lead guitarist, was leaving imminently for New York and so would be unable to whip up anything new. But wait, Bicknell said—there was one track left over from the sessions for Dire Straits' *Love over Gold* LP. Knopfler had left the song off the album because he'd felt it was only appropriate for a female singer. He had never even put a vocal on the track. It was called "Private Dancer."

Roger Davies: Ed called Mark, who dug out this raggedy old lyric sheet, and the day before he was supposed to leave for New York, he went into AIR Studios and put a vocal on this track, to give us the melody. I wanted to just use that track and put Tina's vocal on it, but getting clearance from Dire Straits' record company would've been too complicated. So Mark offered to let me

use the band to rerecord it—and to do "Steel Claw," too, since some of them had played it with Paul Brady before. Great: two more songs and a band as well.

As recording bills began to mount, Davies called John Carter over from Capitol in the States to monitor the album's progress. Carter arrived, liked what he heard, and pitched in to produce the Dire Straits–backed "Private Dancer" and "Steel Claw" tracks. Since the band was without its lead guitarist, Davies approached Jeff Beck. Beck came in with a brand-new pink Stratocaster, played brilliantly, and afterward had Tina chisel her signature into the body of his guitar.

It was a frantic period. Tina and Roger taxied all over London meeting prospective producers, trying out songs, scrambling from session to session. Terry Britten, having finished recording his own two tracks, was induced to produce an aggressively electro arrangement of "I Can't Stand the Rain," an Ann Peebles hit from 1973. Rupert Hine was finally persuaded to produce "Better Be Good to Me." By early April, adding in "Let's Stay Together" and "1984," the Bowie song from the B.E.F. sessions (and, for Europe only, the Crusaders' version of "Help"), Davies had an album's worth of tracks. It had taken two weeks and—figuring in airfare, hotel, food, and taxis— about $150,000. Davies delivered the tapes to Capitol at the end of April, then embarked with Tina on a four-month tour as opening act for the now-solo Lionel Richie.

Overnight Sensation

Capitol quickly released "What's Love Got to Do with It" as a first single to prepare the way for the soon-to-come album. To Davies's horror, American radio greeted the song with a collective yawn—only eleven stations added it to their play lists. He leaned on Capitol to promote the single more heavily, and by the second week of its release, it was being aired on more than one hundred stations. By mid-June, when *Private Dancer,* Tina's LP, entered the album charts at number 101, "What's Love Got to Do with It" was a Top 50 pop hit, and climbing rapidly.

Private Dancer was a spectacular achievement, a polished pop album of extraordinary stylistic range and emotional resonance. With four separate producers credited, it stood the cult of the celebrity producer—a phenomenon that had flowered mightily since Phil Spector's day—on its ear. Here, the singer was central. The music ranged from reggae to electro-funk to hard rock 'n' roll (in the case of the scorching "Steel Claw," almost heavy metal), with Tina's awesome vocals the only unifying element. The lyrics were definitely adult, but tough, almost punkish,

and decidedly female. And while no encompassing theme had been intended, several of the titles—"I Might Have Been Queen," "What's Love Got to Do with It," "Show Some Respect"—had the appearance of referring to Tina's life story. *Private Dancer* was a high-tech dance-rock album that also sounded deeply personal—an unprecedented effect.

Critics were enthralled. *Rolling Stone* awarded the record four stars. Tina's voice, said the *Los Angeles Times*, "melts vinyl." But would the album yield hits? In a recording career that now spanned twenty-four years, Tina had never had a number-one record. By mid-August, with the Lionel Richie tour concluded, "What's Love Got to Do with It" stood at number two.

Tina: I'll never forget the day. Roger and I were in New York again, playing the Ritz, and he came to my hotel room and told me he'd just gotten a call from George Miller, the Australian director. He said George wanted me for a part in his next Mad Max movie. I went, *"Owww!"* Just started screaming. Because only the day before I'd been telling Roger how much I wanted to do another movie. Something larger than life, like the part Grace Jones had gotten in *Conan the Destroyer*—that was the kind of role I wanted. And I loved the Mad Max movies— *The Road Warrior* may be my all-time favorite film. George Miller wanted me to play a warrior woman named Entity, the ruler of a wasteland city called Bartertown. It was perfect. What a way to start the day: my first film role in ten years—and playing a queen again! I was really flying by the time we left for an autograph session at Tower Records, down in the Village.

Roger Davies: It was just supposed to be a normal in-store appearance—meet the fans, sign some albums. But when we got to Tower, there were people lined up around the block. Tina said, "Who's here, Bowie or

somebody?'' I said, "Those people are here for you, darling." She couldn't believe it. We got in there and Tina started signing albums one after the other while I ran to the phone every five minutes to call *Billboard*—it was Wednesday, the day they gave out the next week's chart positions. Finally, I got the word. I went back to Tina—she's sitting at this table autographing records—and I said, "Bad news." She looked at me. I said, "The single is number one." She jumped up and started screaming, right there in the middle of the shop—"My record's number one! My record's number one!" And all the people started cheering. It was wonderful. Then *Rolling Stone* called to say they were putting Tina on the cover. Everything came together all at once.

Suddenly, Tina was everywhere. She did TV talk shows, she did radio, she did endless telephone interviews. MTV rotated her videos around the clock. *US* magazine hailed her as "the grittiest rock & roll singer in the world." After a quarter of a century, Tina Turner was an overnight sensation.

Private Dancer sailed up the pop charts and by September had reached number three, where it remained for the next three months, stymied in its rise to the very top only by the combined might of two unbudgeable blockbusters: *Purple Rain,* the Prince album, and Bruce Springsteen's *Born in the U.S.A.* Tina's LP went on to spawn two more Top 10 singles, "Better Be Good to Me" and "Private Dancer," and a European hit with "I Can't Stand the Rain." The album remained in the Top 100 for more than two years, and ultimately sold ten million copies around the world. Tina's comeback became a saga, a parable.

She wound up 1984 playing out a series of small U.S. and Canadian dates that had been booked before her breakthrough. Then, she boarded a plane for Australia to star with Mel Gibson in the George Miller epic *Mad Max*

Beyond Thunderdome. Later she turned down director Steven Spielberg's offer of the starring role in *The Color Purple* ("I've *lived* that story," she said).

She was back for the American Music Awards, held in Los Angeles on January 28. After picking up top prizes in the female-vocalist and video-performer categories, Tina made her way to a recording studio at A&M Records to join Michael Jackson, Lionel Ritchie, Bruce Springsteen, Bob Dylan, and forty-two other top rock, pop, and R & B stars in a ten-hour session for "We Are the World," the benefit single for African famine relief.

By the time of the 1984 Grammy Awards ceremony in February, Tina was the toast of three continents. Already embarked on a triumphant European tour, she flew back to L.A. for the awards show and was greeted by an outpouring of affection unprecedented in the hype-addled precincts of the music business. Undeterred by a debilitating case of the flu, Tina took the stage to perform "What's Love Got to Do with It" and was rewarded with a standing ovation. In a state of delight and disbelief, she picked up Grammys for Best Female Pop Vocal Performance (for "What's Love") and Best Female Rock Vocal Performance (for "Better Be Good to Me"). Then, capping the most unforgettable night of her career, she strode up onstage again, this time with Terry Britten in tow, to accept the sweetest statuette of all: for "What's Love Got to Do with It," Record of the Year.

Clutching her prize, she thanked Roger, she thanked Terry, she thanked everybody who had ever believed. Then, holding the Grammy aloft, the past forgotten now, the future a vast plain of unbounded possibilities, Tina said, "We're looking forward to many more of these." The crowd, in its clamor, made clear that she was not alone.

Epilogue

Tina: Is this a happy ending or what? A number-one record, a movie, *Mad Max Beyond Thunderdome*, with Mel Gibson, enough money to pay off all those debts I had. Me, a girl from the Tennessee cotton fields, sitting on what feels like the top of the world.

I had help along the way. Ike Turner gave me my start. Mike Stewart kept me working after the divorce. Anna Shorter and her sister, Anna Maria, took me in and chanted with me. And Roger Davies, especially, encouraged me to change and grow, to find my way back into the kind of music I love. But the real power behind whatever success I have now was something I found within myself—something that's in all of us, I think, a little piece of God just waiting to be discovered.

What was it like when I walked out and left Ike? Yeah—I was afraid. But sometimes you've got to let *everything* go—purge yourself. I did that. I had nothing, but I had my freedom. My message here, and I do hope that in this book there is a message for people, is: If you are unhappy with anything—your mother, your father, your husband, your wife, your job, your boss, your car—

whatever is bringing you down, get rid of it. Because you'll find that when you're free, your true creativity, your true self comes out.

Now, you might not be able to stand that because you might find that your true self doesn't live up to what you think you are. You've got to know what you're dealing with when you purge yourself.

So there I was—dealing with me. Who was I? What did I know? I knew I had talent, but what I didn't have was the backing to get me back into my work. But I never said, "Well, I don't have this and I don't have that." I said, "I don't have this *yet*, but I'm going to get it." Buddhism changed my old patterns of thought, it taught me to be a positive thinker. It helps you to stop saying, "What I can't do and what I don't have," and start saying, "What I am going to do."

I never allowed myself to get lost, even when I was a little girl. I held on to the positive side. I never gave in to alcohol, never gave in to drugs, not even to smoking. I gave in to myself. I went inside of me to help me. It can happen. You *can* do it.

I am very proud of how I came up. I don't know how I would feel if I'd had an upper-class upbringing, but I didn't have it, and I feel very good with myself. If I had another child—I'd like a girl—I can't say just how I'd raise her, but one thing I can tell you is that she will not be spoiled. The whole thing is about earning your way, and you don't really get there until you earn it. That's the real truth.

It might seem that my mother, my grandparents, and everybody who helped raise me were not necessarily nice people. They were good people, but I did not receive a lot of love from them. It's that receiving of love that has been missing from my life.

I found Roger, and by now we're almost like family—we really care about each other, but not in a romantic way. Roger came in, looked at my career, and told me what had

to be done to get to where I wanted to go. I knew he was right.

One of the things I always wanted was to have a home and now I have one. I bought my mother, my family, a house. Now we all have a home. My mother is there. That was a dream of mine.

How can I explain my mother? She's very strong and proud. She never asked for any support from me unless she really needed it. I respect her.

After my divorce, and I got my life together, I sent for my mother to come to Las Vegas to see my performance. When she saw it, she was really quite shocked. She had no idea that I would be able to do that on my own. She thought I needed Ike. And so she was very proud.

During that same period I saw that my mother was unhealthy. Something in her eyes wasn't right. So I invited her to come back to Los Angeles with me and I took my mother to a doctor who was trained in homeopathic medicine, who said that my mother had heart trouble. My mother couldn't believe it because she'd had regular visits to the doctor and had no signs. So when she went back home to St. Louis she went to a heart specialist and found that she had a goiter pressing on one of her heart valves. She would have been dead in five months because it was growing constantly.

When Ma told me I had to explain to her that Alline and I could not come to St. Louis to take care of her and that she would have to move to Los Angeles. She wasn't happy about that, but it was the beginning of us really getting to know each other. I was in the house she lives in now. What's so wonderful about the story is that the bedroom where my mother is now was my master bedroom, and the bedroom where she was when she came is now the room I use when I stay with my mother.

After she got well she became edgy. She wanted to work. She didn't really enjoy living in L.A. It was too big, too confusing. She had no friends there like she had in St.

Louis. I wondered what kind of job would be good for her, because she only knew basic housecleaning and I wanted something more for her. Someone in my manager's office knew of a beauty salon in Beverly Hills that needed a receptionist. She tried that but found that it was confusing, because she had to learn how to work the switchboard and do paperwork and she had no experience with those things. But there was an opening in the back, working with the beauticians, mixing hair colors, serving coffee, things that were a smaller step beyond what she was used to, so she took that on.

She was very happy there and people liked her. It wasn't because she was Tina's mother. Only later, when I had my big success, did they learn that she was Tina's mother. I felt that I had found a good environment for her where she could meet people and see the California way of life, which was so different from what she was used to. St. Louis is like a small town by comparison.

When I got the house for her, though, it seemed better for her to stop working, although she had been happy at work and was very sorry to leave. But she was not in good health, and I wanted a better life for her. So she called her boss and said she wouldn't be able to come back. Of course they were very disappointed. All the clients were asking, "Where's Zelma? We miss her, we want her to make our coffee," and I said, "Ma, sure, they always want that. But now you can go, and they can serve you coffee, and you can still say hello to them and they can find someone else to work. You can still have what you want, but enjoy it in a different way."

I gave a birthday party for her, and she invited all her neighbors and all her friends from work and she showed her house off. My strategy was that they had to know where she lived in order for her to invite them to tea or for dinner. But she had to learn how. She was used to one way of life and she had to learn the new one.

So now I sit here in London in the middle of spring and

all its beauty. I was told once that London was cold, wet, and depressing. And I was also told, through astrology, that every city holds an energy for certain people, where you can achieve anything positive because it's your place in the world. Well, London is mine. It *is* wet. In the winter it is cold, and in the summer you don't get much sun. But I find it beautiful. My career started here. "River Deep, Mountain High" hit here, and that was my first hit on my own. And success has followed me here.

I'm forty-six years old now. A lot of people seem to think that anybody that age ought to be looking around for a place to lie down and die. Why is that? I remember Wilson Pickett came backstage after one of my shows at the Ritz a few years ago. He looked fantastic—I wondered why he wasn't still working. He pulled me aside and asked if I thought I was strong enough to "hold up" under this new success I was having. I said, "What do you mean? I'm not sick." I will never give in to old age until I *become* old. And I am *not old yet!* If I look in the mirror in the morning and don't like what I see, I don't accept that it's because I'm an old woman. I do whatever I can at the moment to bring myself back to life. Perhaps a facial mask, a massage, a sauna, whatever I can do naturally to return the glow to my face. As long as you're alive, why not keep living as beautifully as you can.

It's not a matter of money. Success has brought me many material things: the chance to travel, to experience and learn from other cultures, the opportunity to meet and work with other artists I admire. It's allowed me to secure my family—to help my sons, for example, whenever they decide to help themselves.

So success has been useful to me, and to the people I love. Most of my earthly dreams have come true—I'm glad I never stopped pursuing them. But I always knew that singing and dancing weren't the fulfillment of my destiny. I always seemed drawn to spirituality, but I was

also smart enough to realize that I shouldn't confuse performing and spiritual teaching.

My career is still in bloom, and I'm not ripe enough to teach anybody. When I'm ready, I will devote all my time to that—I'll tell what I've learned. Many of you will listen, and some of you will hear.

**Love,
I, Tina**

Cast of Characters

Pat "P. P." Arnold—mid-sixties Ikette

Artettes—Robbie Montgomery, Sandra Harding, and Frances Hodges: Art Lassiter's backup group; sang on "A Fool in Love"

Mickey Baker—New York session guitarist, partner with Sylvia Vanderpool in the group Mickey and Sylvia; did male vocal on "Think It's Gonna Work Out Fine"

Joe Bihari—one of the four Bihari brothers of Modern Records

Valerie Bishop—introduced Tina to Nichiren Shoshu Buddhism

Carolyn Bond—Tina's high school friend in Brownsville

Roy Bond—principal of Carver High School, Brownsville

Marie Booker—Tina's chanting friend; sister of Anna Maria Shorter

Bonnie Bramlett—briefly an Ikette

Terry Britten—Australian songwriter

Alex Bullock and Roxanna Bullock—Tina's paternal grandparents

Alline Bullock—Tina's sister

Floyd Richard Bullock and Zelma Bullock—Tina's parents

Essie Mae Bullock—"Frog," Richard's second wife; Tina's stepmother

Nettie Mae Bullock—"Pig," Essie Mae's daughter

Ann Cain—Ike's business manager and onetime paramour

John Carter—staff producer for Capitol Records in Los Angeles

Evelyn Currie—Tina's half sister

Joe Melvin Currie and Margaret Currie—Tina's cousins

Josephus Currie and Georgianna Currie—Tina's maternal grandparents

Roger Davies—Tina Turner's current manager

Carol Dryer—psychic reader based in Los Angeles

George Edick—owner of the Club Imperial in St. Louis

Venetta Fields—one of the three original Ikettes

Gloria Garcia—one of Ike's early women in Los Angeles

Jack Good—producer of the *Shindig* TV show, and of Tina's post-divorce stage show

Rhonda Graam—the Revue's road manager

Bob Gruen—photographer who worked briefly with the Revue

Miss Connie Henderson—Tina's mentor-employer in Ripley

Raymond Hill—Revue saxophone player; father of Tina's first child, Raymond Craig

Rupert Hine—producer of the English band the Fixx; one of the producers of the *Private Dancer* album

Mick Jagger—lead singer of the Rolling Stones

Bobby John—singer with the Ike and Tina Turner Revue

Miss Jonelle—housekeeper

Eddie Jones—saxophone player with the Revue

Jessie Knight, Jr.—bass player with the Revue; Ike's nephew

Lee Kramer—English manager of pop singer Olivia Newton-John, and briefly of Tina

Bob Krasnow—head of Loma and Blue Thumb Records

Art Lassiter—St. Louis singer, originally scheduled to sing "A Fool in Love"

Arthur Leeds—Tina's divorce lawyer and onetime business manager

Clayton Love—singer with the Kings of Rhythm

Darlene Love—Phil Spector's favorite vocalist; star of some of his greatest "girl group" records

Larry Levine—Phil Spector's engineer

Bob Mackie—costumer to the stars

Ginny Matrone—one of Tina's readers

Booker Merritt—owner of the Club Manhattan in East St. Louis

Robbie Montgomery—one of the three original Ikettes

Henry "Juggy" Murray—head of Sue Records in New York

Carlson Oliver—saxophone player with the Kings of Rhythm

Richard Perry—Los Angeles record producer

Ruby and Vollye Poindexter—owners of the farm on which Tina's father worked

Ken Russell—director of the film *Tommy*

Anna Maria Shorter—Tina's chanting friend; sister of Marie Booker

Jessie Smith—one of the three original Ikettes

Phil Spector—first of the star record producers; creator of the "wall of sound" and numerous hit singles in the sixties

Mike Stewart—head of United Artists, Ike and Tina's last record company

Nate Tabor—Ike's attorney

Harry Taylor—Tina's first love

Lorraine Taylor—one of Ike's wives, and mother of his sons Ike junior and Michael

Ann Thomas—Tina's friend and successor as Ike's woman

Jimmy Thomas—singer with the Revue

Duke Thornton—the Revue's bus driver

Craig Turner—son of Tina Turner and Raymond Hill

Ike Turner, Jr.
and Michael Turner—sons of Ike Turner and Lorraine Taylor

Ronnie Turner—son of Ike and Tina Turner

Sylvia Vanderpool—one half of Mickey and Sylvia; producer of "Think It's Gonna Work Out Fine"

Martyn Ware—member of the British band Heaven 17 and the production unit B.E.F.

Gene Washington—drummer with the Kings of Rhythm

Johnny Williams—baritone-sax player with the Revue

Annie Mae Wilson—one of Ike's wives; also his business manager in East St. Louis

Florence Wright—Ripley beautician

Bill Wyman—bass player for the Rolling Stones

Appendix B

Tina Turner's Greatest Hits

"A Fool in Love"
"I Idolize You"
"Think It's Gonna Work Out Fine"
"Poor Fool"
"Tra La La La La"/"Puppy Love"
"You Shoulda Treated Me Right"/"Sleepless"
"I'm Blue (The Gong-Gong Song)"

These songs from the Turners' Sue Records days are root-level R & B of a kind that is unlikely ever to be made again with anything near this quotient of unselfconscious artistry. "A Fool in Love," motivated by a band track of unabashed bluntness, has a dark and ominous power whose origins can be traced back to the Delta blues of Ike Turner's Clarksdale youth; and Tina's pulverizing vocal still astonishes. "Poor Fool" and "I'm Blue" are essentially revamps of the "Fool in Love" riff; but it's a hell of a riff, and Tina—even confined to backup on the latter track—still proves herself to be a singer like no other then or since. She works similar wonders on the otherwise melodi-

cally undistinguished "I Idolize You." "Tra La La La La" and "Puppy Love" are strangely intense little pop-blues tunes—decidedly more blues than pop, and all the more intriguing for it. "You Shoulda Treated Me Right" and "Sleepless" are anomalous additions to the early Turner canon: the former a straight jump-band number in the somewhat dated style Ike started out in as a youth; the latter a searing, if unusually stylized, straight blues with no pop pretensions whatsoever. Tina puts both songs over with hair-raising emotional force. "Think It's Gonna Work Out Fine" is as poppy as Ike and Tina releases ever got on Sue. Thanks to Mickey and Sylvia's ministrations in the studio, it is also the least dated of their early singles.

The Turners' original Sue singles, like the albums they subsequently graced, are out of print, difficult to find, and expensive when one does. However, several of the above songs are more readily available on various still-kicking-around compilation albums.

River Deep–Mountain High

The title track of this A & M album, since reissued and still widely available, is a flirtation with sonic melodrama that's extreme even by Phil Spector's standards. It is also his most exhilarating combination of white songcraft with black vocal power, and thus truly one of the most unforgettable pop singles of the sixties. The rest of the album—which could have been solid throwaways for all anyone in America cared at the time—is surprisingly strong, particularly Tina's incandescent reading of "A Love Like Yours," which still should be heard in order to appreciate the full range of her interpretive gifts.

Outta Season
The Hunter

These two Blue Thumb albums contain some nuggets that

still sparkle. *Outta Season*, which presented Tina in a program of blues classics, was a shrewd idea in 1969, but now sounds obvious and somewhat dated. Tina's rendition of Otis Redding's "I've Been Loving You Too Long," however—especially divorced from the sex-play trappings with which it was encumbered onstage—is still a gripping track. *The Hunter* contains "Bold Soul Sister," Ike and Tina's hottest dance hit up to that point.

"Come Together"/"Honky Tonk Women"
"I Want to Take You Higher"

In the aftermath of Woodstock, the Turners started their stint with United Artists as purveyors of blues-rock authenticity to the hippie masses. The idea has dated, but "Come Together" and "Honky Tonk Women" proved Tina to be a rock 'n' roller of the first rank; and the ferocious "Higher" pulled off a considerable feat in not being an embarrassment when compared to Sly Stone's magnificent original.

"Proud Mary"

If "Honky Tonk Women" didn't prove that Ike and Tina could make any song their own, this reinvention of the Creedence Clearwater Revival hit most certainly did.

"Nutbush City Limits"

Together again—in the artistic sense—for the last time, the Turners scored a fiery dance hit that was even more popular abroad than at home. Written by Tina, it's a rocker that still rocks in her concert performances.

"Ball of Confusion"

It must have sounded like an odd notion—Tina Turner, queen of gutbucket R & B, backed by an English new-

wave synth band. This track from the British Electric Foundation's *Music of Quality and Distinction* LP proved that, by 1982, all bets on oddness were off—and Tina Turner, beyond question, was back.

Private Dancer

"Artistic triumph," "Comeback of the decade"—pick your own critical accolade. With *Private Dancer,* Tina repositioned herself at the forefront of commercial rock 'n' roll, investing everything from electro-rockers and synth ballads to quasi-reggae, quasi-metal, and the art-song title track with an emotional resonance rare in any year, and unexampled in most. Played to death on radio and in dance clubs around the world, this LP is still as fresh and compelling as it was the day of its release.

"Tonight"

A duet with David Bowie, featured on his 1984 album of the same name, this song—an Iggy Pop original that ponders love and mortality within a haunting reggae arrangement—is one of the semihidden treasures of Tina's extraordinary oeuvre.

"We Don't Need Another Hero"
"One of the Living"

These are Tina's two songs from the soundtrack of the 1985 film *Mad Max Beyond Thunderdome*. "Hero" is a perfect little pop song, given an appropriately measured reading that respects the delicate instrumental riffs without descending into goo. "Living" is a sort of post-art-metal crunch opus.

A high school picture of me,
age fifteen

My grandmother, Roxanne Bullock

High school picture of me around
graduation, age seventeen

A childhood photograph of my
sister, Alline

My cousin and closest childhood
friend, Margaret Curry

My first love, Harry Taylor

My mother, Zelma,
in the early 1970s

Another photograph of my mother
in the mid-1980s

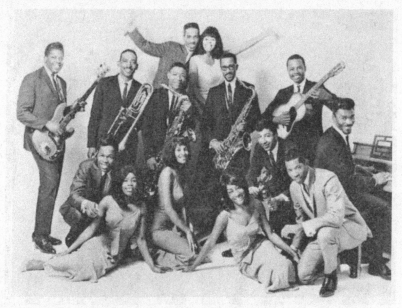

Ike and Tina Turner Revue publicity shot, 1964. This was taken while the group was still based in St. Louis. *(Courtesy of Rhonda Graam)*

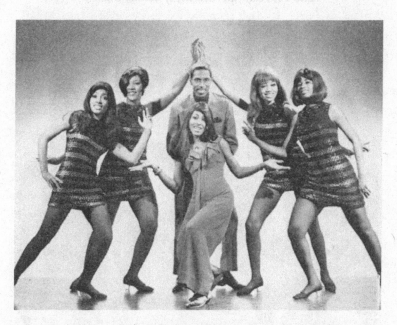

A publicity picture from late 1965. Ike and me *(center)* with *(from left)* Ann Thomas, Paulette Parker, Pat Powdrill, and Jean Brown. *(Courtesy of Rhonda Graam)*

A club date in 1965. *(From left)* Ann Thomas, Vermita Royster, me, and Pat Powdrill. *(Courtesy of Rhonda Graam)*

My birthday party, 1966, backstage at Edwards Air Force Base. *(From left)* Jean Brown, Ann Thomas, me, and Pat Powdrill. *(Courtesy of Rhonda Graam)*

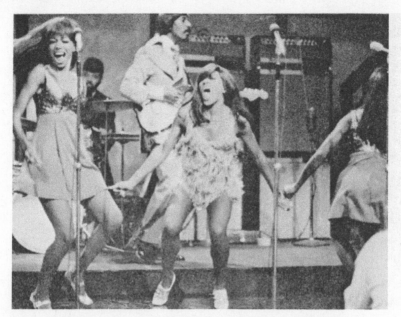

Playboy After Dark TV show, 1968. *(From left)* Pat Powdrill, Ike Turner on guitar, me, and Claudia Lennear. *(Courtesy of Rhonda Graam)*

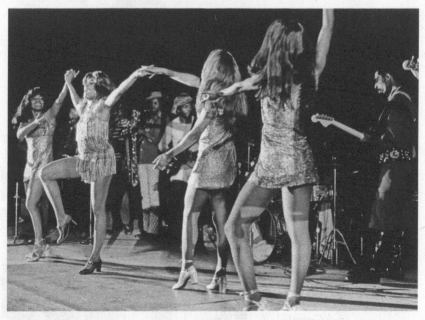

The Ikettes and me at the Filmore West in San Francisco. *(From left)* Esther Burton Jones, me, Edna Lejeune Richardson Woods, Jean Brown, and Ike *(at far right)* on guitar. *(Bob Gruen)*

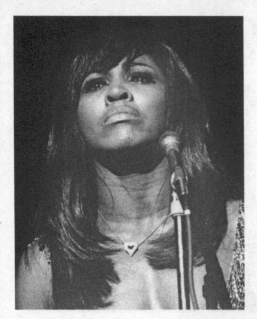

Late 1960s
(Bob Gruen)

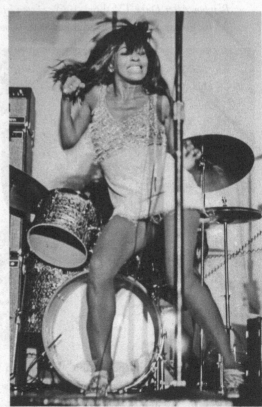

In the late 1960s
(Bob Gruen)

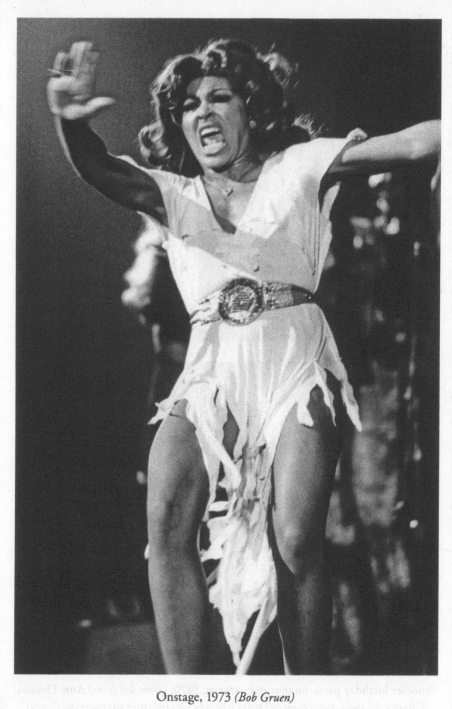

Onstage, 1973 *(Bob Gruen)*

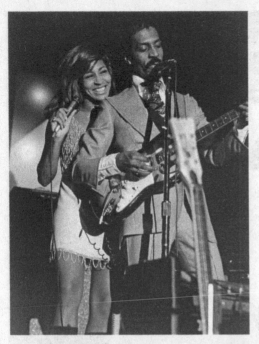

With Ike onstage in
the late 1960s
(Bob Gruen)

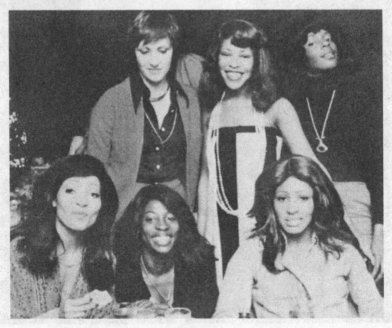

Another birthday party, on tour in Germany, 1970: *(from left front)* Ann Thomas, Charlotte Lewis, me; *(from left rear)* Rhonda Graam (tour manager-secretary), Debbie Wilson, and Linda Sims *(Courtesy of Rhonda Graam)*

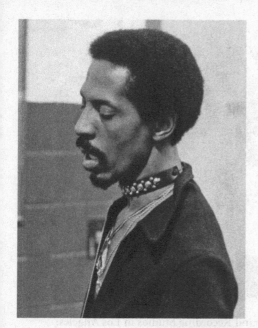

Ike Turner,
backstage in 1973
(Bob Gruen)

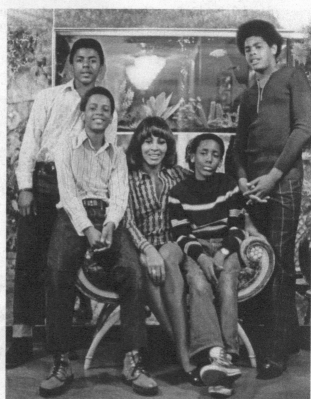

In the early 1970s
with the children:
(from left) Ike
Junior, Michael,
Ronnie, and Craig
(Bob Gruen)

The opening of the Bolic Sound Recording Studios in Los Angeles: *(from left)* Psychic Peter Hurkos, Ikettes Jean Brown and Esther Jones, secretary Linda Kraus, Ike, and me *(Globe Photos)*

Ike's "Scarface" office at Bolic Sound Studios *(Globe Photos)*

A painting sent by a fan, which hung in our home
(Bob Gruen)

The kitchen and dining quarters of Ike's Bolic Sound Studios, complete with a full-wall mural of a couple making love. The man depicted is former football star Jim Brown, a friend of Ike's at the time. *(Bob Gruen)*

The famous guitar-shaped coffee table
(Globe Photos)

In front of the fireplace at home
(Globe Photos)

With Elton John at the press conference to launch the film *Tommy*
(Bob Gruen)

At the *Tommy* press
conference in New
York in 1974
(Bob Gruen)

Performing at the Ritz nightclub in New York, 1984, on one of my happiest days. "What's Love Got to Do with It" had gone to number one that day, and I had just learned that I would be staring in *Mad Max Beyond Thunderdome*. *(Bob Gruen)*

With Keith Richards *(left)* and David Bowie *(right)* after my 1983 performance at the Ritz in New York *(Bob Gruen)*

Performing with Mick Jagger at the historic Live Aid concert in Philadelphia, July 1985. *(David Seelig)*

Performing in New York on the 1985 Private Dancer tour. *(Bob Gruen)*

CPSIA information can be obtained
at www.ICGtesting.com
Printed in the USA
LVHW03192825O523
748102LV00012B/338